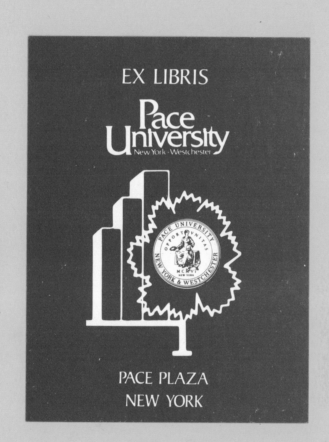

Picture the Songs

Picture the Songs

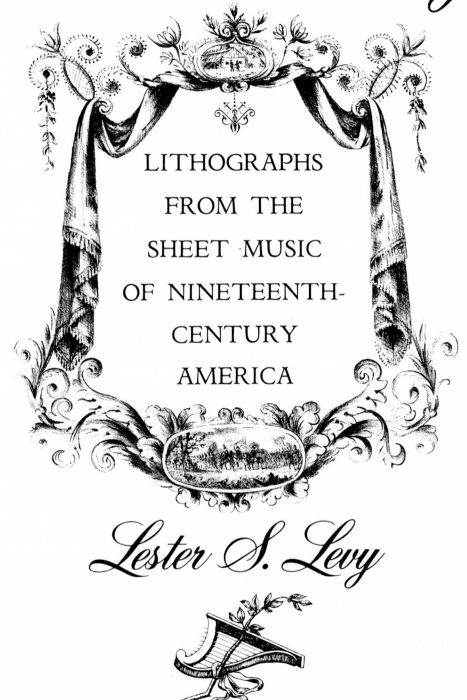

LITHOGRAPHS
FROM THE
SHEET MUSIC
OF NINETEENTH-
CENTURY
AMERICA

Lester S. Levy

THE JOHNS HOPKINS UNIVERSITY PRESS : BALTIMORE AND LONDON

Manufactured in the United States of America

The Johns Hopkins University Press, Baltimore Maryland, 21218
The Johns Hopkins Press Ltd., London

Library of Congress Catalog Card Number 76-13518
ISBN 0-8018-1814-1

Library of Congress Cataloging in Publication data will be
found on the last printed page of this book.

TO
SUSAN, ELLEN, RUTH, AND VERA
WITH LOVE

Contents

Foreword

Not long ago, writings on American art focused primarily on painters and sculptors and mentioned—when they thought to mention less "serious" art at all—only Currier and Ives among popular printmakers. In fact, the nineteenth century was an era of extensive activity in the graphic arts, but we are just beginning to assess that activity in any systematic way. The American public was bombarded with printed images a century ago, and even the unsophisticated could hardly have escaped noticing the illustrated broadsides, pictorial advertisements, and cuts in books and on letterheads produced by scores of printmakers and publishers across the country. Compared with these, the audience for works of art in museums and galleries must have been small indeed; thus, conventional artists played only a partial role in establishing the visual sensibilities of the American public.

Without detracting from either the American "high" artists or those who have written about them in the past, recent critical opinion has broadened our horizons and enlarged the field of study of American art. We have come to understand that a civilization is not comprehended by its highest art forms alone. To suggest the precise quality of our own time without mentioning television situation comedy, rock music, or advertising art would be as futile as trying to evoke the last century without mentioning its popular art forms. To state the case this way reveals a fascinating point: "serious" art and popular art are not isolated from each other; the idioms and forms of one influence the other.

Having come to this realization about our own time, historians and critics have started to reexamine the past and give serious attention to objects formerly ignored. So it is with the music covers of nineteenth-century America.

Music covers were by no means the only form of graphic art produced in the United States during the last century. From the beginnings of urban development in the colonies, engravers and etchers had produced necessary things—maps, currency, tradesmen's cards—and with the coming of the Revolution, politically motivated cartoons and portraits became common. With the nineteenth century came an expansion of the American population, territory, and industrial capability, which was reflected both in the increased demand for pictures and in the increased ability to produce them. By mid-century, there were dozens of lithographers producing topographical, portrait, and cartoon prints in quantity, along with advertisements, sentimental and artistic sheets, and renditions of current events. Illustrations for books and periodicals occupied engravers, lithographers, and printers, as well.

After World War II, a few public collections (including the Library of Congress, with its vast copyright deposits, and the New York Historical Society) and one or two private collectors (Lester Levy prominent among them) began to look more carefully at the pictorial content of the popular

music covers they had assembled, and it became evident that these covers depicted many things in a way not found in other pictorial publishing of the time or only otherwise recalled to us through written sources or by tradition. Advertisements portrayed individual products, but music covers revealed them in use and in place. In topographical prints we could see "portraits" of buildings and places, but in music covers we could see them as they appeared in everyday life. The mere presence of a person or a place on a music cover suggests a popular appeal and indicates a public regard we may not have appreciated fully. So this new study has expanded our knowledge of our society and its developing concerns and added a new corpus to the history of American graphic arts.

As Mr. Levy points out in his text, the growth of the sheet music industry coincided with the expansion of the lithographic printing industry, so the availability of a new market was eagerly exploited by a generation of new craftsmen and artists. This was not exclusively an American development, of course, but the subjects and styles of music covers in the New World developed characteristically into an independent and compelling pictorial form. Whereas in the eighteenth century engraved music sheets in the Colonies had been indistinguishable from their British counterparts save for their crudity or artistic incompetence, in the nineteenth century they became a truly indigenous American medium, no longer mimicking British or Continental prints.

To follow the development of these music covers is also to follow the change in the function of American music from sacred to secular, from timeless to timely. This increasing specificity in musical material was directly related to the pictorial matter printed in the eighteenth century with increasing prominence on the first page of the musical score—becoming in the nineteenth century a cover for the booklet of music—and helped to determine the kinds of artists and kinds of pictures sought by the music publishers.

Here, then, was a popular form in the visual arts emerging as a result of social, technological, and cultural changes. Looking back at these objects we now find that their producers have left us a record of their time incomparably richer and more authentic than any that could have been created as a conscious historical record.

When Lester Levy started his collection no doubt he was charmed by the pictures that adorned the music sheets he acquired, but it is unlikely that he realized how rich a source of graphic culture he was about to explore. As his collection grew, however, it became clear that in this unexamined area was an extraordinary treasure, a pictorial encyclopedia of personalities, costume, topography, history, interior and exterior architecture, sport, and politics. Quite apart from the unselfconscious depiction of things as they were, the selection of motifs, events, and people turns out to be an exceptionally revealing indicator of what attracted and preoccupied the American public during much of the last century.

For perceiving these possibilities, Mr. Levy deserves great credit. He began by collecting music and has ended up by writing history. He has gone beyond simple delight in his holdings to serious investigation of their significance. It is a tribute to the freshness of his approach that he has retained his enthusiasm and interest even as his knowledge has increased, and we are grateful to him for sharing his findings in books such as this.

ALAN FERN
Director, Department of Research
Library of Congress

Acknowledgments

This book owes much of its substance to the support I received from libraries and individual historians across the land. Help came from Carson City, Cheyenne, Cincinnati, Detroit, Ithaca, Kansas City, Louisville, Providence, Savannah, Syracuse, and a dozen other places.

I want particularly to thank Dr. Gertrude Rosenthal, Chief Curator Emeritus of the Baltimore Museum of Art, who examined an enormous number of lithographed sheet music covers and, with her skill and expertise, generously guided me in the selection of those that combined the greatest appeal with the highest pictorial value.

I am indebted to Dr. Elliott W. Galkin of Goucher College and to Mr. P. W. Filby, Director of the Maryland Historical Society, for their advice and encouragement.

For hard-to-find facts about the subject matter of some of the old Philadelphia prints, I want to thank Alice F. Stern and Jane G. Levy, a pair of literary archaeologists, who spent countless hours digging and coming up with the wanted material.

Once more, as so often in the past, I have relied on Evelyn Wagner for a major portion of the required research and for the assembling of much of the material that went into the book.

Before dotting the last *i* and crossing the last *t* of each story, I submitted it to my wife, Eleanor, the critic in whose judgment I have the most complete confidence, one who is always candid and, above all, helpful in her suggestions.

Introduction

It was just sixty years ago that Irving Berlin wrote, for one of his first musical shows, a song called "I Love a Piano." He might well have dedicated it to nineteenth-century America, for the piano trade then constituted a respectable part of the industrial picture of the United States.

In the 1860s, for example, some 110 American manufacturers built twenty-five thousand pianos annually; there were by that time many hundreds of thousands of pianos in homes across the country, and the sales of popular sheet music, both vocal and instrumental, were enormous. There was a steady demand for new songs—sentimental, patriotic, topical, or humorous—and for new romantic waltzes and sprightly polkas and schottisches. Many of these pieces had title pages with lithographed illustrations—decorative previews of the music on the inner pages. An attractive cover not only attracted the purchaser but also provided a touch of beauty, or whimsy, to the sheet on the music rack.

My earlier books traced America's development through its songs. These books point out that an event or a change in mores was sung about immediately after the subject had become a matter of public interest. The purpose of this book is to illustrate how a prime and inexpensive form of art was delivered into the hands of the public by the medium of sheet music for the piano.

The heyday of American lithography spanned the middle decades of the nineteenth century, and lithographed sheet music covers were sold in staggering quantities. Unfortunately, these covers were subject to wear and tear and the ravages of time, so that today only a small fraction of those that were printed remain in public libraries or private collections. Their inclusion in any history of American art has inherent value, for they represent the art form most readily and reasonably available to people of moderate means. This book offers choice examples of those early imprints.

When sheet music was first published in America, in 1788, it carried, for the most part, no form of embellishment. The bars of music—and the words, if it happened to be a vocal number—were cut on a metal plate and struck off, usually in a very limited "edition," on sheets that were sold at quite reasonable prices, sometimes as low as twelve and a half cents apiece. Occasionally in those early years, an engraved vignette would decorate the top of the first page of music. Less often, a fully engraved illustrated title page would introduce a musical work. These were more expensive; an eleven- or thirteen-page pianistic "tone poem" describing a famous battle, with an engraved scene or portrait decorating the cover page, might sell for as much as a dollar.

And then came lithography. It was in 1819 that the first American lithographer, Bass Otis, struck off his initial picture by the new method and had it published in the July issue of the *Analectic Magazine*, which had earlier described the art of lithography—an innovation developed by Alois Senefelder in Munich, Germany, in 1798—and discussed the type of stones

that were employed. Within a dozen years, the popularity of the lithograph had blossomed like dandelions in spring. The ease of reproduction, the low cost, and the availability of local artists induced enterprising young businessmen in Boston, New York, Philadelphia, and Baltimore to open little lithographing establishments, which occasionally grew into sizeable institutions. These shops turned out every form of popular artistic reproduction for sale to the public, from elaborate letterheads and billheads, to likenesses of statesmen and fair ladies, to subjects that graced the title pages of music sheets. It is with this last category that this book is concerned.

A lithographed title page had artistic advantages which, to the mind of the publisher, far surpassed the cruder attractions of the pictorial engraving. Moreover, a music publisher could sell a printed march or song for ten to twenty-five cents more if the title page was attractively illustrated. So he would contact his lithographer, who in turn employed his artist, and in no time the result would be in the publisher's hands for distribution.

In a few instances the operation was streamlined; some artists, like the Endicotts of New York, operated their own lithographic establishments and even their own music publishing houses. But for the most part, publisher, lithographer, and artist were three separate players on the same team, working together smoothly and, by the standards of mid-nineteenth-century prosperity, profitably.

By the 1850s there were music publishers throughout the length and breadth of the land, from Portland, Maine, to New Orleans, and from Charleston, South Carolina, to San Francisco. Frequently a publisher in a smaller city would contract with a big New York or Boston lithographer to furnish illustrated title pages for his music, but the lithographing operation was so uncomplicated that firms soon sprang up in nonmetropolitan areas. San Francisco, which began its growth in 1849, published its first illustrated piece of sheet music just three years later, with an illustration conceived by a San Francisco artist and lithographed by a San Francisco firm. Charleston's first illustrated title page had appeared some twenty years earlier. Saint Louis was a little river-boat town in the 1830s; but before 1840 a music publisher there had issued music illustrated by a hometown concern. By mid-century there were some two hundred lithographic establishments in over two dozen American cities.

To return to the pioneers. In 1822 Henry Stone, then living in Washington, D.C., set up a small lithographing shop in that city. It was necessary to explain to the public what *lithographing* meant, so Stone arranged for the *Washington Gazette* to do this in November, 1822. From that paper we learn that Henry Stone, "by his skill and experience in drawing, [lay] upon a smooth surface of marble with chemical and other ink, and print[ed] off beautiful designs of various figures for needle-work, etc."

The "etc." soon included music. In 1823 Stone lithographed a sheet of music entitled "The Soldier Tired," which had no pictorial decoration but which nevertheless qualifies—as far as we know—as the earliest American lithographed music sheet. During that same year, again in Washington, there was issued a seventy-two-page lithographed *Miscellany of Music*. The pages were ornamented with flourishes, scrolls, lyres, and thistles. One crude mid-page illustration of a sleeping girl above a song, "The Maid of the Rock," bears the initials "H. S."

The first lithographed title page on sheet music was the work of David Claypoole Johnston, a Philadelphian with a satirical streak. His artistic gibes at political figures so aroused the usually somnolent citizens in that town of brotherly love that soon Philadelphia print sellers shied away from the cartoons Johnston submitted to them, fearing possible libel suits by the persons lampooned.

Johnston believed he had a second accomplishment; he was convinced that he could act. For three seasons he worked with Thomas Wignell's celebrated troupe at the Chestnut Street Theatre in Philadelphia, leaving the company in 1825 to accept an acting engagement in Boston. After a stint with the Boston Theatre lasting one year, he decided to turn to a career as an engraver and artist.

In 1825 the first commercial lithographing operation in the United States was set up in Boston by the Pendleton brothers. They soon became acquainted with Johnston and were pleased when he arranged to make designs for them. In Boston Johnston continued to turn out his cartoons, many of them tinged with sarcasm directed against the "establishment." So impressed was his public that they called him the American Cruikshank, after the well-known English illustrator whose cartoons had profoundly influenced Johnston's work.

Johnston's first lithographed sheet music title page, for A. P. Heinrich's "The Log House" (March 14, 1826), is presented in this book. It is a rather "busy" illustration, but it gives evidence of the whimsicalities that characterized Johnston's work.

Thereafter, and for over fifty years, the lithographed sheet music cover was exploited. From primitive beginnings it flourished until most of the music publishing houses in the United States were using competent artists to design sheet music covers. And some of the artists were much more than "competent"; their later works hang on the walls of America's great galleries. James McNeill Whistler had a go at designing a cover (only one try, unfortunately); but Winslow Homer produced a dozen or more entertaining title pages. Alfred Jacob Miller's work graced a few sheets of a Baltimore publisher; Fitz Hugh Lane did a dozen covers for publishers in Boston. And many other artists, well known by their contemporaries, found the work lucrative.

Best of all, many of the covers tell stories, or picture men, places, and the mores of times when there was no other medium to record pictorially the event, or the individual, or the characteristics of that particular period in that particular way. Thus, thanks to these title pages, we have preserved a facet of American history that might otherwise have been lost.

True, the covers on music sheets represented only a fraction of the lithographers' output. But the portraits and sentimental subjects, the steamships and views, priced to sell at a dollar or two, added up to an enormous volume, and they were used to decorate the walls of town and country houses throughout the land. And it was the medium of the sheet music cover that relayed to the people, pictorially, the everyday news that they get today, to an extent, from television and the weekly newsmagazine.

Knowledge of the contribution to our history that these song sheets have made was the motive for writing this book. Because of space limitations, many excellent sheets dealing with important subjects had to be omitted. The choice frequently lay between covers depicting outstanding events of American history and those covers notable for artistry of illustration. If the latter were oriented toward a subject with which the people of that time were familiar, they qualified for inclusion in this volume.

Here are displayed 100 title pages from the author's collection. Handsomely drawn, these lithographs illustrate some occurrence or personage or location of temporary or, occasionally, lasting significance in the development of the United States in the mid-nineteenth century. They are arranged in approximate chronological order and include work by fifty lithographers. Opposite each illustration is a brief story of its background, of the lithographer, and occasionally, of the composer of the music, so that the reader may fit it into the larger picture of our history.

Picture the Songs

Anton Philip Heinrich, or "Father" Heinrich, as he was better known, was one of the most aspiring musicians who ever emigrated to the United States. Had his talents kept pace with his aspirations, we would be hearing his works—which were voluminous—in today's concert halls. But while the bravura passages captured the fancy of many Americans from 1820 to 1850, they failed to attract later generations. Heinrich's compositions, therefore, are strictly period pieces, and his exalted visions of creating a novel, distinctive, compelling interpretation of music for the new world were never realized. Still, he must be rated as one of the important musical figures of his milieu.

Heinrich, who had been a banker in Hamburg, Germany, was nearly forty years old when he came to America. Moving to Kentucky soon after his arrival here, he taught violin in Louisville but spent a great deal of time among the Indians living in Bardstown and became fascinated with the idea of using Indian themes for large-scale compositions. When in 1820 he published his comprehensive *Dawning of Music in Kentucky; or, The Pleasures of Harmony in the Solitudes of Nature*, he wrote that "no one would ever be more proud than himself, to be called an American Musician" (Upton, p. 51).

One contemporary magazine called him the Beethoven of America, which inspired him to turn out full-blown works like *The Columbiad* and *Jubilee*, the latter arranged for full orchestra and chorus and commemorating the story of the country from the landing of the pilgrims to the "consummation of American liberty."

Heinrich had plenty of inspiration, but his voluminous writings are not appreciated by today's musical intellectuals. One of his works, "The Log House," must be singled out, not so much for the quality of the music as for the illustration on the cover of the music sheet. "The Log House" is the first example of American sheet music to bear a lithographed title page. The lithographers were Bostonians (lately from Philadelphia) named John and William Pendleton, and the artist was David Claypoole Johnston, a master caricaturist soon to be known as the American Cruikshank (see Introduction and "The Ice-Cream Quick Step").

The design for the title page of "The Log House" attempts to encompass the story of Heinrich's life in America. The composer, portrayed with fiddle in hand, sits on the rung of a ladder beside his log hut, with copies of his musical compositions strewn about him. A ragged beggar, enthralled by the music, is offering him a small donation to continue to play. Two small vignettes indicate Heinrich's departure from Louisville, pursued—in the artist's imagination—by unfriendly Indians, and his subsequent arrival in Boston, where, in front of the State House, he is greeted by friendly Muses. The title page is embellished with small line drawings at the bottom by John P. Van Ness Throop, a copperplate and general engraver and a well-known painter of miniatures.

"The Log House" was No. 19 of a massive work that Heinrich entitled *The Sylviad*. The rest of this epic accomplishment, which bore the subtitle *Minstrelsy of Nature in the Wilds of North America* and which ran to 412 pages, was destroyed in a Boston fire.

Johnston's output of caricatures, from the early 1820s until his death in 1865, was massive but not as overpowering in quantity as Heinrich's musical works. Only about a dozen of Johnston's pictures were designed as covers for sheet music; some mocked the reforms of his day, such as temperance agitation and anti-Masonry. In the field of lithography, he remains one of the premier draftsmen on the American scene.

In the early years of United States history, a bow and arrow was important equipment for the American Indian to fell the game needed to give him a balanced diet. The white man in America had no use for, and no skill with, these weapons; but strange to say, the time came for him to adopt them, not for a quest after deer or buffalo, but for pure sport—archery.

It was nearly one hundred and fifty years ago, in 1828, that two Philadelphia artists, the sons of the famous Charles Willson Peale, joined three of their friends to organize the United Bowmen of Philadelphia, the first group of its kind in America. There were decided advantages to being a member of the Bowmen, who in the course of years numbered several hundred. In the first place, they were able to wear a distinctive uniform, consisting of green coats trimmed with gold, white pantaloons, and green caps. In the second place, each elected member received or inherited his "mark," a device on a shield with an appropriate or humorous motto. When the club gathered for its banquets, each member's shield was placed by his seat. This leads to a third advantage; the club had its special brand of punch, called the Hail Storm, a particularly potent concoction, whose ingredients remain a secret to this day.

But the primary purpose of the Bowmen was to develop skill in the field of archery, rather than to look dapper in their uniforms or even to guzzle Hail Storm punch.

At least once a year these several activities were observed at an anniversary celebration. Ladies joined the gentlemen of the society on these occasions, usually held at the extensive estate of one of the more affluent members. A handsome marquee was erected, and under it were assembled a number of musicians to entertain those of the couples who did not stroll off for tête-à-têtes in the wooded groves.

In their archery contests the Bowmen competed for prizes, fiercely but politely. The company's massive silver bowl went to the winner, who retained possession of it for one year; the runner-up received a handsome silver arrow with the inscription *Secundus Hoc Contentus Abito* ("He who achieved second place should go away satisfied with this award").

So much interest was exhibited from the very outset in the activities of the association that in 1829 one of its musically inclined members, Mr. W. H. W. Darley, composed a selection for the piano which he "Respectfully Inscribed to the United Bowmen" and which he called "The Archers March." The title page portrays a stylishly outfitted bowman, wearing a distinctive coat that appears to be an early model of the Eisenhower jacket, with a peaked cap and white pantaloons. He has just let fly his arrow, and, sighting its direction past the great bow held in his left hand, looks for all the world like a classical dancer. Behind him is a replica of the target used in the games.

The lithograph is one of the earliest on any Philadelphia music sheet. It is the work of David Kennedy and William B. Lucas, who formed a partnership in 1829 and maintained it for six years. Kennedy and Lucas were best remembered for illustrating a treatise on railroads and for a work entitled *The Annals of Philadelphia*, both published in the year 1830. They also collaborated on *The Floral Magazine and Botanical Repository* a year or two later.

The early Philadelphia directories took no notice of the partners' lithographic talents. They listed the firm as a "looking-glass store."

THE ARCHERS MARCH

Composed, Arranged

for the

PIANO FORTE,

And Respectfully Inscribed to the

UNITED BOWMEN

by

W. H. W. DARLEY

Member of the Association.

Philad.ᵃ Published by R.H.Hobson, 147 Chesnut St.

Entered according to act of Congress. July 8ᵗʰ 1829.

Late in the fall of 1830, a meeting was called at the home of Jacob Mason, one of Philadelphia's public-spirited citizens, to discuss the building of a railroad. Prior to that time, only one such road, the Baltimore and Ohio, existed in the United States, running southwestward for a dozen miles out of Baltimore. Mason and his associates from towns north and west of Philadelphia were determined to create a line that would join Philadelphia and Norristown, some eighteen miles away, with an intermediate stop at Germantown.

There was no difficulty in steering through the Pennsylvania legislature a bill authorizing the road's construction; and in February, 1831, the Philadelphia, Germantown, and Norristown Railroad Company was incorporated, with a capital of eight thousand shares of fifty-dollar par value each. The offering of the stock caused enormous excitement, and the issue was heavily oversubscribed.

Construction proceeded rapidly. By the beginning of June, 1832, the wooden rails, covered with flattened iron bars, had been laid between Philadelphia and Germantown, and on the sixth of the month the road was formally opened. The invited celebrities at the gala occasion were conveyed to Germantown in nine horse-drawn cars, built like large mail coaches, with a driver's seat in front and another seat in the rear. The cars were painted in gaudy colors; each bore its own name, like the Pullman cars later on. One was the Benjamin Franklin, another the William Penn, a third the Germantown. Each could accommodate twenty passengers inside, and another fifteen outside; so the total carrying capacity of the train came to about three hundred. The fare was twenty-five cents; children under twelve paid half price.

But the best was yet to come. In November, 1832, Philadelphia got a glimpse of an amazing novelty, a locomotive engine built for the railroad company by Matthias W. Baldwin, who later developed the great Baldwin Locomotive Works outside Philadelphia. On November 23, the track was cleared, and the engine went charging away at the breakneck speed of twenty-eight miles per hour. The next day the locomotive drew four cars loaded with passengers from Philadelphia to Germantown, a six-mile run, arriving at its destination in twenty-eight minutes. By August, 1835, the tracks had been laid all the way to Norristown, and the vision of the founders of the road became a reality; the Philadelphia, Germantown, and Norristown Railroad Company lived up to its name.

Before the road had been completed there appeared a charming lithograph of Baldwin's little steam engine, drawing some of the quaint cars, each with a coachman mounted in front, and carrying a group of well-gowned women and high-hatted men. The lithograph bears no name, but the work is apparently that of Kennedy and Lucas, who are also represented in this book by their cover of "The Archers March."

The artist is probably W. L. Breton, who contributed many pictures of ships and views of the Philadelphia environs during the 1830s. When a *History of Philadelphia* was published in 1839, Breton designed the frontispiece.

A Philadelphia music publisher, George E. Blake, then decided to republish the lithograph with a musical composition on the reverse page. He chose the "Rail Road Steam Galop," by Joseph Gungl. Gungl was a Hungarian who had a full musical career. At an early age he played the oboe in a Hungarian artillery regiment. He soon became conductor of the regimental band and went on from there to conduct a more prestigious band in Berlin. He composed a great many marches during his lifetime; a number

RAILROAD DEPOT AT PHILADELPHIA.

12

of them found their way to America, which welcomed the music of Europeans. It is probable that the "Rail Road Steam Galop" was written for performances in Gungl's native Hungary and was brought to the United States as additional adulation for the new railroad.

People who decided to splurge and buy a copy of the new galop did not find the cost excessive. The price was six and a quarter cents!

HUNTSMAN ROUSE THEE!
HARK THE HORN!

CA. 1831

Hark! How echo answers sound,
To neighing steed and yelping hound!
Then rouse . . . and join our jovial crew,
And swell our cry haloo! haloo!

This sporty title page carries an illustration by the venerable lithographing firm of Endicott and Swett. George Endicott and Moses Swett were two of the first half-dozen artisans in America to turn out lithographed sheet music covers. They became partners in 1830, doing their early work together in Baltimore and then moving to New York, where their "Huntsman" cover was designed.

For centuries hunting had been a popular sport in Europe, where the aristocracy bred and used hounds in pursuit of boar and stag. In America as early as the latter half of the seventeenth century, packs of hounds were used to run down raccoons, wolves, and foxes that preyed on the livestock and produce of the colonists.

Occasionally, a wealthy emigrant from England would arrive with dogs as part of his entourage. For example, we are told that in 1650 one Robert Brooke, an Englishman who decided to move to Queen Anne's County, Maryland, brought with him his pack of hounds. These were in addition to Mr. Brooke's wife, ten children, twenty-one manservants, and seven maidservants—a not inconsequential colony of humans and animals.

The use of horses and hounds for sport spread in the colonies in the early eighteenth century, when untrained dogs were occasionally used to chase a fox, "in between Indian vigils." George Washington was an avid hunter in the period between the French and Indian Wars and 1776. In fact, much of his spare time was devoted to fox hunting, and his diary is peppered with reports of the results. For example, the entry of February 12, 1768, reads, "Cotch'd two foxes," and that of the following day, "Cotch'd two more foxes." Another entry, that of April 14, 1774 reads, "Went a hunting. Killed a bitch fox, with three young ones almost hair'd" (Van Urk, p. 56).

Thomas Jefferson, Alexander Hamilton, and John Jay were hunting enthusiasts, as were other prominent revolutionary figures. Some were governors of the prestigious hunt clubs, whose members included many of the wealthiest citizens of nearly every state from Virginia to Massachusetts. The Charles Town Hunt Club, the first in Massachusetts, was organized in 1814 by a gentleman who loved animals with a passion and was a breeder of fine hunting horses. The chase would always wind up in Woburn, where hunt breakfasts would be served at—naturally—the Black Horse Tavern.

By the time of the Revolution the exciting pastime had become well recognized as a form of adventurous amusement for the sporting element, and within a dozen years, wealthy landowners in the Middle Atlantic States were hunting foxes with regularity. The affluent gentlemen farmers

Lith. of Endicott & Swett.

HUNTSMAN ROUSE THEE! HARK THE HORN!

Song of Chase

The Words by

JOHN IMLAH ESQ.

The Music Composed expressly for, and Dedicated to

John Braham Esq.r

By

JOSEPH DE PINNA.

New York. William Bunce. No. 453 Broadway

14

of Pennsylvania and Maryland regarded their hunting steeds and their packs of hounds as important assets, as much as their slaves and guns.

One of Mr. Brooke's descendants bred fine hounds. His prize animal, named Barney, was described by a hound historian as "immense in size," with "grand carriage" and a "neck like a coach horse. . . . His splendid note started deep and full, and finished high, clear and musical beyond description" (ibid., p. 136).

Alas for the unwary fox that Barney scented!

NEW YORK. O WHAT A CHARMING CITY!

CA. 1833

Mr. I. A. Gairdner, the gentleman who expressed himself lyrically in 1831 on the subject of the virtues of New York, seems always to have looked on the bright side of things. Nowhere do the seamier aspects of life in the great metropolis occur to the narrator of his ballad, who explored the town with the following results:

In Bowery, in Broadway, He rambl'd up and down,
Took byway, and oddway, Resolv'd to see the town;
And as he went, he sung this song, "Now, is it not a pity,"
I should have stay'd away so long, From such a charming City.
New York! New York! Oh! what a charming City.
New York! New York! Oh what a charming City.

Here Freedom and duty, And truth, and taste remain,
Here honour, and beauty, And love, and valour reign;
Then hither Freedom's friends resort, The grave, the gay, the witty,
For here I'll henceforth keep my court, In this delightful city!
New York! New York! Oh! what a charming City.

Certainly the scene on the title page, lithographed by J. B. Pendleton of New York and designed by B. Lopez, was lovely, an almost idyllic pattern of urban tranquillity. The Pendleton brothers, John and William, were among the pioneer lithographers of New York and Boston and have been looked upon as the real founders of lithography in the United States. Many of the most skilled artists, and indeed a number of the lithographers of the period, were protégés or employees of one Pendleton or the other.

The brothers were singularly accomplished. In 1816, before John, the younger of the two, was twenty years old, the boys were commissioned to install gas fixtures for lighting the Peale Museum in Philadelphia. Four years later they took charge of a traveling exhibit of works of Rembrandt Peale, the paterfamilias of the artistic brood. Then they separated, John going to France and William to Boston, where in due time he was joined by his brother.

But John was peripatetic; he returned to Philadelphia after a couple of years with William, and shortly thereafter he engaged in business in New York, where he produced, among other artistic pleasantries, the title page of "New York. O What a Charming City!" In 1834 he sold his business to a pupil, Nathaniel Currier—*the* Currier.

Actually, New York in the early 1830s was not altogether as charming as Mr. Gairdner made it out to be. The Bowery and Broadway were both shopping streets. Broadway was comparatively genteel; but the storekeepers and their assistants on the Bowery were tough-fibered salesmen. There, potential customers strolling the streets were not only dragged into stores

New York.

O what a charming City!

Written and Composed

BY

I. A. GAIRDNER. A. M.

Published by Geo. Willig Jr. Baltimore.

by the clerks but were frequently cheated when they were inveigled into making a purchase.

The predecessors of the dangerous gangs that today can be found in parts of Brooklyn and upper Manhattan were active in the Bowery area in the 1830s. Foremost among them were the Bowery Boys, who were aided and abetted by the American Guards, the O'Connell Guards, and the Atlantic Guards. These gangs were constantly afeudin' and afightin' with similar and even more vicious groups from the Five Points (which later became Union Square) and the East River area—the Plug Uglies, the Buckaroos, and the Swamp Angels.

New York suffered some hard times during these years. A cholera outbreak in the summer of 1832 killed nearly 4,000 persons. In the winter of 1835 a disastrous fire leveled the heart of the city, destroying 693 buildings. The financial panic that started in 1837 cost thousands of people their jobs. At one time, every third working man was unemployed.

In spite of all the minuses, there were many pluses. The city had a magnificent harbor and was the center of foreign commerce. Culture abounded among the better classes; the theaters and concert halls were patronized. Newspapers flourished; in 1832, eleven dailies were published in New York. The Municipal Council had developed a healthy public school system, with some 12,000 pupils in the 1830s. The Erie Canal, bringing the produce of the American farmer to the metropolis, had made New York the middleman for the country's agricultural output and for the manufacturers of England.

If a beehive has charm, then New York might fairly have been called a charming city.

MAJOR JACK DOWNING'S MARCH CA. 1834

In the 1830s about the most popular military man in the United States was Major Jack Downing. The gentleman had, however, one outstanding peculiarity for an American major. He was not a member of the United States Army. In fact, he wasn't even a gentleman. The major was, to be exact, a figment of the imagination of Seba Smith, who was born and raised in Maine and graduated from Bowdoin College and who launched the first Maine daily newspaper.

In that paper, the *Portland Courier*, Jack Downing was "born" in January, 1830. The Downing letters, written by Seba Smith, who at no time disclosed his authorship, appeared in the *Courier* over a period of nearly four years and were later assembled and published in book form as *The Life and Writings of Major Jack Downing, of Downingsville, Away Down East in the State of Maine.*

Jack Downing was the spiritual, if not the biological, ancestor of Josh Billings and Mr. Dooley, both imaginary characters who delighted in lambasting numerous members and projects of the government of their day. (Will Rogers could certainly qualify as a descendant, too.) Readers of the *Courier* were delighted with the plain language and frequent misspellings in Downing's rambling letters. Beginning with an apocryphal grandfather, Downing's rambling account of his antecedents' history was quickly disposed of, and he began reporting on his own adventures.

After a short period as a trader and seller of merchandise, mostly of Maine origin, Downing became an observer and ruthless critic of the shenanigans of his state's legislature. After a while, Smith sent Downing to Washington, to comment on the spoils system under Andrew Jackson and,

MAJOR JACK DOWNING'S MARCH

H. Inman Del.

Composed & arranged

FOR THE

Piano Forte,

Dedicated to the Second Brigade Downingville Militia,

BY

J. T. NORTON.

May be had at all the music stores in the U. States.

Childs & Inman Lith.ᵗ Philadelphia.

by skillful maneuvering, to become a recipient of spoils himself. Awarded a commission as captain in the army, Downing, in a little over a year, was promoted to major, a rank he held throughout the balance of his letter-writing period.

Major Downing's friends urged him to run for political office. He declined to try for the mayoralty of Portland but did go after the Maine governorship, and even the presidency. Despite—or perhaps because of—his sardonic comments about President Jackson and president-to-be Van Buren, Downing's candidacy never got off the ground.

But his letters did. Reprinted in Boston, they were soon circulating throughout New England. Downing's dry wit was so entertaining, his humorous, satirical hints of the many dangers the country was facing under Andrew Jackson's high-handed leadership so engrossing, that the letters were reprinted in local papers all over the country. The major was America's foremost commentator.

Such popularity rated a musical tribute, which was supplied by a well-known Philadelphia composer, J. T. Norton, who, in 1833, wrote "Major Jack Downing's March." The title page carries a delightfully humorous portrait of Major Downing as conceived by Henry Inman, who later became one of America's foremost artists.

Inman, a native of Utica, New York, moved to New York City and, at the age of thirteen, was apprenticed to John Wesley Jarvis. He established his own studio some years later. When Inman was twenty-four he helped to found the National Academy of Design and served as its vice-president for five years. At thirty he moved to Philadelphia, where he became a partner of Cephas G. Childs in the lithographic firm of Childs and Inman. He pulled out of the business in 1833, and Childs replaced him with George Lehman. It was under the auspices of Childs and Lehman that Inman produced his portrait of Jack Downing.

Norton's music is a caricature of a military march: the right hand plays an air that resembles the blast of a trumpet, while the left-hand accompaniment is subdued and does not interfere with the bravado of the melody. Major Downing would have been proud.

PAGANINI QUADRILLES CA. 1834

Niccolò Paganini, the most exciting violinist of his time, commenced his musical studies in 1789 at the age of seven, wrote his first sonata a year later, and overwhelmed a fascinated audience at his first concert when he was thirteen. From then on his talents were in greater and greater demand, first by the music-loving public and later by a bevy of female admirers who found him irresistible. Indeed, Paganini was a most attractive as well as a susceptible young man, and when he became enamoured, there was often a question of just who had seduced whom.

In 1828 Paganini left Italy for a grand tour of Europe. After three incredible years of prodigious fingering and bowing, along with the composition of numerous works for the violin, most of them with orchestra parts, he left the continent for London, where acclaim for this genius of the fiddle reached its peak: many of his listeners were even convinced that Niccolò had sold himself to the devil.

In London Paganini had a brief and tumultuous love affair with a seventeen-year-old girl named Charlotte Watson, who eloped with him to Boulogne, hotly pursued by her papa, Paganini's new impresario. Watson, after having reclaimed his daughter, made peace with his star performer (what is a child's honor compared to the management of the world's fore-

Lith by O'Kramm. No. 150 William St.

Les Extraordinaires.

Paganini Quadrilles,

The Subjects taken from the Works of the above

CELEBRATED VIOLINIST;

Arranged for the Piano Forte,

by

N. C. Bochsa.

New York: Published by E. Riley No. 29 Chatham St.

most musician?) and dreamed dreams of the riches a grand tour would bring. Naturally, those dreams were centered on America.

Watson's dreams were not to be fulfilled, but there was great hope in New York that the genius would appear there. In anticipation of the consummation of those hopes, New York music publishers began to display simplified piano arrangements of some of Paganini's best-known works, in most cases embellishing the title pages with a picture of the great artist.

One engaging lithograph, the cover for a series of quadrilles whose themes were culled from Paganini's compositions, is reproduced here. The lithographer was Gustavus Kramm, a native of Germany who came to New York as a youth, worked there briefly, and then moved to Philadelphia. His sheet music covers are rare; this one, done in the mid-1830s, possesses a delicate charm that makes us regret that Kramm's artistry was not more prolific.

As a likeness of the great man himself, Kramm's rendering appears more flattering than realistic.

JIM CROW AND ZIP COON CA. 1835

A century before ragtime, jazz, blues, and rock, there was one form of musical entertainment indigenous to America: the Negro minstrel show.

This unique appeal to the fun-loving public started when the Virginia Minstrels, a troupe of four white men who had applied black cork to their faces, put on their first song-and-dance act in February, 1843, in a small hall in New York. One of the four was Daniel Decatur Emmett, who, just prior to the Civil War, wrote the immortal "Dixie."

The presentation was enthusiastically received. Not only were the Virginia Minstrels invited to perform in other cities, but imitators sprang up at once, so that before the end of the 1840s America was deluged with minstrel troupes large and small, singing the popular songs of the period as they pranced around the stage.

But the troupes themselves were successors to individual entertainers, comedians who corked their faces and utilized a highly stylized Negro dialect to amuse their audiences. Of the half dozen such actors performing around 1830, two or three were enormous drawing cards. Unquestionably foremost among blackface comics was Thomas Dartmouth "Daddy" Rice.

"Daddy" Rice, born a poor boy in New York, was a wood carver by profession but an actor by instinct. Before he was twenty he abandoned his craft and took to the road as an itinerant Thespian, singing and dancing his way through frontier settlements in the Ohio River valley. While struggling to keep alive by playing small stock parts in a Louisville theater, Rice ran across a ragged, shuffling, elderly Negro crooning a queer melody that he accompanied with a strange little jump whenever he repeated the chorus. Rice was fascinated, and determined he would imitate the old fellow's actions on stage when the next opportunity arose.

The manager agreed, and in the presentation of the local drama Rice made his entrance dressed in tattered garments, crooning the words of the verses he had heard the old man sing, adding others of his own, and introducing the chorus:

> Weel about and turn about and do jis so,
> Eb'ry time I weel about I jump Jim Crow.

His success was sensational. The applause of the audience was thunderous. Rice went from Louisville to Cincinnati to Pittsburgh to Philadelphia to

JIM CROW.

NEW YORK.

Published by Firth & Hall, No 1 Franklin Sq

New York, where, in 1832, at the Bowery Theatre, he is said to have brought more money to the box office than any other American performer prior to that time. London, Dublin, and Cork followed; the Irish *loved* blackface minstrels!

Of course, sheet music publishers in America, and later in England, made hay. Nearly every edition bore on its title page a likeness of "Daddy" Rice doing his odd footwork. One of the most picturesque covers was one published by Endicott of New York (see "Santa Claus' Quadrilles"). Its designer was Edward W. Clay, a Philadelphia lawyer who early on had abandoned his profession to work in the field of art. Engraver, portrait painter, and above all caricaturist, his satirical likenesses of prominent Americans were frowned upon by too many persons of influence. Like David Claypoole Johnston, Clay decided that discretion bade him pursue his activities elsewhere. He chose New York, where a number of lithographers were ready to accept his services. Though his affiliation with Endicott was brief, we are grateful that it produced the delightful "Jim Crow" cover.

After New York, Clay went to Europe for additional art study, but his eyesight failed and he was forced to abandon a promising career.

A strong second to Rice in popularity was George Washington Dixon, whose black impersonations were considerably more varied than his rival's. Dixon made his stage debut in Albany, New York, in 1827, in a circus. The following year he participated in a Negro burlesque in New York City. Soon he was popularizing songs like "Coal Black Rose," the first burntcork song of comic love, and "Long Tail Blue," which describes a strutting Negro dandy.

Dixon's greatest success, however, was scored with his rendition of "Zip Coon," an overwhelming favorite first introduced around 1829. The origin of the melody, which we know today as "Turkey in the Straw," has always been in dispute. Some say it was first heard around Natchez, Mississippi, at gatherings of river pirates, courtesans, and gamblers. One student of minstrelsy insists that it derives from an old Scottish reel. Authorship has been claimed by an old minstrel, Bob Farrell, who insisted that he was the original Zip Coon and whose name was linked to some of the many editions of the song, which goes in part:

O ole Zip Coon he is a larned skoler,
Sings posum up a gum tree an coony in a holler.
Posum up a gum tree, coony on a stump,
Den over dubble trubble, Zip coon will jump.

Chorus
O Zip a duden duden duden, zip a duden day.
(*Repeat three times, and go into six more verses.*)

The stylishly garbed gentleman on the title page of "Zip Coon" is another product of Endicott's lithographing establishment. In this instance, the artist chose to remain anonymous; it may well have been George Endicott himself.

In 1833 Charles Fenderich of Philadelphia executed a lithographic portrait of Sergeant Andrew Wallace and sold copies of the likeness for the benefit of the aged soldier, who apparently was in straightened circumstances. The picture seems to have gained considerable publicity, for two years later a similar, though not identical, portrait turned up on the title page of a song entitled "We'll Sing of Patriots Gone," the verse of which, after repeating the title, continues:

> Gone to the silent grave,
> Their mighty deeds we'll ne'er forget,
> Deeds of the holy brave.

Sergeant Wallace, while undoubtedly a patriot, was not yet gone, for the descriptive matter on the sheet, giving the sergeant's age as 105 years, reads in part, "This extraordinary Man still retains the full power of memory and sound sense, and is a living Chronicle of the days of 'Auld Lang Syne.'"

The old man had a colorful career. Born in Scotland in 1730, he emigrated to America and joined the revolutionary forces in 1776, continuing in the service for almost thirty years. In September, 1777, he participated in two engagements that proved disastrous to the American forces, the Battle of Brandywine Creek, and the "massacre" of Paoli. General Anthony Wayne was the commander of the American troops, and his mistakes in judgment cost many lives—but not Andrew Wallace's.

At Brandywine the young Marquis de Lafayette was attached to the revolutionary army. There he suffered a leg wound and was carried two miles on Wallace's back until he could be deposited at the house of a friend and the injury treated.

At Paoli, Wayne had planned to surprise the British and trap their forces. Unfortunately, his arrangements with other supporting commanders miscarried, and when the enemy realized that there was a lack of coordination in the Americans' preparations, they attacked at night in great strength. Under Major General Sir Charles Grey, the British charged with fixed bayonets, killing nearly two hundred of General Wayne's men in what became known as the Paoli Massacre. Andrew Wallace, who was with the American troops, was miraculously unhurt.

The portrait of the old sergeant on the title page of "Patriots Gone" does not bear the name of the lithographer, but it was probably the work of George Endicott of New York, who is referred to often in this book. It shows Wallace attired in Masonic regalia and also wearing the medals he had won for his military service.

William Clifton, who wrote the song, achieved mild popularity. To place him in today's perspective it might be mentioned that he once (around 1840) took a famous eighteenth-century English air, "Malbrouk," and arranged it to fit the words to "We Won't Get Home until Morning." The melody has more recently become popular as "For He's a Jolly Good Fellow."

Joseph Atwill, the publisher, began his operations in New York in the mid-1830s. Some fifteen years later, when he learned of the discovery of gold in California, the lure of new fields was so intriguing that he decamped for the West at once. He was San Francisco's first music publisher.

WE'LL SING OF PATRIOTS GONE.

SERGEANT AND^w. WALLACE.

Aged 105 years.

A Veteran of the REVOLUTION, the rescuer of Lafayette at the Battle of Brandywine.

This extraordinary Man still retains the full power of memory and sound sense, and is a living Chronicle of the days of

'Auld lang syne'.

He was born at Inverness (Scotland) in the year of our Lord 1730, & left his country for America in 1752.— At the commencement of the Revolution, he enlisted in the Service of the U. S. in which he continued with little interruption for nealy 30 years —He assisted at the most remarkable Battles during the War, escaped the Massacre of Paoly and in the Battle of Brandywine when Lafayette was wounded, rescued him from his perilous, situation and bore him on his back about 2 miles to the house of a friend.

New York: Published at ATWILL'S MUSIC SALOON, No. 201 Broadway.

THE COMET

Edmund Halley was born in England in 1656 and received his advanced education at Oxford. From the age of twenty he was actively involved in astronomical matters, and he had an opportunity to observe, in 1682, the great comet that later bore his name. After almost a quarter-century of deep study and detailed research, he determined that the comet would reappear in the vicinity of the earth every seventy-five to seventy-six years, and he prophesied its return in 1758.

Halley did not see the comet again—he died in 1742—but the comet returned, just as he said it would, at the appointed time. Back it came in 1835, and then again in 1910; the train—or more accurately, the tail—was right on schedule.

The Royal Society Club, affiliated with the notable scientific institution of that name, was founded by Halley in 1731. Before the regular meetings of the society, for which he traveled to London from his home in Greenwich, he enjoyed dining at the club with his friends. Whenever he appeared the members would gather round him and count noses; then they would send out for an ample quantity of fish for the dinner (poor Halley had no teeth in his later years, and could no longer eat meat). Of course, the meal would not have been complete without porter and whiskey; the ancient annals of the club tell that "the ordinary and liquor usually came to half a crown [fifty cents], and the dinner only consisted of fish and pudding" (Turner)—which indicates the deference given Halley by his fellow members.

For centuries the appearance of a comet had been accepted as a just cause for dread. In fact, two great astronomers, Dr. William Wishton (who succeeded Sir Isaac Newton at Cambridge) and Pierre Laplace, a Frenchman, concluded that the great flood of Noah's time had come after the appearance of Halley's comet (unchristened, naturally, at that early date).

The comet's return in 1758–59 signaled the advent of other dire happenings, among them the overrunning of Germany by the armies of France, Austria, and Russia; great sea fights between the British and the French; and the loss by France of the stronghold in America when Montcalm was bloodily defeated on the Plains of Abraham below Quebec.

The comet of 1835 witnessed the outbreak of bubonic plague in Egypt; nine thousand people in Alexandria are reported to have died in one day. Later in the year the comet was visible to the naked eye in America, and shortly thereafter, New York City was ravaged by a fire that destroyed its entire business section, caused losses amounting to some eighteen million dollars, and gutted the homes of a substantial portion of the population, who suffered frightfully in the intense cold.

The songwriters of 1835 refused to take the phenomenon seriously. In England, Charles Melton wrote "The Comet," a comic song for which John Blewitt composed the music. Blewitt, a native Irishman, was one of Britain's most prolific and most admired composers. So popular was "The Comet" that within a few months' time it had been introduced into America by a publisher named Elizabeth Riley. It went, in part:

Some sages declare 'twas known to appear
Some centuries back, and that people could hear
The Planets one night, all striking a light;
When they saw it jump out of the Tinder-box bright!

. .

Oh! this wonderful, wonderful Comet!
Whisht! went the Comet's long tail!

THE COMET

Lith. of Endicott.

A COMIC SONG
Sung by
Mr W. H. WILLIAMS
with unbounded Applause.
WRITTEN BY
Chs. MELTON ESQ.
Music by
J. Blewitt

Pr. 50 Cts.

Published by E. RILEY &Co. 29 Chatham St.
NEW YORK.

Mrs. Riley's music sheet was cleverly illustrated by George Endicott, then of New York, who used an earlier British title page as his inspiration. Endicott, who worked as an ornamental painter in Baltimore as a young man, took up lithography in 1828 and moved to New York three years later. There he acquired a reputation unsurpassed by any of his contemporaries in his field.

The cover for "The Comet" depicts John Bull attempting to fasten the tail of a jovial comet with a ten-penny nail, while the Great Bear views the scene with amusement. It is one of the most entertaining lithographed title pages of the 1830s.

THE TEXIAN GRAND MARCH 1836

In November, 1835, a group of strong-minded men assembled in the small town of San Felipe, about one hundred and fifty miles northeast of San Antonio. Texas was then a province of Mexico, but many of its residents were dissatisfied with the association, and pressed insistently for independence. The action of the group at San Felipe was intended to implement such a step, and so it did. Texas was declared a republic in 1836, with a president, David G. Burnet, and a military force, whose general and commander-in-chief was a strapping giant from Tennessee, Samuel Houston.

For some months the existence of the Republic of Texas was tenuous. Mexico had strong and ruthless military troops, which, when victorious in battle, showed no mercy to their adversaries. On March 6, 1836, the Mexican Army under General Antonio Lopez de Santa Anna overwhelmed and massacred a much smaller force of Texans defending the citadel of the Alamo, in San Antonio. Three weeks later, having captured another three hundred men at Goliad, southeast of San Antonio, Santa Anna's soldiers marched them out of town and then shot them down in cold blood.

But the tide soon turned. On April 21 at San Jacinto, Houston, with a force of seven hundred to eight hundred men, engaged in battle with a slightly larger Mexican force under Santa Anna and defeated them decisively, eliminating Mexico's hopes of regaining control over Texas.

Sam Houston was a casualty at San Jacinto; his right leg was shattered above the ankle by a copper ball fired from a Mexican musket. Pain did not deter him from continuing to direct his men; only after his horse had been shot and he had narrowly avoided being pinned under the animal did his wound become obvious. Fellow officers lifted the injured general and carried him to a cot under the oak that had served as his headquarters.

The following morning, weak and half-conscious, Houston became aware of a slight, teary Mexican prisoner standing by his pallet. The frightened man, dressed in elegant but soiled clothes, had been assumed to be a common soldier until he was spied by a group of prisoners under guard sitting on the ground. Immediately they leaped to their feet, saluted, and cried, "El Presidente."

Indeed, the prisoner was the despised Santa Anna, who admitted to the wounded man on the cot that he was the president of Mexico, now subject to Houston's disposition.

Such was the historic occasion that one music publisher decided to record. John Firth and William Hall, were the founders of the firm that dominated this field in New York for half a century, from the late 1820s on. In 1836 they released "The Texian Grand March," a pedestrian composition by a little-known writer, Edwin Meyrick, who dedicated his piece "Respectfully to Genl. Houston and his brave Companions in Arms."

Swett

THE TEXIAN GRAND MARCH

for the Piano Forte

Respectfully dedicated to

GEN.ᴸ HOUSTON

and his brave Companions in Arms.

BY

EDWIN MEYRICK

NEW-YORK

Published by FIRTH & HALL, 1 Franklin Square

The title page bears an illustration depicting the wounded Sam Houston, who reclines on his cot with a subservient Santa Anna before him. The Mexican general is doffing his hat and presenting his sword to the conqueror.

The cover is the work of Moses Swett, lithographer and artist. A fine draftsman and at times a sly cartoonist, Swett was an itinerant journeyman in the trade, allying himself with fellow lithographers in Boston, New York, Baltimore, and Washington. Everywhere the high quality of his workmanship was recognized. "The Texian Grand March" is an impressive example of Swett's talent.

THINK AND SMOKE TOBACCO 1836
AND SNUFFS, PUFFS, CHAWS 1848

When Christopher Columbus landed in San Salvador, the natives offered him as tokens of friendship large, strange dried leaves. Members of his crew gazed in wonder as they watched men and women roll and twist similar leaves, set them alight, and draw smoke from them.

Other explorers discovered that tobacco leaves served ritualistic and social purposes. The Indians chewed them, sniffed them, and made cigars and even husk-wrapped cigarettes from them. The ritual smoking of the pipe of peace—the long-stemmed calumet—later became a much desired ceremonial indicating that the Indian was willing to accept the white man as his brother.

The growing of tobacco in Virginia was stimulated after the arrival of John Rolfe in 1610. Rolfe may best be remembered for his marriage to Pocahontas, the Indian princess; but of far greater importance to mankind was his planting of a West Indian seed, *Nicotiana Tabacum*, which eventually introduced the entire world to a means of gratification of undreamed-of proportions.

Still, tobacco had its detractors from the outset. In the early 1600s King James of England called the use of the "precious stink" a folly, an extravagance, and a sin, "a custome lothsome to the eye, hateful to the Nose, harmefull to the braine, daungerous to the Lungs, and in the black stinking fume thereof, neerest resembling the horrible Stigian smoke of the pit that is bottomelesse" (Robert, p. 6).

In the nineteenth century there were many who echoed King James's sentiments (in the phrases of their day), but there were likewise untold numbers whose vote would have been cast on the side of the tobacco users. On the popular song front, antitobacco songs are rarely, if ever, to be found. However, songs extolling the use of tobacco in one form or another seem to have been well received.

Contemplate the philosophic verses of an 1836 example, "Think and Smoke Tobacco," described as "A Favorite Old Song on Mortality," which begins,

> This Indian weed now wither'd quite,
> Though green at noon, cut down at night,
> Shows thy decay: All flesh is hay,
> Thus think and smoke Tobacco
> Thus think and smoke Tobacco.

The origin of the words is unknown: they antedate the sheet music. The portrait of the three impressive gentlemen on the title page was designed by Joseph Gear and lithographed by William Pendleton of Boston (see "The Log House").

A Favorite Old Song

ON MORTALITY,

THINK & SMOKE TOBACCO

Made agreeable & pleasing to all Classes,

from the King to the Beggar.

Set to Music for a Single Voice and may be repeated as Chorus

With an accompaniment

For the Piano Forte

BY

JOSEPH GEAR,

of the Tremont Orchestra, Boston.

Respectfully dedicated to

Charles Sprague Esqr.

Boston. Pub.d by John Ashton & Co. 197 Washington St.

Poudens's Lithography.

Price 25 cts.

Entered according to Act of Congress in the year 1834 by Joseph Gear in the Clerk's Office of the District Court of Massachusetts.

Gear was an Englishman by birth, a marine painter and caricaturist whose work was exhibited at the Royal Academy. He was well up in his fifties when he came to America, where he gained prominence in both artistic and musical circles. The Boston Athenaeum exhibited his work, and he performed with the Tremont Orchestra, which he took pains to mention when his arrangement of "Think and Smoke Tobacco" was published in Boston by John Ashton and Company.

Songs extolling the virtues of "the weed" continued to flourish. Occasionally, professional entertainers used them.

In the 1840s two distinct types of entertainer were in wide demand, the blackface minstrel troupes and the singing families. (The Hutchinson family singers are referred to in the story on "The Old Granite State".) The "Orphean family" commanded a wide following; one brother, Jacob, was the songwriter; his siblings were the performers.

In 1848, three of the Orpheans, Samuel (or "Sammivel"), Jemima, and Jonathan, sang a three-part number of Jacob's entitled "Snuffs, Puffs, Chaws," or "Tobacco Trio." The three characters, costumed as an Englishman, a Frenchwoman, and an American, are shown in a John H. Bufford of Boston lithograph (see "Death of Warren"). A small "balloon," typical of the cartoons of the day, escapes from the mouth of each; the Englishman eyes the French lady and remarks, "She snuffs"; she, in return, says of the Englishman, "He puffs"; while the American declares, "I chaws." The verse is as follows:

> The world are all given, good lack o
> To using in some way, tobacco.
> The Frenchman he snuffs
> The Englishman puffs
> And the Yankee he chaws his tobacco.

The Indians of San Salvador would have heartily approved.

In early colonial times, the pipe was the principal medium for the consumption of tobacco. It was supplanted by snuff when the dandies of France and England sniffed at the less elegant Americans. The use of snuff, which had been so extensive late in the eighteenth century, declined sharply in America after the 1830s, when tobacco began to be inserted not in the nostrils, but in the mouth. As snuffing waned in America, the chaw waxed. A British journal referred to it as a "peculiarly disgusting American form of tobacco vice."

Charles Dickens, while visiting the United States, could not take his eyes from fellow travelers who had yellow streams from half-chewed tobacco trickling down their chins. Another Englishman, Charles Mackay, thought it a mistake for the United States to adopt as its national emblem the eagle; he felt the spittoon would have been more appropriate. A rather crude sentiment, especially from an Englishman—he might more delicately have suggested a tobacco leaf.

TOBACCO TRIO.

SNUFFS - PUFFS - CHAWS.

Music
Harmonised with Piano Forte accompaniment
BY **JACOB**, OF
THE ORPHEAN FAMILY,
And sung by the
ORPHEANS.

NEW YORK.
Published by **C. HOLT J**ⁿ 156 Fulton St.

Price 25 ...

THE FIREMAN'S CALL
AND WHIG GATHERING

Although these two music sheets do not have the same subject matter, there is a tie that binds them. The title pages were designed by two young New England artists, William Rimmer and Benjamin Champney, sometime associates in the field of lithography in Boston. Each went on to establish a solid name for himself in the budding New England art world.

William Rimmer, English born, whose cover of "The Fireman's Call" might be classified as a primitive, was brought to the United States in 1818 as a small child. By the time he was ten his family had made Boston their home, and he was dabbling at sculpture; at fifteen he was carving figurines in gypsum. During the next half-dozen years he became a jack-of-all-trades —typesetter, sign painter, and lithographer.

Renting a studio, Rimmer began to produce paintings of religious subjects, placing them in several chapels. Then he had a brilliant idea: to paint an enormous canvas, *After the Death of Abel*, exhibit it for a twenty-five-cent admission charge, and make a small fortune. After persuading a friend to finance the project, Rimmer went furiously to work on the eight-foot masterpiece. Unfortunately, the finished picture failed to draw the anticipated crowds, and Rimmer's friend wound up sixty dollars in the hole.

At twenty-one Rimmer did the title page for "The Fireman's Call." The billowing flames, the distraught mother, the brave fireman rushing from the doomed building, cradling the child in his arms, tell a story that makes words almost superfluous:

Then the firemen onward rush where danger lies,
To quench the mighty flames that awful rise
Amidst destruction he beholds a mother wild, mother wild,
Exclaiming, see, the room's on fire, save my child! save my child!
He rushes thro' terrific flames amidst alarms, 'midst alarms
And nobly bears the smiling babe to its mother's arms. . . .

The song, published in 1837 and dedicated to the Fire Department of Boston, was set to a melody in *The Maid of Judah; or, The Knights Templars*. This opera, based on Walter Scott's *Ivanhoe*, was an English adaptation of a pastiche of themes by Rossini. The featured artist chosen to popularize the ballad was none other than the blackface entertainer George Washington Dixon, who had a few years before advanced the cause of American minstrelsy by his portrayal of Zip Coon, a classic of the 1830s.

Rimmer soon branched out into new fields of learning. Touring Massachusetts and painting portraits for five to fifty dollars apiece was not incentive enough nor did it produce sufficient income for his impetuosity. So he took up the study of medicine and became a great anatomist. Still he did not earn enough to support his wife and family, and he turned to shoemaking as a sideline.

But Rimmer continued his efforts as a sculptor, begun so many years earlier, and he eventually gained recognition. His skill as an anatomist brought him teaching positions in anatomical art; he was called to the Cooper Institute in New York, where for four years he was the director of its School of Design for Women. Later, as instructor in anatomy at the Boston Museum of Fine Arts (a position he held until shortly before his death in 1879), his many pupils included such eminent men as John La Farge, the painter, and Daniel Chester French, the sculptor.

Like Rimmer, Benjamin Champney, who was born in 1817, was, for a time, "in shoes." Fatherless at an early age, Champney became a shoe clerk

THE FIREMAN'S CALL,

As Sung by

GEORGE WASHINGTON DIXON,

Respectfully Dedicated to the Officers and Members of the

Fire Department of Boston.

Music from the Opera of the Maid of Judah.

Boston: Published by C.H. Keith, 67 Court Street

Entered according to Act of Congress in the Year 1837, by C.H.Keith, in the Clerks Office of the

in Boston. From the rear window of the shop he could look into a lithographer's studio where artists and engravers were working at their trade.

For several years Champney had enjoyed sketching, so he summoned sufficient courage to present himself to the lithographer—who turned him down flat. Some time later, the head draftsman of the lithographing concern, Robert Cooke, took a room at Champney's boarding house. The two men became fast friends. Cooke supervised Champney's efforts to draw and then assisted him to secure an apprenticeship with Thomas Moore, proprietor of one of Boston's lithographing establishments.

Whereas Rimmer designed only two or three lithographic covers before changing artistic direction, Champney was more prolific; he did almost a dozen sheet music covers. He drew in greater detail and had a more ornate style than did Rimmer, as the "Whig Gathering" title page indicates.

The view is of venerable Faneuil Hall in Boston, and the occasion pictured is a rally on behalf of William Henry Harrison, Whig candidate for president of the United States in 1840. A stream of marching men, led by a brass band, is parading past the old building. The song begins:

> Gather whigs, gather whigs,
> See the foe is falling round you
> Gather whigs, gather whigs
> Break the chains that long have bound you
>
>
>
> Hail the chief where valor found you
> Hail to the chief!

A Boston paper called the gathering, held in the late fall of 1839, "one of the largest and most enthusiastic meetings that ever assembled at the old Cradle of Liberty."

The old hall, which may have been bursting at its seams that day, appears to have suffered all this flamboyance without loss of historic dignity. First offered to the city of Boston as a market house by Peter Faneuil at a town meeting in 1740, the gift was accepted, after a spirited debate, by a vote of 367 to 360. The forty-by-one-hundred-foot building, originally a two-story affair, located between Dock Street and the waterfront, was opened two years later. Destroyed by fire in 1761, it was promptly rebuilt with the aid of a public lottery, and through the years accommodated countless town and mass meetings. In 1805–6 it was tripled in size by the addition of a third story and a doubling of its width to eighty feet. As may be seen from the picture, the result was an imposing edifice.

Champney became a founder of the Boston Art Club and eventually its president. While he was known as an exponent of the so-called Hudson River School, which comprised many of the leading landscape painters of the day, he was an artist of catholic tastes, an early admirer of the Barbizon group and of Claude Monet, a pioneer of Impressionism.

The lithographer who produced "The Fireman's Call" did not put his name on the music cover, but he was almost surely Thomas Moore, of Boston (see above), the successor to the business of William Pendleton (see "The Log House") in 1836. Moore was a man of the world, who enjoyed his liquor and his love-life. Upon his death a friend and fellow lithographer, Charles Hart, discovered a large bundle of intimate letters from female correspondents, which, prudently—but unfortunately for future biographers—he promptly destroyed.

Another Boston firm, of which Benjamin W. Thayer was the proprietor (see "The Pretty Flower Girl"), was responsible for the production of "Whig Gathering." Thayer had bought out Moore's interest in 1841 and conducted the business for ten years before retiring.

WHIG GATHERING,

E. Champney del. B.W. Thayer's lith. Boston.

SONG AND CHORUS

Respectfully dedicated

TO THE **WHIGS** OF THE

UNITED STATES.

BOSTON.

Published by *HENRY PRENTISS*, 33 Court St.

Entered according to Act of Congress in the year 1840 by H. Prentiss in the Clerks office of the District Court of Massachusetts.

CHARTER OAK! CHARTER OAK ANCIENT AND FAIR!

The quaint lithograph on the title page is by Nathaniel Currier (see "The Gallant Old Hero"), who was just coming into his own in 1837, when the song appeared. The artist who designed the picture was William Keesey Hewitt, a native of Philadelphia whom Currier employed from time to time to draw not only music sheet covers but larger pictures as well. In fact, Currier's first enormously successful lithograph, depicting the burning of the steamboat *Lexington* in 1840, was Hewitt's work. Hewitt was also a portrait painter of renown and a crayon artist, who frequently exhibited at the Pennsylvania Academy of Fine Arts in Philadelphia. He lived until 1892.

The prolific Henry Russell, who, after his arrival from England, wrote the music for so many favorite songs of the 1830s and 1840s, composed this charming ballad.

The lyrics were the work of Mrs. Sigourney, whose poetry was so widely known that there was no need to add her first name to the title page. For later generations, however, it might be noted that she was born Lydia Huntley, in Norwich, Connecticut. She was a school teacher by profession, and she was forty-five years old when she wrote the verses of "Charter Oak!" As a writer, the quantity of books she turned out bid fair to surpass the musical output of Henry Russell. Sixty-seven of her works are extant; the theme of most of them centers on the melancholy subject of death.

The venerable tree, known as the Charter Oak, was a landmark of Hartford, Connecticut. Its part in history goes back to the reign of Charles II of England and the desire of the colonists for a firmer tenure of their lands than had theretofore existed. To accomplish the ends sought by his constituents, Governor John Winthrop sailed for Britain in 1661. His request for a new charter met with a favorable response, and after the charter had been drafted, signed, and sealed in duplicate on April 23, 1682, he brought one of the copies back to Connecticut.

Twenty-three years later, King James II attempted to annul all charters that then existed. The Connecticut colony petitioned to be allowed to retain theirs; but, if their request was denied, they asked to become a part of the government of Massachusetts rather than that of New York. Officials in England assumed this to be a surrender of the freedom of the colony, and in 1686 they despatched Sir Edmond Andros to receive the old charter on behalf of the king. Much disputatious correspondence followed, to the great dissatisfaction of Andros, who finally marched from Boston to Hartford with an escort of troops to take over the government.

On the evening of November 11, 1687, Andros, at Hartford's public court house, read the orders annexing the colony to the Dominion of New England and demanded that the charter be brought in. As Governor Treat of Connecticut was arguing against the surrender of the charter, the lights were suddenly extinguished. When they were rekindled, the charter had vanished; an intrepid Connecticut Yankee named Joseph Wadsworth had made off with it and secreted it in a hollow oak tree.

Andros never recovered the original charter, and the tree in which it had been deposited became known as the Charter Oak. The great tree stood for almost two hundred years more, until, at an age estimated at one thousand years, it was felled by a storm in 1856.

And as for the charter, it remained the supreme law of Connecticut until the state adopted a new constitution in 1818.

CHARTER OAK! CHARTER OAK ANCIENT AND FAIR!

AN ANCIENT AMERICAN BALLAD:

written by

M^{RS} SIGOURNEY.

the Music Composed

AND MOST RESPECTFULLY DEDICATED TO

my friend

D^R JOHN D. RUSS,

(of Hartford, Con.)

by

HENRY RUSSELL.

NEW-YORK.

Published by **HEWITT & JAQUES** *239 Broadway*

Price 37 Nett.

In the art world, Alfred Jacob Miller is best remembered for his sketches and water colors of the great West. Miller was a pioneer. No American artist before him had crossed the broad plains, reached the Rocky Mountains, and consorted with the Indian tribes in territory still mysterious to most of his compatriots.

But our particular interest lies in a field Miller briefly tried, that of lithography for the title pages of sheet music. In 1834 George Willig, Jr., of Baltimore, a music publisher, asked Miller to execute two song covers, one of which is reproduced here. The romantic cover, in soft flowing lines, was "Designed and Lith'd by A. J. Miller." It illustrates a song by R. H. Pratt, with music by John H. Hewitt. Entitled "Far O'er the Deep Blue Sea," its verses plead the cause of a young marine who makes a passionate appeal to the object of his devotion:

> Then leave thy downy couch, my love,
> And with thy sailor flee;
> His gallant bark shall bear thee safe,
> Far o'er the deep blue sea. . . .

R. Howard Pratt, the lyricist, was a printer by trade and a journalist with a predilection for composing ballads on the side.

John Hill Hewitt, scion of a music-oriented family, had many compositions to his credit. His best-known song is "The Minstrel's Return'd from the War," the first successful American secular song, for which Hewitt wrote the words and music in 1825. Originally printed in Boston by Hewitt's brother James, it was distributed by other publishers up and down the coast; its circulation ran into the tens of thousands. Hewitt was less successful with the piece illustrated by Miller, and the artist's venture into lithography has been largely overlooked. More's the pity.

Miller, born in Baltimore in 1810, had as a child shown talent for drawing. By the time he was twenty-one he was studying with the well-known portraitist Thomas Sully. But Alfred Miller's ambitions drew him to Paris, where, with a bit of "pull," he gained admission to the Ecole des Beaux Arts. He was the only American student there. Recognized as a young man with more than ordinary ability, the critics and his fellow artists called him the American Raphael.

Back in Baltimore in less than two years, Miller set himself up as a portrait painter; but restlessness propelled him off again, and he landed in New Orleans with thirty dollars in his pocket. Approaching a prospective landlord and introducing himself as a portrait painter, he was told, "If the room will suit you, I will sit to you. You perceive that I have a damned ugly countenance and you cannot miss the likeness. On its success I will be the means of securing you half a dozen additional portraits" (James).

The likeness proved a success; commissions followed, one after the other. Then occurred the event that changed the artist's career. A stranger, whom Miller took for a Kentuckian, entered his studio, examined his work, and then handed him a card reading "Capt. W. D. Stewart, British Army." Stewart had made several journeys to the Rocky Mountains and was preparing for another. This time, however, he wanted to engage an artist to make the trip with him and record it in detail. Miller accepted the invitation with alacrity. The expedition, which took place in 1837, produced some three hundred sketches, many of which the artist later translated into vivid water colors. The majestic scenery, the picturesque natives, the travelers themselves, were portrayed in memorable scenes. Miller's journal, *Rough Draughts for Notes to Indian Sketches*, augments the picture of a land hitherto unknown to Easterners, who would one day claim it.

FAR O'ER THE DEEP BLUE SEA

Written by

R. H. PRATT ESQ,

Composed by

John H. Hewitt.

Price 50 Cents.

Baltimore Published by G. Willig &c.

FAREWELL AWHILE MY NATIVE ISLE

Nathaniel Currier had had four years of business experience by 1838. He had not as yet become the most important lithographer in New York, but he was fast achieving popularity, and demand for his illustrations on title pages was growing among music publishers.

One of the most respected New York publishers was Hewitt and Jaques, a partnership entered into in 1837. James L. Hewitt, a member of a family long known in the composing field and a successful publisher since 1825, enjoyed a four-year association with the younger Edward I. Jaques.

In 1838 they issued an emotional ballad entitled "Farewell Awhile My Native Isle." The title page, executed by Currier, portrays a splendid early steamship, smoke belching from its funnel, with a full spread of sail to add to its speed. The vessel is the 1,320-ton *Great Western*, owned by a British railway company of the same name.

"Farewell Awhile My Native Isle" celebrates the first western passage of the *Great Western*. Its composer, Austin Phillips, was an English psalmodist and organist. The lyricist, M. Wilson, had a number of popular songs to his credit. The song itself first saw publication in London and had an illustrated title page bearing a picture of the *Great Western*. As occasionally happened with popular English ballads of the period, which had no copyright protection in America, a copy was brought to the United States and reproduced for American consumption. The design of the Currier lithograph follows faithfully the original cover executed by Moseley and Wellington of London for a Bristol publisher, J. Cockram. Currier had copied other English covers from time to time, no doubt at the request of his New York publishers, who attempted to comply with every detail of a song that had proved successful in England.

The artist Currier employed was William Keesey Hewitt, a Philadelphian (see "Charter Oak! Charter Oak Ancient and Fair!").

The *Great Western* was a 236-foot beauty, built of wood in Bristol, England, in 1837, with two 750-horsepower engines which, on an average run, consumed almost a ton of coal per hour. Her maiden voyage to America, begun on March 31, 1838, was threatened with disaster when fire broke out in her boiler section at the very start of her journey. The ship was beached on the sands, and the fire—a superficial one—was extinguished; thereafter everything proceeded as planned. In a little over fifteen days, having maintained an average speed of 8.2 knots per hour, the *Great Western* steamed into New York harbor to be greeted by an excited citizenry. On her return voyage to England she carried, at a rate of thirty-five guineas per head, sixty-eight cabin passengers (the largest number ever transported by a single ship up to that time) and twenty thousand letters.

The *Great Western's* departure from New York was honored by the participation of a number of American officials. A boat carrying the mayor of New York City, Philip Jones, and a group of distinguished citizens accompanied the majestic ship down the bay as she got under way. The governor of the state, W. L. Marcy, who was aboard the *Great Western* when she steamed off, left her near the Narrows and transferred to the mayor's boat for the return to shore.

The *Great Western's* eastbound voyage was even swifter than the westward one. For twenty years the big vessel managed to compete with newer, more modern ships, but in the late fifties her usefulness was at an end; her seafaring days were over.

N. Currier's Lith. N.Y.

On board the GREAT WESTERN STEAM SHIP on her Voyage from BRISTOL to NEW YORK this Song
was Written Composed & Sung by
Mr. WILSON, THE CELEBRATED VOCALIST.
and a Copy launched overboard for behoof of all Lovers of Song, with Sails set & Colours flying & so may the good Ship
reach the desired Port in safety.

FAREWELL AWHILE MY NATIVE ISLE.

SONG

Written & Sung by

Mr. WILSON,

Composed by

MR. AUSTIN PHILLIPS,

and

With permission

Most respectfully Dedicated to the

DIRECTORS of the GREAT WESTERN STEAM-SHIP COMPANY.

and to

LIEUT. JAMES HOSKEN, R.N.

Commander.

Price 50 Cts.

NEW-YORK.

Published by HEWITT & JAQUES, 239 Broadway.

The stately gentleman, literally and figuratively on his high horse, is David Rittenhouse Porter, scion of a distinguished family and governor of Pennsylvania. The year is 1839, and he is beginning the first of two three-year terms as the loftiest official in the state.

His father, Andrew, a schoolmaster and a renowned mathematician, left his institute at the outbreak of the Revolution and served as a colonel in several historic engagements, including the battles of Trenton and Princeton. He appears to have taken off sufficient time to sire seven sons, all of whom became men of stature, one having been appointed governor of the Territory of Michigan by Andrew Jackson and another having served as secretary of war under President Tyler.

But apparently Governor David was the only Porter to be honored by a march in his name. David came up through the ranks, via the assembly of the legislature and then the state senate. His first election to the governorship was something of a squeaker, but his three-year performance was so impressive that the majority he received on his next attempt was nearly four times greater than that which was given him initially.

Porter's first annual message to his legislature contained a recommendation for "the construction of a continuous railroad from the city of Pittsburgh through or near the capitals of Ohio, Indiana, and Illinois to some point on the Mississippi River, at or near St. Louis" (Armor, p. 385). Such a suggestion, coming in 1839, when only a few railroad lines were serving the cities of the East Coast, produced widespread comment, mixed with ridicule. Nevertheless, Porter's proposal bore fruit, and before he died he was able to travel in a railroad car from the seaboard to the Mississippi.

Porter was a tough executive, able to resist encroachments by the legislature on his prerogatives. For example, when the state senate took him to task for not reporting his reasons for withholding the dispersal of certain funds, he stated peremptorily, "I must decline to comply with [your] requisition. Being an independent and co-ordinate branch of the Government, I do not recognize [your] right to make such a demand" (ibid., p. 387).

Near the end of his term, Porter exercised great personal courage in suppressing serious riots that occurred in Philadelphia. Such spirit was again exemplified fifteen years after his term had ended, when, at the outbreak of the Civil War, the seventy-year-old patriot shouldered a gun and drilled with the young men of Harrisburg, proclaiming, "The Union must and shall be preserved."

"Governor Porter's March" was written by Stephen Glover, an Englishman of prodigious musical capacity, who is known to have composed more than three hundred popular songs, duets, and pianoforte transcriptions. The portrayal of the governor in dress uniform is the work of Peter S. Duval, who came to Philadelphia in 1829 and was, incidentally, that city's first trained professional in the lithographic art. Duval learned his trade in Paris, where he was an expert pressman. The picture was copied from one that appeared in Huddy and Duval's *U.S. Military Magazine*.

William M. Huddy, a young man with a reputation for artistic talent, had been a major in a Philadelphia militia. In 1837 a disastrous fire, coupled with a dangerous illness, placed him in a precarious situation. When a few friends staged a benefit performance in his behalf and raised fifty dollars, Huddy got the inspiration for a magnificent military magazine, in which he would depict the uniforms—with the records—of the various Philadelphia volunteer corps. The *U.S. Military Magazine* was started in March, 1839, with Huddy supplying the art work and Peter Duval super-

GOV.R PORTER'S MARCH
as performed by the
MILITARY BANDS.
Composed & arranged for the Piano
BY
Stephen Glover.

Price 50 C.ts

Philadelphia, GEORGE WILLIG, 171 Chesnut St.

vising the printing. Within two months the two men formed a partnership, which lasted for three years, during which time the magazine had an impressive subscription list, including notables like the King of Prussia. But then Duval pulled away and formed his own lithographic establishment, which was one of the foremost shops of its kind until his retirement in 1879. By then, the impetus of the lithograph as a popular work of art was spent, and most of the great old names in lithography were gone for good.

LA CACHUCHA 1840

The child was born in 1810 in a suburb of Vienna and was named Franziska. Her father, Johann Florian Elssler, had been music copyist and valet to the great Franz Josef Haydn. Evidently the Elssler family had music in its blood; in Franziska's case (the girl was known to everyone as Fanny) the music moved, magically, to her feet.

Vienna, then the center of the ballet world and host to the great ballet masters of the period, was the city where Fanny Elssler's first ballet appearance took place. She was seven years old. Four years later, playbills listed her as "Elssler the younger," to distinguish her from her older sister Thérèse, a fine young dancer in her own right.

In her middle teens, attractive and voluptuous, Fanny was prey, as were many of the girls of the corps de ballet, to the designs of wealthy older men. Fanny's seducer was the Prince of Salerno, brother of the King of Naples, and the alliance with him resulted in the birth of a boy when Fanny was not quite seventeen years of age. But the unhappy affair quenched neither Fanny's ambitions nor her progress.

Soon there was no ballerina to dispute her rise to stardom. Fanny captivated audiences in Vienna, Berlin, London, and Paris. In 1838 a London theatrical agent suggested that she accept an engagement in America. Fanny was completely uninterested, considering the idea preposterous. But the management of the Park Theatre in New York refused to be discouraged. Stephen Price, the theater's dominant partner, was able to secure an interview with the dancer in Paris, and after much deliberation, she agreed to sign a contract. It was a generous one: Fanny was to dance at the Park Theatre for forty nights for approximately half the "house"; she stood to earn $30,000.

In early 1840, after a London performance before an audience that included Queen Victoria and Prince Albert, Fanny sailed for America with her cousin-companion, Katti Primster, on the wonderful new steamer *Great Western*. At the end of a rough seventeen-day voyage, she arrived in New York, where a tumultuous welcome almost overwhelmed her.

Elssler determined to form her own company in the United States. She experienced difficulty in assembling an acceptable group but finally succeeded; it was known, simply, as the Elssler Company.

Her American debut was sensational. Not only in New York but also in every other city where she performed, she drew huge, excited crowds. So delighted was Elssler with America, and America with Elssler, that she made over two hundred appearances before returning to Europe in 1842.

Philadelphia and Baltimore waxed ecstatic. President Martin Van Buren attended one of her Washington performances and was so charmed that he invited her to the White House. One evening when she danced, so many members of the House of Representatives went to see her that a House quorum, mustered for seven o'clock, could not be secured until nearly eleven. In Boston she captured the hearts of Ralph Waldo Emerson, Henry Wadsworth Longfellow, and Oliver Wendell Holmes.

Fanny Elssler
in the Character of
LA CACHUCHA
ATWILL *Publisher 201 Broadway* NEW-YORK.

The music used for her ballets was scored for the piano and distributed widely by the sheet music publishers of Philadelphia, New York, and Boston, usually with a likeness of Elssler on the title page, showing her performing one of the dances that most endeared her to her public—La Cracovienne, La Gitana, or La Cachucha.

One of the most beguiling of these likenesses appears on the title page of a music sheet published in 1840 by Joseph Atwill in New York. The music is for "La Cachucha," and Fanny is pictured wearing the flamboyant costume that became so well known to her aficionados. She manipulates her castanets gracefully. The enthusiasm of the audience is suggested by the wreaths and flowers that lie at the dancer's feet.

The cover is the work of Eliphalet Brown, Jr., a portraitist and marine artist of note. A native of Massachusetts, he spent more than a dozen years of his working life in New York City. Then, in 1852, he was asked to serve on Commodore Perry's expedition to Japan, as a floating "artist in residence." When the ships returned to America, Brown received Perry's permission to publish his sketches of the "landing in Japan"—at his own expense. Four large and colorful folios were completed.

As far as is known, neither in America nor in Europe did he ever see Fanny Elssler perform. Had he done so, he could hardly have produced a more delightful picture than appears on his title page of "La Cachucha."

THE TEE-TO-TAL SOCIETY 1840

George W. Lewis, lithographer and engraver of the mid-nineteenth century, had a delightful sense of humor, as his vignettes on the title page of "The Tee-To-tal Society" illustrate.

Lewis's first lithographs appeared in 1840; the one shown here is among his earliest. Located in New York, he had a busy career, teaming up in 1844 with William K. Brown and then, after a few years, continuing on his own again. For a while he quit his profession to serve as a prompter at the Broadway Theater; he may have been down on his luck to descend to such an inferior calling. But three years later he was back at his old trade, which he seems to have pursued successfully from 1855 to 1867.

Temperance was a national issue in the second third of the nineteenth century. In 1840 a group of young topers in Baltimore went for a lark to hear a noted temperance lecturer, Rev. Matthew Hale Smith, with an unexpected consequence: they were so thoroughly convinced of the rightness of his cause that they formed themselves into a temperance organization, calling it the Washington Society. They drew up a pledge, as gentlemen, to drink no spirituous or malt liquors, wine, or cider, and they went forth to reform the world.

Their success was fantastic. They converted drunkards to the cause, and the new adherents of temperance went forth, in turn, to secure new prospects. The reformers fanned out over the eastern states; their ranks swelled like a snowball rolling downhill. It is estimated that before the unusual appeal had run its course, some quarter of a million drunkards and three times that many "common tipplers" had taken the pledge.

It is not surprising that the temperance movement was at times held up to ridicule by portions of the populace. Sensing that the field for comic songs on temperance was a fertile one, the songwriters exploited it. Some of their compositions were illustrated with great good humor. The title page of "The Tee-To-tal Society" consists of several Cruikshankian cartoons accompanied by such comments as, "The man that drinks water I'd have made a Pump of."

THE TEE-TOTAL SOCIETY,

AS SUNG ~~BY~~ M.ᴿ CHAPMAN,

WITH THE BY AT THE

GREATEST APPLAUSE PARK THEATRE.

New York ATWILL, Publisher 201 Broadway.

Lith of G.W. Lewis 136 Nassau St N.Y.

The author and composer of the song unfortunately remain anonymous. The rollicking melody, in 9/8 time, lends itself to such verses as:

I've come to exhort you so free, all you that fond
 of the bottle are,
And when you my argument see, everyone will become
 a TEE-TO-TAL-ER.
Of Gin, Brandy, Rum, Wine or Beer, to drink is a great
 impropriety,
Of such trash I would have you steer clear, and join the
 TEETOTAL SOCIETY.

An old man that was troubled with corns, that scarcely
 the stairs could he hobble up,
He used to drink beer out of horns, and all sorts
 of liquors would gobble up
His corns have all left one by one, and now he's
 the pink of sobriety,
And pray how was all this done? WHY! he joined the
 TEETOTAL SOCIETY.

Folks ask what makes my nose so red? I'll tell
 and end all this puzzling,
It 'ant drink what gets in my head, it's blushing
 to see so much guzzling.
Drops of brandy we take two or three, as medicine
 and no impropriety,
And put some in our gruel and tea, it's allowed
 by the TEETOTAL SOCIETY.

Through the years, many people have felt that drinking was fun. In the 1840s—strange to say—so was temperance.

POLICE QUICK STEP
1840

The gentleman gracing the title page of this Boston musical sheet bears no physical resemblance to today's blue-uniformed guardians of public safety and breakers-up of traffic jams. Even in 1840 he could be identified as a policeman only by the leather badge worn over his left lapel. It was not until late in the 1850s that Boston got around to adopting an elaborate uniform for its police force, allowing each member twenty-five dollars to outfit himself properly.

From 1820 on, the chief police official of Boston was a Marshal of the City, having jurisdiction over the "internal police." These officers were somewhat less than guardians of the peace. They were responsible for preventing the violation of ordinances, having to do, for example, with carriages and horses, carts, dogs, and exhibitions; with the suppression of unauthorized fireworks, unlawful games, and plays; and with coursing on sleds in the highways and swimming in exposed places.

But there was an insufficient number of men to prevent disorders and assaults. Strangely, the statutes of the State of Massachusetts outlining the policemen's duties at that time made no mention of felonious or moral offenses; nor was there any mention of crime or criminals—although one constable was appointed to arrest vagabonds and common drunkards.

However, serious troubles in the mid-1830s made Bostonians realize that their police force had to have sufficient "clout" to protect the citizens against personal injury and property damage. In 1834 a mob of several thousand, led by belligerent Boston truckmen, had stormed and burned the

POLICE QUICK STEP,

W. Sharp & c. Pinxt.

Thayers Lith. Boston.

B Cook sc.

Composed and Arranged

for the

PIANO FORTE

by

G. KEUNER,

Price 25 cts. Nett.

BOSTON

Published by HENRY PRENTISS, No.33 Court St.

Entered according to Act of Congress in the year 1840 by Henry Prentiss in the Clerks Office of the District Court of Massachusetts.

Catholic Charlestown Convent and had gone unpunished for that shocking incident. The following year another crowd of violent men, in forceful conflict with the opinions and writings of the great abolitionist William Lloyd Garrison, invaded his newspaper office and seized the famous anti-slavery leader, whom they roped and dragged through the streets.

When in 1837 a sixth of the city's population rioted against some of the Irish immigrants, injuring scores and causing extensive property damage, Mayor Samuel A. Eliot and the city government realized that stronger measures were required. Mayor Eliot thereupon recommended a standing daytime police force of thirty-two patrolmen and four captains and a night force of forty watchmen. For the first time regular wages were to be paid the men on duty—two dollars a day.

In 1840 a ''Police Quick Step'' was composed by G. Keuner and published by Henry Prentiss of Boston. The picture on the title page, displaying a wary policeman in civilian attire, was an early lithograph by Benjamin Thayer (see ''The Old Arm Chair''). The work was done by Robert Cook, or Cooke, as he later signed himself. Cook's draftsmanship was meticulous, and his services were in great demand by Boston lithographers. Three to four dozen of his skillfully drawn covers, many of which were done before he took up portrait painting as a profession, can be found in sheet music collections.

The original portrait that was the subject of Cook's artistry was done by William Lydston, Jr., a miniaturist and painter from Boston. Lydston was a native of Massachusetts who was active as a portraitist for some twenty-five years. His well-groomed, watchful policeman on the cover of this quick step was executed when he was in his late twenties. It represents one of Lydston's extremely rare appearances in the field of sheet music.

THE GALLANT OLD HERO 1840

Oh what has caused this great commotion, motion, motion
Our country through.
It is a ball a rolling on
For Tippecanoe and Tyler Too.
And with them we'll beat little Van, Van, Van,
Van is a used up man.

The year was 1840 and the words were those of the best-known among the dozens of campaign songs written on behalf of General William Henry Harrison, the Whig party's candidate for president of the United States.

William Henry Harrison had all the necessary qualifications to attract the voters. Son of a signer of the Declaration of Independence, Indian fighter from the time he was eighteen, inspiring leader at the decisive battle of Tippecanoe in 1811, victorious tactician who routed the British in the western territories in the War of 1812, congressman, senator, ambassador —Harrison was indisputably destined for the highest office in the land.

His first attempt to gain the presidency, as head of the Whig party, was no more than a noble gesture; the Democrats, with Martin Van Buren as their candidate, controlled the country by a solid majority. Four years later their party was demoralized. Their financial programs had broken down, the banks were insolvent, and the entire country was in a state of panic.

The Whigs took full advantage of the situation and, with Harrison as their obvious and most trusted candidate, swept into the White House with nearly four-fifths of the electoral votes. Certainly the stirring music helped

TIPPECANOE, THE HERO OF NORTH BEND.

WILLIAM HENRY HARRISON

SIX PATRIOTIC BALLADS,

RESPECTFULLY DEDICATED TO

THE

TIPPECANOE ASSOCIATIONS.

PARTLY WRITTEN AND ARRANGED BY A MEMBER OF THE

FIFTH WARD CLUB.

Nº 1. GOOD HARD CIDER. 4. LOG CABIN.

2. GALLANT OLD HERO. 5. TYE'S INVITATION TO LOCO.

3. BUCKEYE SONG. 6. CINCINATUS OF THE WEST.

Sam¹ Carusi

Baltimore

swell the enthusiasm of many thousands of voters. There were high-spirited verses with catchy melodies like "Tip and Ty," quoted above; encomiums like "The Gallant Old Hero," the title page of which is pictured here; and stirring quicksteps and stately marches, most of them with a portrait of the hero on the cover.

The Democrats had committed a tactical error when they cast aspersions on Harrison's intellectual capacity, indicating that he would be happy living in a log cabin with a barrel of hard cider at his constant disposal. True, Harrison had lived in a log house in the early years of his marriage; but it was a five-room residence, sumptuous for its day. The Whigs lost no time capitalizing on the inept attempt to smear their man. "Log cabin" marches and "hard cider" quicksteps were distributed by the thousands, to the delight of all good Whigs and the embarrassment of the unhappy Democrats.

The title page of "The Gallant Old Hero," written by a "member of the Fifth Ward Club," portrays the strong physiognomy, particularly the elongated nose, of the future president. Beneath the portrait is a drawing of an imaginary log cabin (Harrison's new trademark), with a barrel of cider outside the door.

The lithograph is the work of Nathaniel Currier, who employed Charles Lewis to execute the design. There appears to be no record about Lewis as an artist, but Currier had "arrived" some years earlier. Apprenticed at the age of fifteen to a firm of Boston lithographers, he had learned his trade so rapidly that within five years' time he had been able to start his own business in Philadelphia. That venture proved unsuccessful, so he moved to New York. The year was 1834.

In 1835 the city was swept by a disastrous fire that destroyed hundreds of buildings and wiped out investments of millions of dollars; but it turned out to be the making of Nathaniel Currier. Four days after the fire, Currier offered for sale a lithograph entitled "Ruins of the Merchants' Exchange N.Y., After the Destructive Conflagration of Dec.br 16 and 17, 1835." Mr. Currier's alertness gained instantaneous recognition; the print sold in the thousands. Soon his reputation attained national dimensions.

When Mr. Ives, Currier's bookkeeper—and more important, his brother-in-law—was taken into partnership in the 1850s, it signaled the beginning of one of the most successful mergers in America. The combination of Currier and Ives became as familiar, in their day, as ham and eggs, peaches and cream, or Tom, Dick, and Harry. Nathaniel Currier and James Merritt Ives gave the public what it wanted, just as Currier had done even before 1840, when the public wanted pictures about William Henry Harrison.

Small wonder that today when the word *lithograph* is mentioned, "Currier and Ives" naturally come to mind.

THE PRETTY FLOWER GIRL AND CHERRIES RED

1842

CA. 1834

The flower girl sang:

> My fair young Roses come buy come buy
> For ere day closes they'll die they'll die.

And the vender of cherries warbled:

> Cherries red cherries red full and fine
> Their cultures good and taste divine.

The flower girl's appeal is the later of the two attractive song sheets portraying "criers," or street-sellers, of the early part of the last century.

THE PRETTY FLOWER GIRL.

Song

WRITTEN BY EUGENE ROCHE, ESQ, OF LONDON.

Composed and respectfully dedicated to

Miss Elizabeth C. Coles,

BY

SIGÑOR DE BEGNIS.

B.W. Thayer & Co.ᵃ Lith. Boston.

Price 50cts.nett.

NEW YORK.

Published by FIRTH & HALL. Nº1 Franklin Sq.

JAMES L. HEWITT & Cº

239 Broadway.

Entered according to Act of Congress in the year 1842 by Firth & Hall in the Clerks office in the District Court for the Southern District of New York.

The girl is shown hawking her wares at the corner of City Hall Park, in New York, in front of a poster advertising a popular show at the Park Theatre, which is located across the street.

Benjamin W. Thayer of Boston was the lithographer of the title page. It was executed in 1842, early in Thayer's career, which extended for another dozen years, during which he produced much attractive work, including sheet music covers depicting everything from militiamen to blackface minstrels. The artist of the flower girl was William Croome, a designer of engravings on wood and metal who later acquired a solid reputation for his illustrations of children's books.

"Cherries Red" was published in the early 1830s. The primitive title page was probably the work of Anthony Imbert, a pioneer of lithography in America. Imbert, a French naval officer, was captured in combat, and during a long term of imprisonment in England he experimented with marine painting. He came to New York about 1825 and was soon preparing lithographic plates. He was one of the most respected lithographers in New York during the ten years he was active there. He may have employed Dominico Canova, a portrait painter and drawing instructor, to design the cover for "Cherries Red."

"Paul Pry," the then current symbol of a gadabout, had been a favorite comic stage character since the early 1820s. When he emerged in a cozy domestic scene before a theater audience, his opening words were always, "I just dropped in to say hello"; then he would snoop around until he had learned all the secrets of his hosts and was able to use them for his own purposes.

"Cherries Red" was sung in one of the stage versions of "Paul Pry." The singer, Madame Vestris, was a vivacious contralto with a beautiful face and figure. A popular personality, she was best known in England and America for her rendition of the wistfully comic ballad "Buy a Broom," written in dialect to the air we know as "Ach du lieber Augustin." The song was distributed by a dozen publishers, almost invariably with Madame Vestris's picture on the title page.

The cries of hawkers in America, even today heard in some sections of every metropolis, originated nearly three hundred years ago. How colorful they were. "Crabs! Crabs! Alive!" sang the Philadelphia Negro behind his wheelbarrow of live crabs. In the same city the sweet potato peddler used to sing, "Yed-dy go, sweet potatoes, oh! Fifen-ny bit a half pecks!" In Charleston, South Carolina, a huckster would chant "Mullet! Mullet! Mullet! Flounder and Flack Fish! Shark steaks for dem what likes 'em; Sword Fish for dem what fights 'em; Fish-ee! Fish-ee!" The vendor of wood had a simple staccato cry, "Wud! Wud! Wud! Wud! Wud!" The soft soap man sang, "Sam! Sam! The soap fat man!" The little Negro chimney-sweep was usually towed along by a parent, who would petition on behalf of his son with a kind of Tyrolean yodel, "Sweep-ho! Sweep-ho! Sweep-ho!"

Selling was colorful in the "old days."

CHERRIES RED

Written by Sidney Walker

Sung By

Madame Vestris

In

PAUL PRY

Composed by

L. ZERBINI

Firth & Hall 1, Franklin Square, New York.

CROTON WATER CELEBRATION

From the latter part of the eighteenth century, through the first quarter of the nineteenth, most of the water used by the citizens of New York City was distributed by individuals or private companies, to whom franchises had been granted for that purpose. Some few town pumps (free) were available; other water was carted about in hogsheads and sold at one cent a gallon.

After a disastrous conflagration in 1828, concerted efforts in the city council produced a resolution authorizing the appointment of a committee to study the water problem and make a report. From this inauspicious beginning there evolved the appointment of a chief engineer and the authorization to borrow the necessary funds for the difficult project of bringing water almost forty miles south from the Croton River to New York City.

The completion of the undertaking required seven years of steady, and often discouraging, work by Irish and Italian laborers. In June, 1842, the first receiving reservoir in the city admitted, with due ceremony, a flow of water; on the fourth of July, with further pomp, water was introduced into the receiving reservoir at Fifth Avenue and Forty-Second Street, where sixty-nine years later the magnificient Public Library would stand.

But the grand finale, the super celebration for the whole city, was postponed until October 14 of the same year. The weather was superb; the citizens, who had voluntarily incurred a twelve million dollar debt for their municipality, were ecstatic. The parade, which jammed the streets with its many bands and fire companies marching with their engines, and which wheeled past City Hall, was the biggest, the gaudiest, the most demonstrative that New York had ever witnessed, taking (said the New York *Express*) two hours and ten minutes to pass the newspaper's offices on Broadway, after its start at the Battery.

The fountain in City Hall Park threw jets of water sixty feet in the air. By shifting plates in the pipes, the water could be made to assume various shapes—the Croton Plume, the Vase, the Sheaf of Wheat, the Maid of the Mist, the Weeping Willow, and others.

The well-known poet George P. Morris, at the request of the Corporation of the City of New York, wrote a commemorative ode for the occasion. "The Celebrated Croton Ode" was sung in front of the park fountain by the members of the New York Sacred Music Society, to an arrangement of a theme from Rossini's opera *Amida*.

> Gushing from your living fountain,
> Music pours a falling strain,
> As the Goddess of the mountain
> Comes with all her sparkling train

sang the society, and continued for seven 8-line verses, winding up with:

> Ever sparkling, bright and single,
> Will this rock-ribbed stream appear,
> When Posterity shall mingle
> Like the gathered waters here.

The title page of the music sheet commemorating the occasion endeavors to give an idea of the immensity of the parade as it wound around Lafayette Square, home of City Hall. The lithographer's name does not appear, but it was probably the work of the Endicotts, leaders in their field. In this instance their charming, if "busy," presentation wakes a feeling of nostalgia for America's yesterdays.

CROTON WATER CELEBRATION 1842

Entered according to Act of Congress in the Year 1845 by J.F. Atwill in the Clerks Office of the District Court of the Southern District of the State of New York.

Published by J. F. Atwill, 201 Broadway

THE PIONEER'S QUICK STEP

Lewis T. Voigt is best remembered as a fashion artist. For twenty years, from 1845 until the end of the Civil War, he furnished *Godey's Lady's Book* with many drawings of the impeccably groomed, handsomely garbed women whose likenesses graced the pages of that arbiter of female chic.

But Mr. Voigt turns out to have been a man whose gifts were not limited to fulfilling an assignment for the *Women's Wear Daily* of the period. He was also a portrait painter and a miniaturist of some distinction in Maryland, where he eked out a living between 1839 and 1845. Moreover, he fancied himself something of a poet. His poetical offerings appeared at frequent intervals in popular magazines in 1839 and 1840. They indicate that Voigt was something of a lady's man; many of them bore titles such as "Lines to Miss ———." Occasionally, the "Miss" had an initial, as a mysterious come-on, but no further clue to her identity was given. Only rarely, when his thoughts were not bemused by his girl friends, did the poet let himself become excited by more ethereal subjects, as, for example, when he produced a set of verses entitled "Hurrah for the Sunlight!"

In 1842 Voigt was commissioned by an up-and-coming Baltimore lithographer, Edward Weber, to design the title page for a music sheet being published by another Baltimorean, Samuel Carusi. The piece was "The Pioneer's Quick Step," composed by James Monroe Deems. Voigt, rising to the occasion, produced a stunning figure of a man in the full military regalia of his profession, high cockaded hat perched squarely on his head, epaulets on his shoulders, and with long, loose gloves, apparently to protect his hands as he swung his axe to clear the underbrush or fell whatever trees might be in his path.

Weber had arrived from Germany about 1835 and already had a successful lithographing business when he engaged Voigt to illustrate Deems's quickstep. Weber was a pioneer in American color lithography; Voigt's illustration is probably the earliest example of a colored lithograph on a sheet music cover.

James Deems gave early evidence of developing into a prodigy, so his family sent him to Germany to study with the masters of the music world. After two years he returned home to Baltimore and began to turn out one popular composition after another. "The Pioneer's Quick Step" was one of his first. Some years later he was made a professor of music at the University of Virginia, a post he held until the Civil War, when, his linguistic abilities being recognized by the government, he was instructed to carry and transmit important war orders. A participant in some of the most important battles of the war, including Bull Run and Gettysburg, he was decorated for exceptional bravery and eventually attained the rank of brigadier general.

The Pioneers were usually detailed from different companies of a regiment and assigned duties that today might belong to the Corps of Engineers. They dug ditches, felled trees, chopped at underbrush, and generally cleared the way for the fighting men to advance without undue difficulty. No regiment was deemed properly organized unless its roster included a Corps of Pioneers equipped with saws, pickaxes, spades, mattocks, felling axes, and billhooks.

Certainly so rugged a soldier as a Pioneer deserved, at the least, a musical salute in his honor.

Drawn by J. T. Voigt

THE PIONEER'S QUICK STEP
Composed & Arranged for the
Piano Forte
and Dedicated to his Friend
JAS. W. HERON ESQR
by
JAMES M. DEEMS
Published by Saml. Carusi Baltimore

Entered according to act of congress in the year 1843 by
Saml Carusi in the clerks office of the dist. court of Md.

Lithographed and printed in colours by
Ed. Weber & Co. Baltimore

THE ICE-CREAM QUICK STEP

There is nothing modern about ice cream. Some scholars believe that it originated in Rome in the second century A.D.; the dainty which the Romans then called *mecla* may have been a frozen milk concoction. From that period until the sixteenth century no popular frozen dessert with a milk additive would have appeared in any cookbook, had one been available. But in 1533 the fourteen-year-old Catherine de Médicis brought such a recipe from Italy to France when she arrived there for her marriage to the Duke of Orléans.

Soon afterwards ice cream reached England and, eventually, America. A guest of Governor William Bladen of Maryland wrote in 1700: " . . . We had dessert no less curious; among the rarities of which it was compos'd was some fine ice cream which . . . eat most deliciously" (Dickson, p. 20).

During the four years Thomas Jefferson served as minister plenipotentiary to the court of Louis XVI of France (1785–89), he copied many exotic recipes. The first American recipe for ice cream is in the handwriting of a president of the United States.

George Washington was also an ice cream fancier; at a dinner party at the Alexander Hamiltons which he attended in 1789, ice cream was a high spot of the menu. The inventory at Mount Vernon included two pewter ice-cream pots.

In the White House, in 1811, Dolley Madison, wife of the president, climaxed her most resplendent state dinners with a stunning dessert. Once an impressionable guest wrote: "When . . . the brilliant assemblage . . . entered the dining room, they beheld a table . . . laden with good things to eat, and in the Centre high on a silver platter, a large, shining dome of pink Ice Cream" (ibid., p. 24).

Early in the nineteenth century ice cream became much more common, and ice-cream parlors, or "saloons," as they were often called, sprang up in several of the larger American cities, Boston among them.

In 1841 "The Ice-Cream Quick Step" was composed by J. R. Garcia, a Bostonian. It was "dedicated to Mr. William Lee as a token of respect for industry and enterprise." On the title page, Garcia noted that "the Motive for this Quick Step was Suggested by Mr. Lee's extreme celerity and apparent ubiquity when in attendance upon his crowded Saloon, 253 Washington St."

The illustrated title page, with a lithograph by Thayer and Company, Boston (see "The Pretty Flower Girl"), indicates that Lee's saloon—at which no spirituous liquor was served—attracted a swarm of ice-cream enthusiasts. The two dozen tables were fully occupied, all, apparently, by adults. (It seems that an ice-cream saloon was no place for children.) Male and female waiters carried tempting parfait glasses to the eager diners. On an ornate balcony in the rear of the parlor a band entertained the customers.

The pleasing scene was drawn for Thayer by David Claypoole Johnston, the artist who designed the first lithograph used on sheet music in America (see "The Log House"). The well-groomed clientele of the sumptuous establishment—the men in tailcoats and stovepipe hats, the women in modish gowns and bonnets—are portrayed in a straightforward fashion, without irony and with no trace of Johnston's penchant for caricature.

Indeed, the cover of "The Ice-Cream Quick Step" is a distinct departure from Johnston's usual choice of subjects for music title pages. In 1824, two years before his first musical lithograph for "The Log House," he had produced an engraved music cover of a comedian in burnt cork doing a parody on "Massa Georgee Washington and General Lafayette." Another vicious caricature of blacks came a few years later, to be followed by a

LEE'S SALOON 253 WASHINGTON S?

D.C. Johnston del. Thayer & Co? Lith Boston.

THE ICE-CREAM QUICK STEP,

Composed and dedicated to

M? WILLIAM LEE

as a token of respect for industry and enterprise by

J. R. GARCIA.

Price 25 cts Nett.

N.B. The Motive of this Quick Step was suggested by M? Lee's extreme celerity and apparent
ubiquity when in attendance upon his crowded Saloon 253 Washington St.

To be had at the Saloon and the principal Music Stores in Boston

Entered according to Act of Congress in the year 1841 by J.R.Garcia in the Clerks office of the District Court of Massachusetts

bitter anti-Masonic cartoon, in which all the principals were portrayed with heads of animals. A temperance gathering, as drawn by Johnston, shows a red-nosed orator with a bottle of whiskey protruding from a rear pocket. A school scene has a peevish schoolmaster chastising his young pupils.

It is refreshing to observe "The Ice-Cream Quick Step," where everybody seems to be having a good time, at no one else's expense.

THE BURGESSES CORPS PARADE MARCH 1844

Residents of Albany owed a debt of gratitude to Patroon Stephen Van Rensselaer. His beneficence was the primary reason why the Albany Water Works worked. The patroon had made a grant, back in 1802, that enabled the city to bring water to Albany from the Maezlandt Kill, northwest of town, in hollow wooden logs. The reservoir had been located on the brow of a hill so that water from it would be available to buildings at lower levels throughout the city.

In 1844 a new reservoir, designed in a supposedly Egyptian style, was constructed on Eagle Street. The fashionable residential section surrounding it was known as Quality Row. The Albany Burgesses Corps was proud to be able to drill there.

Quality Row, in return, could be proud that the Burgesses Corps used the area as a drill ground, for the corps was decidedly a quality outfit. Founded in 1833 as a military company, it was also quite a social group, embarking on frequent excursions and participating in important parades in New York City and elsewhere. During the ninety years of its existence, it was renowned "for its military glamor, its precision drilling, and its sumptuous entertainment," according to General Robert E. Mulligan, an authority on military affairs in the Albany area (personal correspondence).

During the Civil War, the corps responded to President Lincoln's first call for troops and relinquished its independent status, serving as Company R of the Twenty-fifth Regiment, New York State Militia. After the war it resumed its former activities, making excursions to various parts of the country and parading in a great number of cities.

The Burgesses Corps survived until the end of World War I, when the social status of ex-soldiers no longer mattered. Second-hand dealers bought the contents of their armory and threw away most of the records of the valiant corps.

The title page of the sheet music, done by Thayer and Company of Boston, "in colors" (as the cover points out—a novelty in 1844), shows the members of the corps standing in formation. Their attractive uniforms —copied from those of Britain's Coldstream Guards—consisted of scarlet coats, sky-blue trousers, and the first black bearskin hats to be worn by an American militia unit. The mansions of Quality Row are seen behind them; to one side is the new reservoir.

Thayer, who did covers for "The Old Arm Chair" and "The Pretty Flower Girl," was one of the earliest American masters of the use of color in lithography.

"The Burgesses Corps Parade March" was written by Oliver J. Shaw, a noted musicologist. Shaw, Massachusetts-born, had the misfortune accidentally to blind himself in one eye when he was very young. He had

VIEW OF THE NEW RESERVOIR OF THE ALBANY WATER WORKS COMPY AND THE ALBANY BURGESSES CORPS.

TAKEN FROM THE ACADEMY PARK, ALBANY, N. Y.

Pendleton's Lithography, Boston.

66

hoped for a career in the navy, but at the age of twenty-nine, when he became totally blind, he turned to music. Moving to Providence, he taught music and served as a church organist. In 1817 he opened a "musical repository," selling sheet music and issuing many of his own compositions. As a prolific producer of both liturgical and popular piano compositions, Shaw was one of the important American musicians of his time.

THE OLD ARM CHAIR
1840

Many children, as they grow up, feel unhappy about their given names. Most of them eventually accept the choice of their doting parents with resignation. But not so Nathaniel Rogers Lane, born in 1804 to a family whose ancestors had been among the first settlers of Gloucester, Massachusetts. His name so displeased Nathaniel Rogers that he proceeded at an early age to call himself Fitz Hugh; and it is as Fitz Hugh Lane that he made his much respected place in the field of American marine art.

Like several other artists who later gained outstanding recognition, Lane apprenticed himself as a young man to a leading lithographer. His employer was William S. Pendleton, Boston's most important lithographic firm in the early 1830s. Pendleton sold his business to Thomas Moore, an Englishman, in 1836; Moore was succeeded four years later by Benjamin W. Thayer.

Among Lane's sixty known lithographs are a dozen and a half sheet music covers. One that exhibits his great skill as a draftsman is "The Old Arm Chair," which he executed for Thayer in 1840. The model's beautiful hands, the open volume on the chair, the sheet of music on the piano, are drawn with the most careful precision and give evidence of the artist's attention to the smallest detail of his work—the mark of a perfectionist.

"The Old Arm Chair" became the best-loved American ballad of the 1840s. The lyrics were by a well-known poetess, Eliza Cook, and the music was written by an even more famous composer of popular songs, Henry Russell. An Englishman by birth, Russell came to the United States in the 1830s and scored his first hit when he set to music George P. Morris's poem "Woodman, Spare That Tree." Russell was a prolific melody man and a lyricist as well—an early-day Irving Berlin. His songs were sung around the piano at home and rendered feelingly on the stage by professional performers.

Of all Russell's songs, by far the most successful was "The Old Arm Chair." It ran through twenty-three successive editions; the number of thousands of copies published cannot be conjectured. The sentimental melody, affectingly simple, was easy to remember, and the expressive sentiments of the verses touched the emotions of old and young.

I love it, I love it; and who shall dare
To chide me for loving that old arm-chair.
I've treasured it long as a holy prize
I've bedew'd it with tears, and embalmed it with sighs.

.

Would ye learn the spell, a mother sat there,
And a sacred thing is that old arm-chair.

Both Cook and Russell continued to contribute to the steadily growing public interest in topical, or popular songs; but never again were they able to repeat the astounding nationwide success of "The Old Arm Chair." In

THE OLD ARM CHAIR,

A Ballad.

The Music Composed and respectfully dedicated to

HOLTON OLMSTEAD, ESQUIRE.

F. B. Lane del.

Bufoe, engraver to Napier

Price 50 cts. nett.

BY

HENRY RUSSELL.

Boston.

Published by OAKES & SWAN, *8 Tremont Row*

Entered according to act of Congress in the year 1840 by Oakes and Swan, in the clerk's office of the District Court of Massachusetts.

volume of distribution it had no equal until the Civil War brought a new batch of songwriters to merge love of country with popular music and make the singing of "Glory, Hallelujah" and "Just Before the Battle, Mother" and "Kingdom Coming" a patriotic rite.

FOOT GUARD QUICK STEP 1845

The fine old Hartford State House was completed in 1796. A Georgian-style building, its exterior was a combination of brownstone and brick, painted white sometime before the "Foot Guard Quick Step" was published in 1845. Its main cornice and balustrade and the mounting cupola were of wood. Standing in the center of the city, its main front faced the Connecticut River. In the 1840s the state guardsmen drilled on the green before the old building.

The Governor's Foot Guard had a long and distinguished record. Organized in October, 1771, by forty-four leading young men of Hartford, the guard was formed to do the honors to the governor and the General Assembly in a dignified manner. Almost immediately the men adopted, and purchased at their own expense, handsome uniforms, consisting of a scarlet coat, faced with black with silver braid, buff knee-breeches, black velvet leggings, and fur hat. The uniform remained practically unchanged up until the time the sheet music cover appeared.

The first parade of the Food Guard was in May, 1772, when the guard served as escort to Governor Jonathan Trumbull and the General Assembly. From 1788 on, the name "First Company Governor's Guard" was adopted, and in 1809 the rank of major was conferred upon the commanding officer. Prior to that date, it had been ordered that in addition to three commissioned officers the company was to comprise eight sergeants, eight corporals, ninety-six privates, and a band of fourteen musicians, six fifers, and four drummers.

The company in formation, with the band to the left of the picture, was sketched by James William Glass, Jr., a young artist who gained recognition after he had completed his studies abroad but who died tragically, by his own hand, at the age of thirty.

The Kelloggs of Hartford, whose ancestors had come to America before 1650 and who lithographed this poignant scene, were among the most widely known and prolific lithographers of their day. Currier and Ives produced the largest number of American lithographs; next came the Kelloggs. The variety of their subject matter was infinite—from animals to soldiers, from brides to generals, from marine views to military formations, from westerns to the "bottle" series of temperance prints. They catered to every taste.

In the year the "Foot Guard Quick Step" appeared, four Kellogg brothers were master lithographers, operating together at times and individually on occasion. Daniel, Edmund, Elijah, and Jarvis were both partners and competitors, and it is usually difficult to identify the work of each, particularly when, as in this instance, the attribution is to "Kelloggs' Lith." However, "Foot Guards" is probably the work of Edmund and Elijah, who operated in tandem from 1842 to 1848.

Charles S. Grafulla, who composed the martial air, was a dominant figure on the American musical scene for over a quarter of a century. A famous band leader who in later years headed the proficient New York Seventh Regiment Band, Grafulla was one of the best march writers America has ever produced. (His music had a marked influence on a second great march composer of a succeeding generation—John Philip Sousa.)

FOOT GUARD QUICK STEP,

Arranged for the **PIANO FORTE,** and dedicated to

MAJOR COMMANDANT L. H. BACON,

AND THE **OFFICERS** AND **MEMBERS** OF THE

FIRST COMPANY GOV?. FOOT GUARD OF CONNECTICUT,

BY

C. S. GRAFULLA, N. Y.

Price 38 Cts. Net.

HARTFORD:
PUBLISHED BY DANFORTH & BREWER N? 6 STATE ST.

Despite the striking regalia and the muskets, the guards were less given to martial combat·than to the entertainment of visiting military corps in Hartford and the reciprocal calls made to these outfits in their home towns. The features of this frequent fraternization were, as may be expected, wining and dining. True, there were threatened summons to action against Burgoyne in 1777 and in an interdepartmental fracas with elements of the United States Army in 1812, but neither materialized into a real fight. The guards' most serious, and actually their only, involvement came in 1835 when they were called on to protect the Negro community of Hartford from threats by white citizens.

THE OLD GRANITE STATE 1843

In the 1840s and 1850s Americans were pleasantly introduced to two types of entertainers: blackface minstrels and family troupes. The former were lusty, comic, often coarse, and always noisy. The latter were far more serious, usually more musical; they were whimsical, appealing, and "straight." Of the family groups of singers, by far the best known and best loved were the Hutchinsons.

The Hutchinsons came from sturdy New Hampshire stock. To say that their parents were prolific would be putting it mildly. The four who composed the singing group had been preceded by twelve others, mostly boys, who helped to run their father's farm.

Early in the 1840s the four youngest Hutchinsons determined that rather than work the farm, they would go out into the countryside and carry music to the people of New England. So Judson, Abby, John, and Asa began in New Hampshire, crossed over to Vermont, and eventually came to upper New York. They originally called themselves the Aeolian Vocalists, and it was under that impressive title that their earliest concerts were given.

They were not what we would today call financially successful. For example, after six concerts at the fashionable resort of Saratoga Springs, the Aeolian Vocalists made the huge profit of $3.75. But they soon turned the corner into affluence.

In 1843 they added to their repertoire a "family song" they called "The Old Granite State." Jesse, their father, had inspired it. The quartet sang:

We have come from the mountains of the "Old Granite State,"

.

We have left our aged parents in the "Old Granite State."

Eight more verses followed, all proclaiming the creed of the Hutchinsons. They sang: "We are all real Yankees"; "Liberty is our motto"; "We despise depression, and we cannot be enslaved"; "Yes we're friends of emancipation"; "We are all teetotalers And have sign'd the Temp'rance pledge." For six decades, year after year, the Hutchinsons regaled their audiences with song. Their total repertoire numbered more than five hundred songs.

One song, which the Hutchinsons introduced in 1864 and which is sung until this day, is "Tenting on the Old Camp Ground," a pathetic ballad written in the late days of the Civil War by their good friend David Kitteridge.

"The Old Granite State" was published in 1843 and reprinted again and again. The portrait of the four singing Hutchinsons on the title page has the appearance of an American primitive. G. and W. Endicott of New York were the lithographers.

THE OLD GRANITE STATE,

Judson. Abby. John. Asa.

Lith. of Endicott

COMPOSED, ARRANGED AND SUNG, BY

THE HUTCHINSON FAMILY.

NEW YORK

Published by **FIRTH & HALL** Nº 1 Franklin Sq.
And **FIRTH, HALL & POND** 239 Broadway.

Price 50 cts. nett.

Entered according to Act of Congress in the year 1843 by John Hutchinson in the Clerks Office of the District Court of the Southern District of N.Y.

DEATH OF WARREN

In the art gallery of Yale University hangs John Trumbull's immense, romantic *Battle of Bunker Hill—June 17, 1775*, executed in a London studio ten years after the historic event. One detail of this massive painting portrays the death of General Joseph Warren, physician, Harvard graduate, close friend of Paul Revere, and as active a revolutionary as any citizen of Massachusetts.

It was Warren who, the night of April 18, begged Revere to spread the word of the threatening British troops to all the countryside; and it was from Warren's house that Revere set out on his famous ride "through every Middlesex village and farm" to Lexington, arousing the population to the lurking danger.

Warren, who was called by the English Lord Rawdon "the greatest incendiary in all America," had been voted a major-generalcy by the Provincial Congress only three days before the battle. He it was who organized the undisciplined troops after Massachusetts' other leaders, John Hancock, Samuel Adams, and John Adams, had departed for the Continental Congress in Philadelphia.

At Bunker Hill Warren fought side by side with his men. When the fort was overrun, he was struck in the head by a musket ball and expired almost instantly. He had once declared that he would like to die fighting the British in blood up to his knees; his wish was granted. A British officer wrote, "He died in his best cloaths, everybody remembered his fine silk fringed waistcoat" (Scheer & Rankin, p. 87).

Seventy years after Bunker Hill a New England poet and minor orator, Epes Sargent, wrote a lyric for "The Death of Warren," which he subtitled "A National Song." It was set to music by William R. Dempster, one of the better-known popular composers of his day.

Sargent prefaces the words of his song with a brief history of Warren's last hours. According to Sargent, Warren addressed his commander, General Israel Putnam, as follows: "Tell me where I can be useful." "Go to the redoubt," replied the general; "you will there be covered." Warren rejoined, "I came not to be covered; tell me where I shall be in the most danger; tell me where the action will be hottest." As the tide of battle turned against his men, Colonel William Prescott gave the order to retreat. But Warren's courage forbade him to obey, and when he finally and reluctantly followed his comrades, a fatal shot cut him down.

The illustration on the title page was inspired by Trumbull's painting. Small details are changed, but the overall effect is the same. In the painting, as in Bufford's lithograph on the sheet music cover, Warren lies expiring in the arms of a fellow soldier, while other Americans hold their flags aloft and Captain Thomas Knowlton of Connecticut and Major Andrew McClary of New Hampshire still offer resistance to the enemy. British Major John Small advances toward the dying man.

The work of John H. Bufford, Boston's most prolific lithographer, is represented on a number of these pages. He was active in the trade for nearly forty years, during which time some of America's best-known artists were in his employ (Winslow Homer was one of them; a sample of his work appears a few pages farther on).

The artist of this particular title page failed to reveal his identity. A pity, for the cover is full of action and consciousness of history; its maker deserved recognition.

DEATH OF WARREN,

A NATIONAL SONG
Written by
EPES SARGENT, ESQ.

The Music composed and
most respectfully dedicated
TO HIS FRIEND
ABRAHAM R. THOMPSON, M.D.

OF CHARLESTOWN MASS. BY
WILLIAM R. DEMPSTER.

J.H. BUFFORD'S LITH. BOSTON.

BOSTON.
Published by OLIVER DITSON & CO. 277 Washington St.

| C.C.CLAPP & CO. | BECK & LAWTON. | FIRTH POND & CO. | JOHN CHURCH JR. |
| Boston | Philadᵃ | N.York | Cinn. |

Entered according to Act of Congress in the year 1846 by Oliver Ditson & Co. in the Clerk's Office of the District Court of Mass.

7½

SANTA CLAUS' QUADRILLES

" 'Twas the night before Christmas . . . "; or was that really the night? Did old Santa really come down the chimney around midnight on December twenty-fourth? Not always, according to various American storytellers and artists. An illustration in the *New Mirror*, published in New York in 1844, portrayed the old gentleman sitting before his hearth and stuffing children's stockings, over a legend that read, "Santa Claus, the Night Before New Year." Some stories had him arriving on December 5, a date that has no special significance in America today.

Santa did not necessarily use an eight-deer "flyer" in those early days, despite Dancer, Prancer, et al., the famous steeds in Clement Clarke Moore's delightful poem written more than one hundred and fifty years ago. Santa Claus was always a bringer of gifts, but in early nineteenth-century reports he might arrive in a wagon, on horseback, or even on foot.

Nor could the illustrators of those times agree on Santa's personal appearance. Around 1810 he was depicted as being tall and stately, dressed in bishop's robes and holding a purse in one hand and a birch rod in the other; for he visited the bad children as well as the good. At one time he wore a cocked hat, which he discarded in the 1840s for a close-fitting headpiece to guard against the cold. Some artists gave him a beard, others left him smooth-shaven. Some trimmed his garments with fur; occasionally he was dressed like a Dutch cavalier, with a long flowing cape.

By 1846 his stature had shrunken, and he was usually shown as a small but full-bellied man, jolly, smoking a little Dutch pipe, and occasionally playing a merry tune as he flitted from chimney to chimney.

The title page of "Santa Claus' Quadrilles," published in New York in 1846, pictures Santa as a gay bringer of goodies. Having alighted from his toy-laden sleigh, drawn by two reindeer, he is beardless, his little pipe firmly fixed between his teeth, and he is just about to descend a chimney with his packful of presents—dolls, toy animals, baby carriages.

The work bears the signature of the artist—"Spoodlyks." Who in the world was Spoodlyks? For several decades, students of American art have puzzled over the name. Obviously, he was a clever cartoonist, for his work appears on the covers of a dozen pieces of sheet music published in the 1840s. It is possible that the artist was either George or William Endicott, the talented brothers who had teamed up as master lithographers in New York in 1845; the quality of their workmanship earned them many awards at exhibitions. The firm of G. and W. Endicott, of Beekman Street in New York, were the lithographers of the title page of "Santa Claus' Quadrilles." Yes, Spoodlyks *must* have been an Endicott.

The quadrilles were composed by Harvey B. Dodworth, an old hand at writing and arranging popular music for the piano. He was best known, however, as a bandmaster. In 1804 Harvey's older brother, Allen, had organized in New York the first brass band in America. For nearly forty years the Dodworth Band was considered the best of its kind.

In 1839, at the age of seventeen, Harvey had become conductor of the Thirteenth New York Regiment Band, a post he held for half a century. When Allen decided to leave the Dodworth Band in 1860, Harvey took over the reins, but the Thirteenth Regiment had no intention of letting him go; as a result, he found himself conducting two great bands simultaneously. In 1867 the Thirteenth New York Regiment Band became the "official" Central Park band and attracted many thousands of New Yorkers to its annual summer concerts.

SANTA CLAUS' QUADRILLES.

as played by
DODWORTH'S QUADRILLE BAND.
ARRANGED AND DEDICATED TO THE
Old Knickerbockers, Pr. 38 cts. nett.
BY
HARVEY B. DODWORTH.
New York,
PUBLISHED BY FIRTH POND & Co. No. 1 FRANKLIN SQ.

KNICKERBOCKER SALOON QUICK STEP

The origin of bowling is shrouded in mystery. Some say it can be traced back seven thousand years to the Egyptians; others, to the Greeks at the time of the return of Odysseus after his post-Troy wanderings. The Germans also claim to be ancestors of the sport; they say bowling originated as a religious activity. Their bowling pin was named *Heide*, which means "heathen." It was placed at one end of a cloister, and a parishioner, at the other end, was given a ball and told to direct it at the heathen. If he hit or "slew" the Heide, he was recorded as a man who was living a pure life; but if he missed, he was a delinquent.

When the Dutch settled in New York in the 1600s, they brought with them the game of ninepins, which, like the sports mentioned above, was played on a green. In 1732, the year of George Washington's birth, the square north of New York's Battery was leased as a bowling green, and it still bears that name.

But not until the 1840s, when the game of ninepins had been moved indoors, did the sport become really popular in New York. One reason for the renewed interest in bowling was that gamblers had entered the picture. Matches for money were so frequently arranged that the state of New York, following an action by Connecticut, outlawed ninepins.

But around 1842 the bowlers discovered how to circumvent the law. They merely added another pin and reset the pin arrangement from a diamond shape to that of a triangle. And so the game of tenpins was born.

It was a fast-growing youngster. Within a few years there were bowling alleys on nearly every block of Broadway from Fulton to Fourteenth Street, and in various parts of the Bowery. (There were even four alleys on the third floor of a building on University Place.)

These were the days of fabulous bowlers like John Cleveland—better known as "Tenpin Johnny"—and Richard (Dick) Pheany. These men and other competent bowlers had little trouble making ten strikes in a row, because the pins were so close together. With scores of three hundred being made so frequently, the game grew monotonous, until, years later, the ten pins were spaced farther apart.

About 1846 there was published the "Knickerbocker Saloon Quick Step," dedicated to the saloon's proprietors. The word *saloon* did not at that time have the connotation it enjoys today; then it was simply an "establishment."

The title page, if it was drawn to scale, depicts alleys considerably wider than those in use today, but otherwise the scene might almost be modern (except for the costume of the bowlers). A pinboy can be seen at the end of an alley; mechanical pinsetters were well over a hundred years away.

Adam Stewart, probably a Bostonian, wrote the lively little quickstep. W. Sharp and Company of Boston were the lithographers.

William Sharp was born near Peterborough, England, and learned lithography in London. Arriving in America in the 1830s, he settled in Boston and soon began to experiment with color lithography; indeed, he was a pioneer in the field. Sharp took on various partners during his days as a lithographer; he also found time to exploit his skill as an artist, and he exhibited his work from time to time at the Boston Athenaeum. By his lights, he was a man for all seasons.

Knickerbocker Saloon
QUICK STEP

W. SHARP & Co LITH.

COMPOSED AND RESPECTFULLY DEDICATED
TO THE
Proprietors
OF THE
KNICKERBOCKER SALOON.
BY
ADAM STEWART

Published by MARTIN & BEALS 164 Washington St.
Entered according to Act of Congress in the year 1847 by Martin & Beals in the Clerks Office of the District Court of Mass.

Samuel Ringgold was born in 1800 and was descended from a line of distinguished fighting men. His father, a general, had represented Maryland in the House of Representatives, and his grandfather, General John Cadwallader, fought gallantly with the revolutionary forces.

Small wonder that the boy yearned for a martial life. At fourteen (!) he was appointed a cadet at the United States Military Academy at West Point and upon graduation four years later, with high honors, he became a lieutenant of artillery. Soon he was made an aide to General Winfield Scott; while serving with him he continued his studies in military science and invented a wide range of improvements in equipment, from a new saddle to a hammer for field guns.

When the war with Mexico erupted in 1846, Ringgold, now a major, organized a flying artillery corps and was one of the first field officers on the scene of battle. His service in this conflict was all too short. On May 8, at Palo Alto, in the initial major engagement of the war, Ringgold placed his corps well within half a mile of the enemy and opened fire with eighteen-pounders, inflicting frightful damage; he personally directed the attack. But a portion of the American forces was detached to stem a counter movement by the Mexicans aimed at gaining possession of some heavy U.S. equipment. Ringgold, on horseback, while continuing to lead his remaining artillerymen, was cut down by a cannon ball that passed through both his thighs. Despite the agonizing pain, he remonstrated with his subordinates who tried to carry him to the rear. "You have work to do," he said to his second-in-command. "Go ahead with your men. All are wanted at the front" (Powell, p. 869).

Ringgold lingered for three days and died at Point Isabel, Texas, on May 11, 1846. His conspicuous bravery was recognized throughout the country. Several pieces of music described the battle and bemoaned his death. In the winter of 1846 his body was returned to Baltimore and interred with full military honors. For this occasion the well-known Baltimore composer, James Monroe Deems (see "The Pioneer's Quick Step") wrote a funeral march that was performed by the military bands participating in the services. Words by Miss Augustine Duganne entitled "The Hero's Requiem" were set to the solemn melody. They went, in part:

> Let the hero's dust be laid
> In the soil that gave him birth;
> And let laurels that shall never fade
> Upspring from the sacred earth.

The title page of the funeral march bears a handsome likeness of the major, done by a process called a *plumbeotype*. As suggested by the strange word, the method of reproducing the portrait was developed by one John Plumbe. Born in Wales, Plumbe moved to Wisconsin, where as a young man his principal interest was railroads. He conceived of a road to span the continent, an idea that did not become a *fait accompli* until almost thirty years after Plumbe had suggested it.

Moving to Philadelphia in 1840 he became fascinated by the emergence of photography and soon entered the field. Here he discovered a method of reproducing in quantity the daguerrotypes then so popular. Plumbe's artists, engaged to copy the daguerrotypes faithfully, then reproduced them on lithographic stones, and such reproductions were called Plumbeotypes.

Headquartered in Philadelphia, Plumbe soon became enormously popular with his portraits of important individuals. Ten branches of his publishing company distributed his product. He promoted a National Plumbe-

otype Gallery and advertised the issuance of a daily portrait, for sale at a price of $15 for a year (313 portraits; never on Sunday), $1.50 for a month (26 portraits), or 12 ½ ¢ apiece.

A handful of his song sheets survive. The subjects include a few officers, actors, authors, and distinguished strangers, among them, fortunately and impressively, the hawk-nosed, clear-eyed, bearded, and epauletted Major Ringgold.

FIFTH REGIMENT MARCH 1848

The death of George Washington in December, 1799, was the occasion for an outburst of lamenting. For months the country was bombarded with funeral parades, orations, and dirges, and for a decade thereafter many memorials of minor importance were produced.

Nearly ten years after Washington's death, several prominent Baltimoreans petitioned the General Assembly of Maryland to authorize the establishment of a lottery in order to raise funds for a monument to the republic's first president. Early in 1810 the legislature approved the project and appointed managers to oversee the entire operation. They were to conduct a $100,000 lottery and choose the design for the monument. A talented French architect, Maximilian Godefroy, then working in Baltimore, was invited to serve as the designer. He welcomed the invitation; but his suggestions did not appeal to the managers, who discarded them and then served notice of a competition for the best plan for a monument. The winner was Robert Mills of Charleston, South Carolina.

In 1815 the cornerstone was laid. Placed within it were some United States coins, some Baltimore newspapers, a copy of Washington's farewell address, a glass bottle containing his picture, and of course, a list of the Board of Managers.

Based on costs of manpower and materials in 1815, it might be thought that $100,000 would have bought almost any monument. Ditch diggers were receiving $1.25 a day; for $3.00 a day a two-horse cart and driver were available; bricks cost $3.85 per thousand. Nevertheless, by the time of the grand dedication in 1843, after nearly thirty years of on-and-off activity, the cost of the monument had risen to $203,000. The most expensive item was the fifteen-foot statue of the president, executed by Enrico Causici of Verona, Italy, for $9,000.

To Baltimoreans, there was no regret for the protracted time of completion nor underestimated gross expense. They had succeeded in building the first major monument to the first president. Baltimore was thenceforth known as the Monumental City.

Among the reproductions of the Washington Monument was a soft lithograph by Edward Weber on the title page of an 1848 sheet of music, the "Fifth Regiment March," written by James M. Deems (see "The Pioneer's Quick Step").

The Fifth Maryland Regiment had a long and glorious history. Organized in 1774 as the Baltimore Independent Cadets, they had served in the Revolutionary Army as the 175th Infantry Regiment.

Deems's Fifth Regiment March was dedicated to General Benjamin Chew Howard, its highly revered commander and the scion of a distinguished Maryland family. Affiliated with the "Dandy Fifth" for many years, Howard pursued a political life. He served five terms in the House of Representatives but refused higher offices.

A man of independent means, most honors were of little importance to him. But Howard was proud to serve his regiment. The Washington Mon-

ument portrayed on the cover of the "Fifth Regiment March" is located on a portion of the great Howard estate, which the general's father deeded to the city to be the site of the memorial erected in honor of the first U.S. president.

THE PHILADELPHIA FIREMEN'S ANNIVERSARY PARADE MARCH 1848

Once again the name of able Peter S. Duval appears, this time as lithographer of the entertaining title page of the "Philadelphia Firemen's Anniversary Parade March." Duval had become Philadelphia's most popular lithographer (see "Governor Porter's March"). The cover artist was James Queen, a native Philadelphian, one of Duval's most dependable associates. A skillful draftsman, Queen did a number of illustrations for the *U.S. Military Magazine*, which, as noted earlier, was a brief but important project of Duval and William M. Huddy.

But to return to the firemen. The 1848 parade was a catastrophe. The day was marked by a driving snow storm that showed no sign of abating. To add to the troubles of marshaling the personnel of the individual companies, the Diligent Hose Company made an unfortunate blunder; it engaged the famous Dodworth Band of New York to attend it as it marched.

Now, it had become customary for the firemen to be accompanied by bands of their own choosing; but heretofore the bandsmen had never been temperamental. The Dodworth Band, however, had an overweening sense of pride; and when its members learned that Frank Johnson's band was to be part of the parade, they refused to take part in the procession. Their reason would surprise musicians today—Frank Johnson was black, and so were the members of his superb band.

As a result, the Diligent Hose Company and the Dodworth men marched in solitary huffiness, while the other companies paraded together with their own bands. All in all, the parade was a great disappointment. Of the nearly one hundred companies organized in Philadelphia, only forty-eight were willing to brave the storm and participate. Although two thousand men started out, at the end of the route only a few hundred stalwarts remained; all the rest had deserted and sought shelter. Only one company's banner was still being displayed; the others had been furled or were in tatters.

Frank—or Francis—Johnson was a rather remarkable person. A forerunner by several generations of Duke Ellington, Johnson was a composer, bandmaster, and versatile musician (he could fiddle, bugle, and play a horn). His compositions were in demand by the Philadelphia music publishers, and his great band of brass and woodwind performers was employed by fire engine companies and National Guard organizations. It also played at great balls; there Johnson added strings to his complement of instrumentalists. His fame spread throughout the length of the Atlantic seaboard, and eventually he took his band to England. He gave a command performance before Queen Victoria in Buckingham Palace, where he was presented with a silver bugle by Her Royal Majesty.

One of Johnson's early compositions was a march, written in 1824, in honor of General Lafayette when he revisited America in that year. "The Philadelphia Firemen's Anniversary Parade March" was among the last pieces he ever wrote. The title page indicates that it was composed specifically for the triennial parade and scored for Johnson's brass band, which undoubtedly included it in their repertoire as they marched.

THE PHILADELPHIA FIREMEN'S

ANNIVERSARY PARADE

MARCH

Composed for his **BRASS BAND** *expressly for the occasion,*

arranged for the

Piano Forte

and respectfully dedicated to the

Property of the Publishers Price 50 Cts

FIRE DEPARTMENT

by

Francis Johnson

―――――◦―――――

PHILADELPHIA,

Published by L. MEIGNEN & Co. Importers of Music & Musical Instruments, Italian Strings &c. 217, Chesnut Street.

THE SWEDISH MELODIES

Fanny Elssler had the grace of a swallow. Jenny Lind had the voice of an angel. And Lind had something else that made her the greatest drawing card of her time: during her stay in the United States, her manager was that remarkable master of showmanship, P. T. Barnum.

Jenny's early years had been hard. An illegitimate child, she suffered from feelings of inferiority and was plagued by an excessive sense of morality. But her lovely voice was discovered early; she was tutored, and she scored her initial success when she was eighteen. For the next twelve years she was the toast of Europe, and when Barnum sought her services she was for a time reluctant to come to America.

Barnum had never heard the Swedish Nightingale, as she was called, when he contracted for the thirty-year-old soprano to give a series of one hundred concerts in the United States. But he had learned of her successes throughout Europe and was sure that under his supervision she would be greeted with immense turnouts wherever she sang.

The results were almost unbelievable. Thirty thousand people were at the dock when Jenny Lind arrived in New York on the steamer *Atlantic* in September, 1850. For her first concert in the largest cities visited, the tickets to her performance were sold at auction. The winning bidder for the first seat at New York's Castle Garden was a hatter, John N. Genin, whose bid was $225.00. (The bid made Genin famous; newspaper reports of it brought him thousands of customers.) In Boston, Providence, and Philadelphia, bids rose to more than $600 for the first ticket at each premier performance.

Castle Garden that first night—September 11, 1850—was packed with five thousand captivated listeners; the second concert drew a still larger audience. From Boston to Havana to New Orleans to St. Louis, and in a dozen other cities, the reception of the little "Nightingale" ran a similar pattern—crowds, first a bit skeptical, then, after her first number, completely surrendering to the incomparable voice. In Washington her concerts were attended by President Fillmore and every member of his cabinet.

The sheet music publishers distributed scores of editions of her songs, many of them with portraits of Jenny Lind on the title pages. One of the first to be published was a song of welcome to the shores of the United States. Barnum had offered a prize of two hundred dollars for the best ode dedicated to the occasion, to be titled "Greeting to America." Hundreds of poems were submitted. The winning verses, chosen by a prize committee, were written by Bayard Taylor, a well-known literary figure. Flowery and bombastic, Jenny was made to greet America as follows:

> I greet with a full heart the Land of the West,
> Whose Banner of Stars o'er a world is unrolled;
> Whose empire o'ershadows Atlantic's wide breast,
> And opens to sunset its gateway of gold!

A lovely picture of Jenny Lind appears on the title page of a sheet published by Vanderbeek of New York. The song is the translation of a Swedish melody, "Panyars Degen"; the English version by J. Wrey Mould is called "The Mariner." The peaceful melody, in three-quarter time, was composed by E. C. Geyer. Jenny poses serenely on the cover, gazing into the distance, her hands lightly clasped, flowers studding her dark hair.

The black and white lithograph on a tinted background is by Napoleon Sarony, the most popular and most prolific artist in his chosen field. Photographer and charcoal portraitist as well as lithographer, Sarony had been employed as a young man by Nathaniel Currier. He founded his own

THE SWEDISH MELODIES,

CORRECT AMERICAN EDITION.

AS SUNG BY

MAD^{lle} JENNY LIND.

AT

THE PRIVATE SOIRÉES MUSICALES OF HER MAJESTY AT BUCKINGHAM PALACE.
HER MAJESTY'S THEATRE, AND THE NOBILITY'S CONCERTS
WITH THE ORIGINAL WORDS, AND ENGLISH ADAPTATIONS.

business in the 1840s and ran it into a huge venture, retiring shortly after the end of the Civil War. Small, animated, eccentric, absent-minded, and generous, he was an unusually attractive personality.

The portrait of Jenny Lind, executed in 1850, is illustrative of the high quality of Sarony's workmanship.

THE NATIONAL UNION 1851

To schoolchildren and to visitors from around the world, the most impressive building in Washington is the Capitol, with its stately, myriad-stepped, columned entrance, its massive wings and great dome, and Thomas Crawford's statue of Freedom soaring above the marble edifice.

No one now alive can remember a Capitol without the high-tiered dome surmounted by the statue, which many still believe to represent an American Indian, or without the broad wings, accommodating the Senate and the House of Representatives. Authorized in 1849 and begun in 1851, the House extension was first occupied in 1857, the Senate in 1859. "Freedom" did not mount her dome until 1863.

In 1851, at the beginning of the new construction, there were two aging giants in the United States Senate, Daniel Webster of Massachusetts and Henry Clay of Kentucky. Clay, the leader of the Whig party and perennial presidential candidate, still commanded a large force of devoted admirers, among whom were some with musical talents. Possibly the last song to be dedicated to him was entitled "The National Union." Written in 1851 by Charles Collins, Jr., Clay acknowledged it with a graceful flourish, as follows: "Both the sentiments and the poetry are very good, and I yield, with pleasure, to your desire to inscribe them to me. With great respect, I am your friend and obed't servant, H. Clay." Inspired by the Missouri Compromise of 1850, which skillfully extricated the country from the mortal struggle between the free and the slave states, the song begins:

> Oh, who would strike the recreant blow,
> To sever Union's chain?
> Oh who would seek to overthrow
> The glory of our name?
>
>
>
> Let peace and union be our song,
> Great Washington our plea,
> His mem'ry will the theme prolong;
> Union and liberty. . . .

The title page is elaborately conceived, with a picture of the old capitol before work had started on the new wings and uplifted dome and with a band of golden rings, surmounted by flags and an eagle, to set off the simplicity of the building. As it happens, the building is almost overpowered. There are thirty-one rings, representing the states then comprising the Union; each bears a state's name and the date of its admission to statehood. At the top of the band are the links of the thirteen "originals"; at the bottom is the ring with California's name and the date of her entry, 1850, when the Missouri Compromise was worked out.

The lithographer was Thomas Sinclair, the best-known and most prolific man in his field in Philadelphia. A native of the Orkney Islands, he learned his trade in Edinburgh, came to Philadelphia in the 1830s, and after a few years drew ahead of his competitors there. In his heyday during the 1850s and 1860s he had few peers; his work compares favorably with that of Sarony, New York's most popular lithographer.

THE CAPITOL AT WASHINGTON

THE

NATIONAL UNION

WORDS AND MUSIC

BY

CHARLES COLLINS, Jr.

and respectfully dedicated, (with permission) to the

HON. HENRY CLAY.

THE UNITED STATES OF AMERICA,

UNION AND LIBERTY, FOREVER, ONE AND INSEPARABLE.

LEE & WALKER,
Music Publishers, 162, Chesnut St, Philadelphia.

NEW-YORK. N. ORLEANS.
Wm HALL & SON. Wm T. MAYO.

New York City in the early 1800s had two great avenues extending north and south, Broadway and the Bowery. According to plans devised by the city fathers in 1807, as the city developed northward, these streets would merge at the Tulip Tree, a particularly showy botanical specimen located in a spot that would today be abreast of Sixteenth Street.

But the planners soon realized that such a development would result in the formation of several irregular blocks, whose shape and size would be so inconvenient that their value would be considerably reduced. To escape from such an unwelcome predicament, the commissioners decided to lay out a small park, triangular in shape, where a breath of fresh air might be found after buildings had sprung up around it. The legislature endorsed this idea in 1815 and established the area as a public meeting-place, or common, for the people of the city. Since it marked the union of the two principal thoroughfares on Manhattan Island, they named the park "Union Place."

Before 1815 the site had been utilized as a potter's field. Thereafter the shanties of squatters dominated the area. But in 1832 it was determined to extend the size of the little park and develop it into a grand, handsome square. By 1845 a vast transformation had taken place; all the shanties had disappeared, and surrounding the square were the opulent mansions of well-to-do New Yorkers. In time, some of these were converted into large attractive business establishments, so that the area became the fashionable shopping center for the entire city.

Union Place was now a well-kept, large park, with a great central fountain—installed in 1842 to celebrate the opening of the Croton Aqueduct, which brought water into New York City—lovely trees, and bright green turf. An iron fence surrounded the square. Its gates were locked each night, for the conservative commissioners wished to safeguard it not only from cutthroats but from amorous young couples as well.

In 1850 a group of businessmen introduced a plan to operate a surface car on Broadway. They determined to lay a double track that would extend from South Ferry to Fifty-seventh Street, and they were able to secure a franchise for this purpose in 1852. The cars would, of course, be horse-propelled.

However, the company struck a snag. Broadway was at that time the chief residential street, with the finest houses in the city; the wealthy home-owners did not take kindly to the idea of having a stream of horse-cars clattering by their mansions at all hours. So they took the matter to the courts, and an injunction was issued. In fact, so successful were the Broadway residents that they kept their street free of tracks until 1885.

No such problems existed for the thoroughfare on the eastern, or old "Bowery," side of the square. Here the Harlem Rail Road operated its cars over the double tracks, propelled by four prancing steeds.

The "Union Park Schottisch," written in 1852 by Paul Eltz and published by Geib and Jackson, carries a beautiful title page depicting the park with its luscious trees, gushing fountain, and forbidding iron fence. In the foreground a Harlem Rail Road car glides by, the driver controlling the pace of his four handsome bays.

The lithographers of the music cover were Nagel and Weingartner. Louis Nagel was a German-born artisan who came to America in his twenties and soon found partners to help him establish his own lithographing shop on Fulton Street in New York. After a brief trial partnership with one

UNION PARK SCHOTTISCH.

New York, Published by Geib & Jackson, 499 Broadway

Wm. Hall & Son, 239 Broadway

Firth, Pond & Co. No 1 Franklin Square

Ferdinand Mayer, he formed a more lasting union with Adam Weingartner, which continued from 1849 until Nagel died (or possibly retired) in 1857.

Their "Union Park Schottisch" cover conveys a sense of nostalgia to those who today see the square surrounded by unattractive commercial structures. Alas, such buildings completely nullify whatever charm might have remained in the lovely park that graced the junction of Broadway and the Bowery a hundred and twenty-five years ago.

SARATOGA SCHOTTISCH
1851

Sarachtogoe? Cheratoge? Sarrantan? There are nearly twenty variations of the early spelling of the resort that became, in the mid-1850s, the most celebrated summer watering place in the United States.

The Iroquois, who had New York state pretty much to themselves before the intrusions of the French and the English, had coined the name; in their language—whatever the English version—it meant "place of swift water," to one authority; to another, "place of herrings," which the Indians used to take from Lake Saratoga each April.

The Indians had long known of the curative powers of the miraculous salt springs in the area. Jacques Cartier, the French explorer, had heard about them in 1535, but until two centuries later, no white man had ever seen them. In 1767 a gouty Irish baronet, Sir William Johnson, proprietor of a mansion at Johnstown, New York, who had become popular with the Indians of the area, prevailed upon some of them to take him to the mysterious springs. Though unable to stand on his feet during the journey, he found the salt waters so miraculous that he walked part of the thirty-mile trip back to his home.

Young Gideon Putnam—his name would eventually be appropriated for Saratoga's finest hotel—a cousin of Major General Israel Putnam, one of George Washington's less spectacular leaders, was the visionary who built the first house in Saratoga. He did even more; in 1803 he built Saratoga's first hotel, which he called Putnam's Tavern and Boarding House.

Eventually the springs of salt and sparkling water became world-famous. There was no spa in the United States that could vie with the popularity of Saratoga Springs. Enormous hotels were built, and they were patronized by the greatest and wealthiest families of the land. Within a score of years, four presidents had been entertained there; war heroes and statesmen strutted and campaigned, fortune hunters hunted, and ministers preached the gospel.

The springs were probably never lovelier than in 1851, when William Endicott and Company of New York lithographed the title page for the "Saratoga Schottisch," written by Johann Munck. Munck's band performed an orchestrated version of the piece at Saratoga, and Munck arranged his pleasant piano score in simplified style.

The skill and popularity of the Endicotts have been dwelt on earlier in the book. The view portrayed on the title page includes two sites of the health-restoring waters: Congress Spring, under the pavilion on the left; and Columbian Spring, under the dome on the far right. The lawn and wooded areas in the background are part of Congress Park; the tall shaft, which appears to be an obelisk, is in reality a water tower.

Gideon Putnam had built his little tavern adjacent to Congress Spring. As he continued to prosper he planned a larger, grander hotel, to be called Congress Hall. Unfortunately, he was injured in a fall from a scaffold and died without seeing the completion of his dream, which was, however, realized by his wife and children.

SARATOGA SCHOTTISCH.

NEW YORK.

PUBLISHED BY JAQUES & BROTHER, No 385 BROADWAY.

Entered according to Act of Congress in the year 1851 by Jaques & Brother in the Clerks office of the district Court of the Southern district of New York.

38½ nett.

A Columbian Hotel was constructed near the Columbian Spring, and soon one hostelry after another arose to cater to the many thousands who sought the restoration of their health—as if the springs had replaced the miraculous discovery of Ponce de Leon three centuries earlier.

In the 1860s the resort added new attractions. It became a drawing card for the country's most extravagant gamblers and for fashionable race-track enthusiasts. By that time, Newport, Rhode Island, was challenging Saratoga as headquarters for the elite and the pleasure-loving, which caused the staid *Godey's Lady's Book* to pair the two famous resorts as "the Sodom and Gomorrah of our Union."

Meanwhile, most visitors to the Union's Sodom had the time of their lives.

SONG OF THE GRADUATES

1852

James Abbott McNeill Whistler started to draw at the age of four. The early attempts of the genius-to-be were not preserved, however, and it was not until he had reached the age of eighteen that he produced the work pictured here.

The title page for the "Song of the Graduates" bears the notation "designed by Cadet Whistler." It is so unlike all the known Whistlers that follow this stilted portrayal of two West Point cadets that there arises the suspicion that the drawing may have been doctored.

The finished product bears a striking resemblance to many of the figures designed by the successful and prolific lithographer and photographer Napoleon Sarony (see "The Swedish Melodies"). The features of the two young men, the stiff pose, and the shapes of their hands and feet seem to indicate that Mr. Sarony took it upon himself to mold Whistler's work to fit his own ideas of how young soldiers ought to look. In 1846 Sarony had affiliated himself with Henry B. Major and formed the firm of Sarony and Major. It is this firm which, in 1852, lithographed the Whistler drawing.

Whistler himself entered the United States Military Academy at West Point in 1851, just before his seventeenth birthday. Apparently the cover was designed in his second year at the academy. A "Song of the Graduates" for the class of 1852 has words by "A Cadet" and music by "A. Apelles."

Augustus Apelles had been second violinist in the Hill Quartet, a group that arranged the first public chamber-music soirée in New York in 1843. One outspoken critic of the soirées, who termed them a miserable failure, added that Apelles was a good clarinetist but a poor violinist. Later the same year Apelles became director of the Military Academy Band, a position he held until 1872 and one that naturally qualified him to compose "Song of the Graduates." The lyrics are attributed to James Watts Robinson of the class of 1852, who served as an artillery officer until the Civil War.

Cadet Whistler was far more interested in sketching than he was in the courses at the academy that would have prepared him for a military career. He did not inherit from his father, who himself was a West Point graduate, the type of inspiration necessary for a soldier's life. He scribbled sketches all over his textbooks and caricatured his fellow cadets and the masters of the academy.

Eventually the affiliation between Whistler and West Point was terminated. At the end of his third year, Whistler was discharged, with "deficiency in Chemistry." At that time he stood first in drawing in his class of forty-three, but thirty-ninth in philosophy.

Other aspects of Whistler's training showed similar deficiencies. For example, he was at a great disadvantage when required to attend cavalry drill. His horsemanship could be likened to his work in philosophy. It is reported that from time to time he would go sliding over the horse's head, and the commander would then call out: "Mr. Whistler, aren't you a little ahead of the squad?" Whistler is supposed to have insisted: "But I did it gracefully."

With his artistic talents, Whistler didn't need to worry about perfecting his horsemanship.

SEVENTY SIX POLKA 1852

New York, which was "such a charming city" in the mid-1830s (see "New York. O What a Charming City!") had not lost its charm twenty years later. Skyscrapers were still half a century away, and the elevated railroad and the subway, which were to add many decibels to the increasing volume of sound in the mushrooming metropolis, were not even dreamed of by city planners in the 1850s. The need for travel about the city was provided for by two principal types of transportation—horse-drawn streetcars, which ran along the tracks of several city railroad companies, and the omnibus lines.

The omnibus was an outgrowth of the stagecoach, which had transported a few passengers at a time—six was the limit—to the wilds of northern Manhattan in the late eighteenth and early nineteenth centuries. New York got its first omnibuses in 1830—a year after London, seven years after Paris.

By the 1850s there were twenty-nine lines, most of them operated by independent owners, a few of whom commanded only a limited number of stagecoaches. Other lines carried a heavy load of traffic, for which they provided a great number of four- or six-horse-drawn buses.

The buses of each company were painted in vivid "company colors"; people nicknamed them the "Red Birds," "Blue Birds," "Yellow Birds," and so on. They were frequently crowded like today's subway cars, with half the sixty or seventy passengers standing. When winter came on and the snow fell, sled runners would replace the wheels, and the floors of each bus would be strewn with straw to "insulate" it from the cold and to keep the passengers' feet warm.

Most omnibuses had a crew of two, the driver and the conductor who collected the nickel fares, which he obtained by wedging his way to the front of the bus through the crowd of passengers and then fighting his way back to the rear platform and registering the fares. At one period there was a notion among many omnibus passengers that the number of nickels collected rarely tallied with those showing on the register and that a good way to become rich was to secure a job as conductor on an omnibus line. Such a claim seems never to have been conclusively demonstrated.

The New York Consolidated Stage Company, operating over seven routes extending from Forty-second Street to South Ferry, employed over three hundred stage coaches, almost half as many as the combined equipment of all its competitors.

A smaller enterprising line, encompassing at least four routes, was the Knickerbocker Stage Company. The Knickerbocker Company, like several others, traveled as far north as Forty-second Street, but it favored the west side of town, using Eighth Avenue as its principal north-south axis and apparently enjoying a monopoly of the traffic on that thoroughfare. More-

SEVENTY SIX POLKA

COMPOSED BY

CHARLES WEISHEIT

and dedicated to

Johnson & Hudson Esqrs

BY

Robert B. Kerry Jr.

NEW YORK

Published by GOULD & BERRY 297 Broadway

Boston	Newark	Easton Pa.	Columbus Geo.
O. DITSON	S. P. HINDS.	H. W. LOWREY.	TRUAX & PEASE.

Price 38 Cts Nett

over, it catered to a nice volume of business in Brooklyn, as the "Seventy Six Polka," written in 1852, testifies.

This attractively illustrated piece by Charles Weisheit, dedicated to the proprietors of the Knickerbocker Line, Johnson and Hudson, depicts one of the six-horse coaches on route "seventy six," a Brooklyn run. The line met passengers at the Fulton Ferry and carried them to Greenpoint via Fulton Street and Myrtle and Classon avenues.

The artist of the spirited scene on the title page was Theodore August Liebler, a German-born landscape painter and engraver who came to America as an eighteen-year-old in 1848 and soon afterwards established a lithographing firm with Joseph Schedler. Schedler and Liebler, whose company name does not appear on the sheet, were doubtless its lithographers.

REINDEER POLKA 1852

Late in the summer of 1850, the handsome paddle-wheeler *Reindeer* was completed by its builders, the New Brunswick Steamship Company, and made her first trial runs on the Raritan River in New Jersey. As soon as her hoped-for speed and seaworthiness had been confirmed, she was assigned to a day-run between New York and New Haven, Connecticut, leaving New York at eight in the morning and New Haven five-and-a-half hours later, in direct competition with the New York and New Haven Railroad. Her passengers were charged seventy-five cents a trip.

The following April *Reindeer* was assigned to the Hudson River day-run between New York and Albany, with a fare that fluctuated—depending on the price battles with her competitors—between fifty cents and two dollars for a one-way ticket.

The trip from New York took nine hours and required eighteen to twenty tons of anthracite coal. The regular fifty-cent charge was at times cut to twenty-five cents for second-class fares, as rival lines almost ruined themselves in their attempts to capture the bulk of the passenger trade.

The schedule continued well into December, when heavy river ice forced the boats to put up for the winter in New York. Before this happened, however, the lines would send their steamers as close to Albany as the ice-clogged Hudson permitted, discharging their passengers when no further river progress was possible and sending them the rest of the way by rail.

The beautiful *Reindeer* had a useful life, but a brief one. At 1 P.M. on September 3, 1852, while lying at dockside, a tragic boiler accident occurred that resulted in the death of some thirty passengers who were trapped in the dining saloon. The ship immediately caught fire and burned to the water's edge. So at the youthful age of two, she perished.

A picture of the ship gliding up the Hudson was drawn by C. F. Lewis (see "The Tee-To-tal Society") and lithographed as a sheet music cover by Charles Currier.

Charles, five years younger than the famous Nathaniel (see "Charter Oak! Charter Oak Ancient and Fair!") was less ambitious than his brother, but he ran his own business and capitalized on his own talents. He invented a lithographic crayon—made of wax, shellac, soap, and other water-repelling ingredients—which was considered the finest of its kind anywhere. Unfortunately, his lackadaisical attitude resulted in snarled and unfilled orders for his would-be customers, so that the promising potential for his business was never realized.

A bit of an eccentric, the short, plump Charles, bearded and side-whiskered but without a mustache, always wore a tall white hat, which was, in a way, his trademark.

C. R. LEWIS DEL.

LITH OF C. CURRIER. 33 SPRUCE ST.

REINDEER POLKA.

New York, Published by JAQUES & BROTHER, 385 Broadway.

Entered according to Act of Congress in the year 1851 by Jaques & Brother, in the Clerk's office of the District Court of the Southern District of N.Y.

The "Reindeer Polka" was the work of William Dressler, one of New York's most popular composers, who was responsible for several other pieces that appear in this book (see "Castle Garden Schottisch" and the "Fort Hamilton Polka Redowa"). Dressler was well known as a conductor and was not above serving occasionally as a professional accompanist—a kind of jack-of-all-musical-trades.

CASTLE GARDEN SCHOTTISCH
AND FORT HAMILTON POLKA REDOWA 1852

Battery Point was located at the southwestern tip of Manhattan Island. As early as the 1790s it featured a waterfront promenade that commanded an unrivaled view of New York harbor. But it was destined for more spectacular prominence in the ensuing century.

When Jenny Lind, the remarkable Swedish soprano, thrilled her first American audience in September, 1850, at Castle Garden, she could hardly have been aware that her concert hall was originally constructed with a different purpose in mind. It was, in fact, a fort, which had been built nearly forty years before Jenny replaced the sound of the old thirty-two-pound guns with the most dulcet tones New Yorkers had ever heard.

Prior to the War of 1812, British vessels had regarded the American coast as their own right-of-way. They roamed the area of Sandy Hook, impressing seamen from American ships and fishing smacks; they attacked American frigates without cause; they even entered New York harbor and fired at ships and shore at will.

The government, indignant, decided that New York City, protected from the seas by only two inadequate forts, required a large modern addition to its defenses. For that purpose it selected a small island two hundred feet off the Battery, to which it was to be connected by a drawbridge. Fort Clinton, as the new edifice was called, was built of red sandstone from Newark, New Jersey, and was completed in the spring of 1812.

As the keystone of the defenses of the New York area, Fort Clinton was not only the headquarters of the third military district of the U.S. Army but also the center for news concerning the progress of the War of 1812.

Several years after the end of the war, the federal government, deciding that Fort Clinton had no further military value, deeded it to New York City, which promptly changed its name from Fort Clinton to Castle Clinton and later to Castle Garden.

As the only place in the city capable of containing as many as 8,000 spectators, Castle Garden became a popular center for great public gatherings, operas, and concerts. When General Lafayette returned to the United States in 1824, nearly fifty years after his participation in the Revolution, it was at Castle Garden that he received his first public reception.

President Andrew Jackson visited New York in 1830 and, after a formal reception at Castle Garden, walked at the head of a procession across the bridge from the garden to Battery Park. The enormous weight of the crowd following the president placed a tremendous strain upon the bridge, and it suddenly collapsed, hurling many people into the water—but not the president, who had reached the Battery in safety. Fortunately, there were no fatalities.

For Jenny Lind's concert in 1850, not only was Castle Garden crowded to the doors but thousands of people lined the waterfront or took to the rowboats they had moored as near as possible to the auditorium, in the hope that the sound of the singer's voice could be heard through the open windows.

CASTLE GARDEN SCHOTTISCH.

NEW YORK, PUBLISHED BY JAQUES & BROTHER 385 BROADWAY

Wm HALL & SON 289 BROADWAY.

LITH. OF G. W. LEWIS 252 FULTON ST. N.Y.

From 1855 to 1896 the garden was the reception center for immigrants, processing over two and one-half million foreigners who opted to make the United States their home.

In 1852 William Dressler, one of New York's best-known popular composers of the period, wrote the "Castle Garden Schottisch," a lively dance melody. The attractive cover, lithographed by George W. Lewis (see "The Tee-To-tal Society"), shows the old building in its heyday, two years after Lind's concert and shortly before it was converted to care for the huge influx of new Americans. It is a quaint and charming period piece.

Another early guardian of the approaches to New York City was Fort Hamilton, situated on the northwestern shore of Long Island, just over five miles from Fort Clinton.

As early as the middle of the seventeenth century the Dutch settlers in New Amsterdam—later New York—had been aware of the vulnerability of the city's harbor, and they erected crude defenses at its entrance, known as the Narrows. But it was not until 1824 that the importance of the Narrows as a bulwark against attack was sufficiently appreciated. In that year the city of New York deeded some sixty acres of land in "New Utrecht" to the United States government; construction of Fort Hamilton was begun in 1825 and completed six years later.

By the standards of that period, the fort appeared to provide the strongest possible defense against attacks, not only from enemy ships but also from any ground forces that might dare to approach it from the rear, where howitzers were mounted in casements.

The fort comprised a series of buildings, which included houses for the military and an inner fort, or redoubt. This later was transformed into a quartermaster storehouse; much of its construction was under the supervision of Robert E. Lee, who had been a captain in the Corps of Engineers and who assumed command of Fort Hamilton in 1856.

But Hamilton had its defects, too. In 1852, when "The Fort Hamilton Polka Redowa" was written—by the prolific William Dressler, who had composed the "Castle Garden Schottisch" that same year—the fort had no hospital facilities for its staff; nor had such facilities ever existed. A short while later a hospital building was erected, but without due regard for its intended purpose; it was so uncomfortable that within a few years it was abandoned. After that, sick men were forced to occupy the upper story of an old barracks, with a thousand holes through which the wind blew and a thousand leaks in the roof through which the rain dripped. But in the end all turned out well; thirty-five years after the completion of the fort, a hospital was authorized.

A narrow strip of sand was all that separated Fort Hamilton on the southeast from the Atlantic Ocean. The strip bore a name that would one day be a by-word: Coney Island.

The comprehensive view of the fort, and of the sailing vessels and side-wheelers coursing through the Narrows, includes also a bulky diamond-shaped building—an island, in fact—adajacent to Fort Hamilton. The two-acre island, about two hundred yards off shore, was ceded to the United States by the New York state legislature in 1807, and a fort was built on it. Completed in 1822, it was first called Fort Diamond and, later, Fort Lafayette. During the Civil War it was used to confine hundreds of prisoners; afterwards the Navy Department stored ammunition there.

The lithographed title page of the polka redowa (which was a dance imported from central Europe) bears no maker's imprint, but it appears to be the work of the same George Lewis who was responsible for the Castle Garden cover.

FORT HAMILTON POLKA REDOWA.

New York, Published by Jaques & Brother, 385 Broadway.

The boy was sixteen when he left his homestead in Vermont and took a position as an office assistant in the Lafayette Hotel in Boston. The Lafayette was the headquarters for several stage lines, and Alvin Adams soon developed a fondness for the horses and a familiarity with the transportation business. But like so many young men he drifted into other fields; and it was not until he was thirty-six years old that he launched the delivery business that made his fortune. His initial investment, back in 1840, was one hundred dollars; when the business incorporated in 1854 it was capitalized at over a million dollars.

The road to riches was a bumpy one. For many months, Adams operated with a staff of one; namely, Adams. Somewhat like the combination of judge and jury that Fury arrogated to himself in *Alice in Wonderland*, Adams assumed the positions of receiving clerk, cashier, messenger, and deliveryman, handling all sorts of small packages for destinations in eastern Massachusetts. After a year he ventured an extension of his business as far south as New York City, where he opened a tiny office in a basement near Wall Street, with a young manager named William Dinsmore. Often the parcels handled in the New York office were trundled to their destination by wheelbarrow, with Dinsmore at the "controls." For his diligence, he was made a partner in 1842, thus marking the beginning of Adams and Company.

In 1843 Adams took over an express company that operated between Philadelphia and Washington. One of the officials was Edward S. Sanford, who aligned himself with Adams and continued the affiliation for several decades.

By 1850 the Philadelphia office, under Sanford's management, had become so lucrative that the company was able to erect a handsome five-story office building on Chestnut Street, between First and Second, where their biggest customer was the United States Mint. Adams's shining dark green wagons—which were as familiar to the populace as the Brill trolley cars would be half a century later—and the robust well-groomed horses were objects of favorable comment wherever they appeared.

Such an impressive building and such attractive equine equipment afforded an opportunity for a popular composer, Francis Weiland, to produce, in 1852, "Adams and Co.'s Express Polka," dedicated, of course, to Adams and Company.

For ten years prior to the publication of this composition Weiland had been a music teacher in Philadelphia. He had been variously listed in the city directory as "musician," "music teacher," or simply "teacher." Apparently, around 1862, he left his profession, for in that year the directory describes him as a "gentleman."

Thomas Sinclair, the great and prolific Philadelphia lithographer (see "The National Union"), has portrayed in detail the exterior of Adams and Company's impressive establishment. Under the huge lettering above the door appears a somewhat more modest sign that reads, "Edward S. Sanford & Co.'s Foreign Express." In the foreground a trim wagon labeled "California Express" is being propelled by a sleek trotter—incidentally, headed west.

Time has taken its toll. For almost three-quarters of a century the Adams Express Company was a leader in its field and a consistent moneymaker; its wagons were superceded by hundreds of railway express cars that transported merchandise on all the great rail lines of the United States. When America entered World War I, the government assumed control of the

railroads and used the express cars to transport troops and equipment. Adams Express had enormous losses, from which it never recovered.

The name *Adams* lives on, in an investment trust; but there are no more green wagons, no handsome horses, not even any railroad express cars. How sad for sentimentalists—unless they happen to own stock in the modern Adams Express Company.

THE ONONDAGA POLKA 1852

The Iroquois, who roamed and hunted in the northeastern United States and Canada from the sixteenth to the nineteenth centuries, were a proud people. Six nations claimed unity as brothers of Iroquoian stock. Among the six were the Onondagas, who for a long time lived in upper New York State, between Lake Ontario and the headwaters of the Susquehanna River. Like each of their brother nations, the Onondagas were subdivided into tribes symbolized by an animal indigenous to the region. The most famous member of the Turtle tribe, in the 1830s and 1840s, was the Head Chief of the Onondagas, Ossahinta. Chiefs frequently adopted American names for use among the friendly white men. There was a Captain Joseph (Ka-ha-yent), a Captain Cold (Ut-ha-wah), a Captain Honnos (Oh-he-nu). Ossahinta was popularly known as Captain Frost.

As a young warrior Ossahinta had been selected by the sachems of his nation to serve as a runner, which meant that his was the responsibility to bear messages of importance from one chief to another. This post required him to understand perfectly the matter with which he was entrusted and to be able clearly to narrate the information to be transmitted.

So ably did Ossahinta carry out his assignments, and so much confidence and esteem did he engender, that his countrymen came to rely more and more heavily upon his judgments. In addition, he became thoroughly versed in the history and in the tribal and religious ceremonies of the Iroquois people. In fact, in his lifetime he was believed to be the only person who perfectly understood the peculiar forms of organization of the general councils of the Six Nations and the practices of all their rites.

Ossahinta presided over the councils of the Onondaga for more than fifteen years. He was an eloquent orator and, even more important, a man of unimpeachable integrity and sound judgment, and he could completely master any subject put before him. Moreover, he was a man of peace. When shrill war-whoops sounded through the hills and valleys of his domain, he acted quickly to suppress these disquieting omens of impending warfare, and he was markedly successful in preventing rapine and bloodshed.

Another of Captain Frost's virtues, one unusual for a man in his position, was his strict temperance. He frequently mourned over the degradation and misery of Indians who were tempted by the palefaces' "fire water." Over and over he admonished his people to leave whiskey to the white man, and he often made eloquent appeals in the national councils, imploring his people to avoid temptations the white men held out to them. His dignity, his sincerity, and his native grace were powerful factors in maintaining the peace and order that characterized his reign.

Shortly before Ossahinta died, in 1846 at the age of eighty-five, he was persuaded to sit for a portrait by a Syracuse artist. He was dressed and decorated as he appeared on state occasions, and this portrait captured the serenity of his countenance and the dignity of his bearing. A few years later, a reproduction of this work was used by Napoleon Sarony and Henry B. Major, New York's successful lithographers, as a title page for "The Onondaga Polka," a spirited dance composed by J. S. Jacobus.

TO

MISS. M. E. CUDDEBACK,

OS-SA-HIN-TA.
CAPTAIN FROST.
HEAD CHIEF OF THE ONONDAGAS.

THE
ONONDAGA POLKA,
COMPOSED BY
J. S. Jacobus

LITH. OF SARONY & MAJOR, N.Y. 25 Cts Nett.

NEW YORK.
PUBLISHED BY FIRTH, POND & Cº 1, FRANKLIN SQ.

SYRACUSE, T. HOUGH. ROCHESTER, GEO. DUTTON Jr

Sarony and Major are referred to elsewhere in this book ("Song of the Graduates," "The Ithaca March"), so their accomplishments need not be elaborated on here.

Wearing his tribal crown, surmounted by a feathery spray, and with the sash of office draped across his chest and his tomahawk in hand, Ossahinta, Head Chief of the Onondagas, bears in his clear eyes and strong features an appearance not unlike a dark-hued Abraham Lincoln.

THE AGE OF GOLD

CA. 1853

It was only natural that in the mid-nineteenth century a number of popular songwriters would capitalize on the excitement that focused the world's attention on California. There could be no richer subject than gold, and so gold fever became, to a lesser degree, song fever, too.

There was "California; or, The Feast of Gold"; "The Dying Californian"; "The California Pioneers"—which was, incidentally, the first song published (in 1852) in the great new state. And there were more.

One of the cleverest of these ballads, entitled "The Age of Gold—Directions How To Get It," was published in Philadelphia about 1853. In it, the lyricist adopted the art of punning, which was highly thought of in that period, and recounted his "directions" with word-twisting dexterity:

The precious metal's precious soft, tis easy work to MELT it,
By HUNTING soon they SCENT it out, and after that they SMELT it,
This is the land of LIBERTY—no POOR'S RATES nor no TAXING,
With only shovel or PICK-AXE, we pick it without AXING.

.

So PEACE and PLENTY's come at last, no need is there for pelf now,
There's PLENTY if you send your friends, and a "Long Piece"
 for yourself now.

.

So if you wish to come by land, by rivers or by fountains,
You'll find your way by MOUNTING ROCKS across the ROCKY
 MOUNTAINS, . . .

And so on, and so on, for seven verses of plays on words. T. R. Pearce wrote the song, and, as you may have noticed, he was a master punster.

The unusual title page, which depicts prospective miners scrambling over the mountains on their way to seek fortunes, while others are already panning and sluicing as they gather the precious metal, is one of the most amusing of the many covers by Peter S. Duval of Philadelphia.

Duval's artist was a Philadelphia drawing master and music instructor, Matthew S. Schmitz, whose work occasionally appeared on title pages, usually depicting his subject matter in a serious, rather than a comical, vein. It must have been Schmitz himself who decided to add a touch of whimsy by quoting on the cover a phrase of Shakespeare's: "Put money in thy purse."

"The Age of Gold" was introduced by George W. Lee and Julius Walker at the beginning of a career that established them as Philadelphia's leading music publishers for over twenty-five years. During that time they employed Philadelphia's finest lithographers and draftsmen to illustrate their output; yet none displayed more whimsy than did their first artist, Matthew Schmitz.

"Put money in thy Purse" Shak?

PHILADELPHIA, LEE & WALKER, 162 CHESNUT ST. SUCCr. TO GEO. WILLIG,

NEW-YORK, Wm HALL & SON. St LOUIS, BALMER & WEBER. NEW-ORLEANS, Wm T. MAYO.

In the 1850s the smart retail shopping center of New York was on Broadway, in the area of Canal Street. One of the finest firms of importers, Carroll and Hutchinson, operated a spacious shop wherein were displayed imports and "fancy goods," which included rich fabrics, fine china, and works of art.

The store, called the Belgian Gallery, was located at 547 Broadway between Spring and Prince Streets. It catered principally to members of the more affluent community, who were attracted by, and who could buy, the costly wares offered for sale.

In 1853 Harvey B. Dodworth, the well-known composer, bandmaster, and publisher, wrote and published the "Belgian Gallery Polka," a sprightly dance that could start anybody's feet in motion.

The polka bore a lithographed title page by Otto Boetticher, designed to show the interior of the attractive gallery, its shelves and cases filled with enticing wares. Well-groomed salesmen waited on stylish customers, while other potential buyers admired the exhibits. Top-hatted gentlemen and bonneted ladies strolled from one well-lighted room to another, pausing to admire vases or ornate marble columns.

Boetticher's career was not confined to lithography. Born around 1816, probably in Prussia, he served in the Prussian army before coming to America about 1850. Working from a studio in New York, he produced lithographs of military subjects, specializing in scenes centering around the National Guard regiments. At the outbreak of the Civil War he volunteered for service with the Sixty-eighth New York Volunteers, with whom he served as an officer until his capture by the enemy in March, 1862, and subsequent imprisonment in Salisbury, North Carolina. There he spent much of his time sketching; his best-known drawing is of a baseball game played by the prisoners.

When Boetticher was released from prison in 1865 he was brevetted lieutenant colonel, "for gallant and meritorious conduct." Then he seems to have disappeared in thin air, for nothing further is known about him. He certainly did not return to his old career as artist and lithographer; no postwar work has ever been discovered.

BELGIAN GALLERY POLKA,

Interior of the Belgian Gallery, 547 Broadway.

Lith. of Otto Boetticher, 397 Broadway.

BY

HARVEY B. DODWORTH.

NEW YORK, PUBLISHED BY H. B. DODWORTH & CO. 493, BROADWAY,
W^M HALL & SON, 239, BROADWAY.

Entered according to det of Congress in the Year 1853 by H.B.Dodworth & C^o in the Clerks Office in the District Court of the Southern District of N.Y.

25 Cts. nett.

C. L. Stancliff and Frank W. Vogdes were highly respected Louisville architects, citizens of substance in their community. In 1853 Mr. Vogdes held the position of recording secretary of the Kentucky Mechanics' Institute, and in 1854, when he was reelected to that post, Mr. Stancliff was elected its president. The institute had ample justification for so rewarding the two gentlemen; without them, it would not have had its handsome new exhibition building.

The Kentucky Mechanics' Institute was founded by some sixty men in March, 1853, to band together a number of industrial associations, according to the catalog of the first exhibition, "for the promotion and protection of manufacturers and the mechanic arts." Within two months the founders had decided to hold an autumn exhibition, displaying a full complement of the products manufactured in the state.

Some doubt existed as to whether Kentucky businessmen would enter such an exhibition without the inducement of material awards for the outstanding examples in various classes. However, after much soul-searching, it was determined that the only prizes to be given would be "diplomas" of first, second, and third class, designated by disinterested, impartial judges.

The success of the venture exceeded the fondest hopes of the sponsors. Over three hundred manufactured or specially designed items were submitted, including steam whistles, centrifugal pumps, self-shutting farm gates, sod and stubble plows, adamantine candles, and lard oil.

Among the first-prize winners were the manufacturers of a lemon cordial, of special coils of rope, of male wigs and curls, and of pork barrels.

So pleased were the entrepreneurs who had promoted the great display of their state's varied products that they determined to abandon the quarters they had rented—the second story of the Farmers' Tobacco Warehouse—and erect a building that might serve them permanently. This was exactly what Messrs. Stancliff and Vogdes had had in mind all along. In fact, before the first exhibition ever took place, the architectural firm had drawn up plans for the new exhibition hall.

The word had apparently spread during the fall of 1853 and a Louisvillian named Otto Ruppius was inspired to write a musical composition entitled the "Kentucky Mechanics Institute Polka." The sheet music was adorned with a title page displaying, nearly a year before the dream became a reality, the handsome hall-to-be, located at Second and Walnut streets.

The cover portrays stylishly dressed ladies and gentlemen promenading before the building or clustering in the doorway. A credit line indicates that Stancliff and Vogdes served as the hall's superintendents as well as its architects.

The lithographers of the title page were Robyn and Company of Louisville. The Robyn brothers, Edward and Charles, had emigrated from Emmerich in Prussia in 1848 and had lived and worked for two years in Philadelphia before moving to St. Louis, where they ran a successful lithographic business until the late 1850s. Apparently they set up a branch office in Louisville, for there they designed covers for sheet music, and probably other lithographic material as well.

THE EXHIBITION BUILDING

KENTUCKY MECHANICS INSTITUTE POLKA,

COMPOSED BY

OTTO RUPPIUS,

LOUISVILLE KY., G.W. BRAINARD & CO. 109 FOURTH ST.

25 ¢ nett

Boston has always been a city proud of its heritage, and with reason. The Revolution could not have been spawned without the great New England statesmen. New England educators were pioneers in the fields of American learning, and Boston's musical culture was foremost in the New World.

In 1851, at an annual dinner of the Harvard Musical Association, an informal supper-table conversation resulted in the appointment of a committee to consider the erection of a great new concert hall. Subsequently, a site and an architect were chosen, and a campaign to sell stock in the project was instituted. The location selected was a plot that afforded entrances on Hamilton Place and Central Court, between Tremont and Winter Streets. Within sixty days $100,000 had been subscribed.

The architect, George Snell, was instructed to design a building "grand in its proportions, chaste and noble in style." The result was an elegant edifice, 130 feet long, 78 feet wide, and 65 feet high, which accommodated nearly 2,600 people. Two galleries, one to the side and to the rear, rose above the main auditorium. Beneath the large hall was a smaller one, used principally for rehearsals. The enthusiastic description, when the Concert Hall "opened for business" in November, 1852, noted that "the seats are stuffed with backs and arm rests . . . each seat being numbered on the top of the back by the insertion of a piece of ivory with a black figure. The interior is brilliantly lighted by a flood of gas. . . . And the effect upon the audience is really remarkable" ("Old Boston," p. 40).

The opening concert was Boston's greatest musical experience up to that time. A capacity crowd filled the handsome auditorium and listened with delight to the Musical Fund Society's performance of Mozart and Beethoven and to the Handel and Haydn Society's rendition of Handel's *Hallelujah Chorus*.

And this was only a beginning. For over thirty years the hall was the scene of Boston's most important musical events. Boston audiences were treated to the music of Donizetti and Rossini, to appearances by the great violinist Ole Bull and the world-famous pianist Anton Rubinstein, and to Jenny Lind, the "Swedish Nightingale," at whose performance one frenzied spectator paid $650 for a choice seat.

The great hall proved useful for nonmusical events as well. Wendell Phillips, the famous abolitionist, used the hall to speak on the cause of antislavery and would have been mobbed had the mayor of Boston not stationed a special guard nearby. Baby, dog, and poultry shows and boxing and wrestling matches were staged there, as were political conventions. When William Jennings Bryan addressed the Democratic state convention in 1896, one member of the opposing faction lost his life when he tried to enter the hall through an upper window.

In 1853, the year after the hall had opened, the "Concert Quick Step" was composed by George W. Lyon and published by Henry Tolman of Boston. The front cover depicts the imposing interior of the great new music hall, as viewed from the gallery to the rear.

The Boston firm of Harvey Upham and Charles H. Colburn were the lithographers of the sepia-tinted title page. The pair stayed together only briefly before going their separate ways.

Although no artist's name appears on the cover, this is probably the work of Marshall M. Jidd—thought to be English by birth—who accepted assignments from Upham and Colburn and who shared their premises on Cornhill Court. A master of perspective, he enables the viewer to appreciate the awesome size of the historic hall.

TO
Mrs. B. M. W. Lyon.

Interior of the New Music Hall. *Lith of Upham & Colburn & Cornhill Court.*

THE
CONCERT QUICK STEP.

COMPOSED FOR THE
PIANO
BY
GEO. W. LYON.

25 cts nett

BOSTON
PUBLISHED BY HENRY TOLMAN
Importer of Musical Merchandise, 153 Washington St. opposite the old South Church.
WM. HALL & SON
New York.

SUN QUICK STEP

The progenitor of the modern skyscraper was a five-story building that housed a Baltimore newspaper. Its unique construction—unique, that was, for 1851—was born in the mind of an eccentric genius from Catskill, New York, by the name of James Bogardus.

Bogardus, originally a watchmaker, was forever inventing things. He introduced improvements in cotton-spinning machinery and grist mills. He sold the British government a new process for manufacturing bank notes and postage stamps, and he invented a pyrometer, a dynamometer, rubber-cutting and deep-sea-sounding machines, and other assorted and impressive apparatus. And he devised a new method of factory construction, which he tried unsuccessfully to sell to the builders of New York City.

His idea, which appears simple today, was startling a hundred and twenty-five years ago. Bogardus merely wanted to distribute the weight of a building, not on the masonry wall, but on cast-iron columns supported by heavy foundations whose base was embedded in the earth. The iron frame, then, became the skeleton around which the body of the building was constructed; the walls served to make the edifice watertight.

In the late 1840s the Baltimore *Sun* had outgrown its quarters, and the management sought a new location. Bogardus, who had been unable to project his radical construction projects in New York, found that his ideas made sense to Arunah S. Abell, the forty-five-year-old proprietor of the *Sun*. The newspaper had started as a four-page tabloid, selling for one cent, in 1837. At the end of its first year it had a circulation of 12,000, but in ten years' time the distribution had jumped to nearly three times that figure. Abell was confident that the new "Sun Iron Building," five stories high, with a fifty-six-foot front and seventy-four-foot depth, would be big enough to care for the paper's growing needs; and so it was, until 1904, when the disastrous Baltimore fire destroyed the venerable structure along with the bulk of the business section of the city.

The score of columns, reaching from the second floor to the roof, were ornamented with elaborate designs and flourishes. Cast in the foundry of Benjamin S. Benson of Baltimore, they even included full-length figures of George Washington, Thomas Jefferson, and Benjamin Franklin. The world's first iron building was an impressive edifice.

In 1854 the "Sun Quick Step" was composed by Albert Holland and "Dedicated to the Readers of the Baltimore *Sun*." Illustrating the music sheet is a handsome picture of the great Iron Building, with an American flag flying from the roof, and with stately passers-by, including a gentleman wearing a high silk hat astride a gray horse.

The lithographers of the "Sun Quick Step" were A. Hoen and Company of Baltimore, leaders in their field since the 1830s, when Edward Weber, the uncle of the Hoens, established the business that would bear the Hoen name for over a century. Weber, like his nephews, was a native of Germany. All were skilled artisans, whose work bore favorable comparison with that of their great New York contemporaries, the Endicotts.

Holland, the composer, a native Baltimorean, wrote the "Sun Quick Step" while still in his twenties. He was a gifted teacher, a flutist, and the leader of the "Independent Blues Band," a popular Baltimore group that entertained at schools and public gatherings. He wrote dozens of marches and dance tunes before his death in 1887.

Sun Quick Step.

DEDICATED TO THE READERS OF THE

BALTIMORE SUN

BY

Albert Holland.

BELL POLKA

The subtitle of this spirited work by W. Buchheister is "Remembrance of the Germania Musical Society." Even without the "Bell Polka," the Germanians would long be remembered.

At the time of the revolution of 1848, many young Germans left home for greener pastures elsewhere. Among them were twenty-five dedicated young musicians who together had acquired a reputation as a competent orchestra. They descended on our shores in order, as they put it, "to further in the hearts of this politically free people the love of the fine art of music through performance of masterpieces of the greatest German composers" (H. E. Johnson, 1953).

And they achieved their goal. First in the great cities of the East and then in the growing communities of the West, they introduced the public to a quality of orchestration that had never before been heard in the United States. For six years they maintained their well-deserved popularity. Over nine hundred concerts were performed, attended by over a million Americans. A few listeners found the sounds somewhat difficult to comprehend. After a rendition of Beethoven's Second Symphony in St. Louis, one woman in the audience was heard to remark, "Well, ain't that funny music?"

The orchestra members were indeed idealists. One for All, and All for One was their motto: and they pledged that no member should seek personal or financial advantage over the others. The welfare of the society was each man's holiest duty.

The individuals on the composite portrait have been identified, and they include some who later, after the group finally dissolved, made names for themselves as concert artists.

Carl Bergmann, the conductor, who sits in the center of his orchestra, was so gifted that when the Germanians eventually disbanded he became conductor of the Philharmonic Society in New York.

Carl Zerrah, flutist, the gentleman at the far left, settled in Boston, where he became an influential musician. From 1854 to 1895 he conducted the famous Handel and Haydn Society, probably the finest choral group ever assembled in the United States to that time.

Mr. Buchheister, composer of the "Bell Polka," a viola player, and Mr. E. Stein, a violinist, decided to make their home in Detroit after the dissolution of the Germanians. (On the title page, Buchheister, a little man with a big black mustache, may be seen somewhat to the left of the conductor: Stein is directly to the right of center, violin in hand). The pair opened a music store on Jefferson Avenue, where they sold Steinway pianos and other musical instruments, as well as sheet music. They did a bit of publishing, too; the "Bell Polka" bears their imprint. The firm carried on for eight years: then it was terminated by mutual consent and Stein returned to Germany.

The lithographers for the composite picture on the title page were the little-known firm of Burger and Schober, pioneers of that profession in Detroit. The invidual portraits were reproduced carefully from a photograph of the Germanians, those dedicated men who introduced the best European music to America.

POLKA.

REMEMBRANCE

OF THE

GERMANIA MUSICAL SOCIETY.

Dedicated to the Ladies of Detroit

by W. Buchheister

C.P. REED & CO BOSTON.

PUBLISHED BY STEIN & BUCHHEISTER 188 JEFFERSON AVENUE, DETROIT MICH.

Entered according to act of Congress A.D. 1853 by Stein & Buchheister in the Clerks Office of the U.S. District Court for the District of Michigan.

25 ¢ nett

CITY MUSEUM POLKA

An up-to-date city like Philadelphia in the 1850s had to cater to the interests of the inhabitants and its visitors. Houses of worship in a godly city, with the spirit of William Penn hovering over it, were all very well; but a man had to have some amusement occasionally.

And so it came about that in 1854 the decision was made to eliminate an old church and replace it with a new museum. A gentleman named John Ashton organized a company to give the *coup de grace* to the Second Universalist Church building on Callowhill Street, between Fourth and Fifth; they proceeded to tear out the church's interior and redesign the entire structure.

On September 11, 1854, the City Museum was formally opened, to the delight of many in the community. On the first floor were displays of curiosities in natural history and science, as well as pictures of animals and portraits of prominent men in the fields of education and the arts. The second floor was fitted up as a theater.

The establishment was considered quite handsome; everything in the theater catered to an intelligent audience. At the opening ceremony, after a prominent Philadelphian had made an inaugural address, there was a dramatic presentation of Shakespeare's *As You Like It*, followed by a now-forgotten farce, *Sketches in India*.

When the drop curtain was lowered, it was seen to represent a framed view of Fairmount, the former estate of Robert Morris, which later formed the nucleus of Fairmount Park. Around the frame were likenesses of American actors and actresses by the well-known portrait painter Peter Grain, Jr.

The building's exterior was a real eye catcher, with paintings of exotic beasts serving as a giant frieze atop the two-story structure.

As happened so frequently in the mid-nineteenth century, the completion or dedication of a new building like the City Museum inspired a piano composition in honor of the event. In this instance, the composer was a music teacher named Adolph Scherzer, who dedicated the "City Museum Polka" to "his diligent pupil Miss Louisa Osheimer."

Rudolph Wittig, publisher of the music, enhanced its appearance with a handsome title page lithographed by the skillful and prolific Thomas Sinclair. One of the comparatively few immigrant lithographers who did *not* hail from Germany, Sinclair was a native of the Orkney Islands, who learned his trade in Edinburgh before settling in America around 1830. For most of his life thereafter he resided in Philadelphia, where he was one of the city's leading lithographers, winning a number of prizes at the Franklin Institute for his superior skills. He is perhaps best known for his many plates depicting male fashions of the period.

Sinclair's artist for the "City Museum Polka" was Peter Kramer, a German who came to the United States in 1848 and spent ten years in Philadelphia before returning to his native country and setting up his own business in Stuttgart. Then, a bit too sure of himself, he printed a caricature of the King of Bavaria which so enraged the monarch that Kramer was exiled. Back he came to America, establishing a studio in New York which he maintained until his death in 1907.

A fastidious artist with an eye for detail, Kramer's striking cover of the City Museum is one of the handsomest of music sheets. At least one copy has long outlived the museum, which was never more than moderately successful. After several ups and downs, its problems were resolved by a disastrous fire in 1868; the final curtain was drawn, and a colorful enterprise faded into history.

CITY MUSEUM POLKA

Composed for the
Piano Forte
AND DEDICATED TO
HIS DILIGENT PUPIL
Miss LOUISA OSHEIMER
BY
ADOLPH SCHERZER

Philadª R. WITTIG Nº 148 Arch St. Piano Ware Rooms.

Entered, according to act of Congress in the year 1854 by G. Vogt in the Clerks Office of the eastern District court of Pa

T. Sinclair's Lith.

In the mid-nineteenth century the river boats were an essential part of America's transportation system. From New Orleans to Memphis to St. Louis to Pittsburgh, and from Pittsburgh back to New Orleans, with many stops en route, the big boats plying the Mississippi and the Ohio loaded and unloaded huge cargoes destined for ports along the way, and with them a stream of passengers for whom transport by water was their only means of reaching their destinations.

What a beauty she was—a queen of the river-boat traffic. And how proud was her captain and owner, Joseph Brown, under whose personal direction the *Mayflower* was built in Pittsburgh in 1855 and who assumed command of the great sidewheeler after her machinery was installed in St. Louis.

When the *Mayflower* began her runs down the Mississippi she was saluted with a piano composition, "The May-Flower Schottisch," produced by C. Muller, a German musician who had settled in St. Louis, and published by William W. Wakelam, also of St. Louis. Muller had written other instrumental pieces over a twenty-year span and later wrote other music with themes built around St. Louis landmarks. Wakelam was primarily a piano dealer and so advertised his activities; his announcements mentioned the music publishing business almost casually. Nevertheless, the music sheets that were issued over his name were of a high order, and he was able to secure the finest lithography firms in America to design his title pages. The cover for "The May-Flower Schottisch," executed by Sarony of New York, shows the steamer to the greatest advantage, with the ornamental rails protecting the passengers on each of the three decks, the great stacks belching smoke, the huge casing hiding the giant paddle-wheel, and the delicate pennant streaming from her bow. None dreamed at that happy time that her life would be cut short.

On December 3, 1855, a few months after her first trip down the river, the *Mayflower* was wharfed at Memphis alongside two smaller vessels, the cotton-packet *George Collier* and the new wharf-boat *Mary Hunt*. The *Collier* had come in to port shortly after midnight, and was apparently afire near her forward lockers when she approached the landing. The flames could not be contained; spreading rapidly, they soon caught up with the *Mayflower*. The Memphis *Daily Appeal* of December 4 reported that "in a few moments this palace of beauty and magnificence was one broad sheet of flame. . . . Capt. Brown, lady and child, had but time to escape in their night clothes. The assistant bar-keeper . . . and a friend of his . . . are among the missing. . . . As beautiful a boat as ever moved the waters, giving character and life to our trade, was in ten minutes made a blackened and worthless ruin."

The *Mary Hunt*, spacious and new, had been the largest wharf-boat on the Mississippi and Ohio Rivers. Her destruction was complete.

The loss of the *Mayflower* was a sad blow to her rugged Scottish-born owner, but he was not a man to surrender to discouragement. Joseph Brown had come to St. Louis as a young boy and had, after a few years, established a prosperous business in Alton, across the river. When his fellow citizens recognized his ability by electing him mayor, he fought to make Alton a terminus for the Chicago and Alton Railroad. Having succeeded in

Respectfully dedicated to Mrs Captn Joseph Brown, by the Publisher

THE MAY-FLOWER SCHOTTISCH.

COMPOSED BY

C. MULLER.

ST LOUIS.

PUBLISHED BY Wm W. WAKELAM, 129 FOURTH STREET CORNER OF LOCUST

that purpose, he entered the steamboat business and was for many years a leader in the promotion of river traffic on both the Mississippi and the Missouri rivers.

After the burning of the *Mayflower*, Brown directed the construction of other fine boats which he then commanded. Eventually he made his home in St. Louis, becoming mayor in 1875 and serving the city well.

BARNUM'S NATIONAL POULTRY SHOW POLKA

Phineas Taylor Barnum was probably the greatest showman the world has ever known. Firm in his conviction that "there's a sucker born every minute," P. T. seduced the public with exhibits of freaks and assorted oddities. However, he was eager to sponsor world-famous artists and to cater to the American public's taste for wholesome pleasure. He had a remedy for everyone's need for entertainment.

Barnum embarked on his chosen career in 1838 at the age of twenty-five, with the presentation of a black woman who he claimed had been George Washington's nurse and who had now attained the age of one hundred and sixty-one. He followed up this extraordinary hoax by an arrangement with a small traveling circus whereby he was assured a small percentage of the profits—if there were any.

In 1841, with an abundance of gall that overcompensated for his weak financial situation, he was able to acquire the American Museum, at the corner of Broadway and Ann Streets in New York, opposite the Astor Hotel. With it came a variety of exhibits, mostly strange objects from foreign lands, collected over the years by the previous owners. With these as a nucleus Barnum began to seek a steady flow of paying customers by adding new wonders to the old stand-bys. Some of the additions were patently fakes—a "genuine" mermaid, an "Ornithorhinchus" from the East Indies (half seal, half duck), a paddle-tail snake from South America, and other weird creatures ("tickets of admission 25 cents each.")

The year after Barnum's American Museum had been launched, its owner was able to consummate one of his most startling deals. He came across a tiny five-year-old boy in Bridgeport, Connecticut, a good-looking dwarf named Charles S. Stratton (see "The Fairy Bride Polka"). Barnum induced the lad's parents to allow their son to be exhibited along with the showman's real and pseudowonders and to be billed as General Tom Thumb. The public went wild over the youngster, who was Barnum's greatest drawing card for more than half a dozen years but was ousted from the number one spot in 1850 when P. T. arranged to bring the great Swedish coloratura Jenny Lind to America. Lind's voice and Barnum's promotional genius made for an unbeatable combination. Lind gave ninety-three concerts in America; they grossed nearly three-quarters of a million dollars.

On the less spectacular side, Barnum arranged "shows" for the general public, baby shows, dog shows, poultry shows, flower shows. Prizes—medals, money, diplomas—were given to the winning entrants. The publicity attendant on these shows was extensive, making them tremendously popular and financially productive.

A man like Barnum was a natural subject for the writers of popular music. They wrote about Barnum and Lind, Barnum and Tom Thumb, Barnum and his shows, Barnum and his wild animals.

NATIONAL P. BARNUM'S POULTRY SHOW POLKA

SARONY & CO. LITH. N.Y.

COMPOSED BY

FRANCIS H. BROWN

50 Cts nett.

Published by BERRY & GORDON 297 Broadway.

NEW YORK

PHILADELPHIA, JOHN E. GOULD.

NEW ORLEANS, H. D. HEWITT.

WILLIAM DRESSLER.

BOSTON, OLIVER DITSON

CINCINNATI. CURTIS & TRUAX

One of New York's most prolific composers of popular marches, polkas, and schottisches was Francis H. Brown. Among Brown's compositions were "Barnum's Great Baby Show Polka" and "Barnum's National Poultry Show Polka." The latter, written in 1855, has a handsome title page with a portrait of the great showman, looking smug and prosperous, surrounded by a variety of fowl, from a handsomely tailed peacock to a Rhode Island Red cock and hen.

The lithographer was the great Napoleon Sarony (see "The Swedish Melodies"), who, in his heyday, might have come close to cornering the New York market had it not been for Currier and Ives.

Sarony came to New York from Quebec in 1846, at the age of fifteen, to study drawing. Ten years later he teamed up with Henry B. Major; the partnership continued for over twenty years, during which period a third associate, Joseph E. Knapp, joined the pair. The firm published under various titles—Sarony and Major; Sarony and Company; Sarony, Major, and Knapp. The "Poultry Show Polka" title page carries the imprint of Sarony and Company.

The cover is unsigned and is probably the work of Sarony himself.

FELIX QUICK STEP 1856

Felix was the first American race horse to "rate" a musical composition in his honor. In retrospect, it is difficult to ascertain how he came to inspire Albert Holland, a recognized composer and popular bandmaster, to make him the subject of a quick step. Felix was a dependable trotter, but not a world-beater. If he had raced against the famous Flora Temple, when both horses, under the ownership of Billy McDonald, were stablemates, he would have been left far behind.

But Felix was not obliged to face such a serious challenge. 2:41½ was his best time for a mile race "under saddle"—which means with a rider on his back, not racing before a sulky, as is done today. He achieved that record on November 1, 1854, when he defeated Kentucky Joe, a stallion, in three straight heats and brought his owner, James Ward of Baltimore, the winner's purse of $3,000.

Not long after that race Ward sold Felix to William McDonald, an enthusiastic Baltimore turfman. From his father, a colonel who had commanded a Maryland regiment at the battle of North Point in 1814, McDonald had inherited a handsome estate, Guilford, just outside the Baltimore city limits. Here he built a set of magnificent stalls, which Felix shared with Flora Temple. Over Flora's stall was a stained glass window bearing a portrait of the handsome mare and an inscription reading, "Flora Temple, Queen of the Turf."

Perhaps Felix shone by reflected glory. Flora had won her first race in 1850. Before her career on the track she used to pull a milk cart in Eaton, Madison County, New York. She was sold to a citizen of Albany, who disposed of her to a New York City man who started her on the road to success after hacking off her tail, which he felt was a burden to her. A few years later, Billy McDonald acquired her. By 1859, when she set a world's trotting record of 2:19¾ for the mile, she was a national idol. Babies were named after her; so were cigars and steamboats. Whiskey bottles and coins bore her image. Currier and Ives issued a dozen different prints of Flora Temple. Rumor had it that Stephen Foster wrote "Camptown Races" after he had placed a winning bet on her in a match race.

TO WILLIAM Mc DONALD ESQ.

Lith. by A. Hoen & Co. Balto

THE CELEBRATED TROTTING HORSE "FELIX" OWNED BY Wm Mc DONALD ESQ.

FELIX QUICK STEP

AS PERFORMED BY THE INDEPENDENT BLUES BAND

Composed by

ALBERT HOLLAND.

PUBLISHED BY HENRY Mc CAFFREY BALTIMORE.

But the great song never mentioned her by name; Foster wrote only of a "bob-tailed nag." And here Felix outdistanced Flora. Albert Holland had been a flutist of some prominence. But he had also tried his hand at piano compositions and was able to sell them to Baltimore music publishers. At times the pieces were deemed worthy of performances by a brass band. Holland, who succeeded James M. Deems as leader of the Independent Blues Band of Baltimore, scored the "Felix Quick Step" for brass band and wind instruments, and it was fitted into the repertoire of the Independent Blues.

The title page of the quick step was executed by A. Hoen and Company of Baltimore (see "Sun Quick Step"). The "celebrated trotting horse," as Felix is designated on the cover, stands calmly and with meditative eye—thinking of his next race, perhaps, or of the bag of oats that will be his when he returns to the stable.

The "Felix Quick Step," written in 1856, is dedicated to "William McDonald, Esqr." Billy McDonald was only in his twenties when his stable and Flora, its star occupant, were the talk of the country. In less than ten years he was dead. The date of Felix's death went unrecorded.

WATER WITCH SCHOTTISCHE 1855
AND FIREMAN'S SCHOTTISCH 1859

Down through the years, the American volunteer fireman has been a breed with a particular pride in his calling. Many fire companies in the last century were outfitted with special uniforms, not only for parades but for active duty as well.

However, the volunteers' greatest concern was for their firefighting equipment, on which they expended the most lavish care—and properly so, for the success of their operations depended on the efficiency of the fire engines and auxiliary vehicles.

From time to time music was written taking cognizance of outfits that boasted the latest and most splendiferous mechanical equipment. One such piece, the "Water Witch Schottische," composed by James M. Bradford and published in 1855, was dedicated to the Water Witch Engine Company No. 6, of Providence, Rhode Island.

Water Witch Engine No. 6 was purchased in 1834 from a New York firm named Smith, and for thirty years it enjoyed a useful career. At the outset the company had forty-six members, but twenty years later, when the schottische was written, the complement of members had diminished to twenty-one, despite the fact that in that year the city of Providence arranged to pay them for their services.

Frequently there was an exchange of courtesies between firemen of different cities, and one group would invite another to be its guests. This led, quite naturally, to the term *visiting firemen*. In 1851 Water Witch Company No. 6 extended such an invitation to the Humane Fire Engine Company of Philadelphia, recognized as the foremost firefighters of that city. When the Philadelphians arrived in Providence they were treated like royalty. The ceremonies opened with a grand parade, participated in by all the Providence companies, and concluded with a sumptuous dinner at the City Hotel. In a break from the festivities, all the guests attended services at Grace Church on Sunday morning.

Two years later Philadelphia played host to Providence. On that occasion a new uniform was designed for the captain of the Providence company. He wore a red flannel shirt; on its breast was a design symbolic of

Water Witch Schottisch

REGULATED BY BENEVOLENCE
IMPELLED BY EMULATION

DEDICATED TO THE WATER WITCH ENGINE CO. EX·SIXES PROVIDENCE, R. I.

BY

James M. Bradford.

S. W. Chandler & Bro. Lith. Bo

his company, with a ten dollar gold piece in the center. His white fireman's hat bore a silver "No. 6"; his white belt had a silver buckle, and he carried a solid silver trumpet. He was the fanciest gentleman in the parade.

In No. 6's engine house convivial meetings were held weekly. Clam chowder was featured; crackers, cheese, onions, and coffee were also available. The neighborhood always knew what was going on by the odor of onions.

The title page of the "Water Witch Schottische" displays the elaborately decorated engine attended by a pair of well-groomed firemen. A drape above the engine bears Company No. 6's motto: Actuated by Benevolence; Impelled by Emulation.

The lithograph is the work of S. W. Chandler and Brother of Boston. Samuel Chandler, a graduate of Harvard, was more than fifty years old when he first went into business with his brother as a lithographer. Their firm remained in existence for less than half a dozen years, but during that time they turned out exceptionally fine work, as the "Water Witch Schottische" demonstrates. A year after the sheet was published Chandler changed occupations, eventually winding up in Philadelphia as a junk dealer.

Another group of prominent firefighters in the 1850s was the Protector Fire Company No. 3 of North Bridgewater, Massachusetts. Like many other volunteer companies of the period, this outfit was dedicated to serving the community, and it guarded its "handtub" with loving care.

The sturdy "tub," or pumper, a suction fire engine, had been purchased for a thousand dollars from a Pawtucket, Rhode Island, manufacturer named Jeffers. It was designed to be pulled by teams of men and boys. The tub, when filled with water, weighed 3,750 pounds—a heavy load for the twenty strong males who assumed responsibility for its transport to fires. To produce a steady flow of water the men who activated the pump had to be in the best physical condition; it was a backbreaking job. Yet, according to reports, these firefighters were capable of projecting a stream of nearly two hundred and twenty-five feet.

The "Fireman's Schottisch," composed in 1859 by A. Reynolds, Jr., displays with feeling the excitement caused when Protector No. 3 was called on to battle a conflagration. The title page portrays scurrying firemen transporting their cherished handtub and spectators who want to be present for the action.

On top of the apparatus is a metal structure, used to pump water through the engine. Leather pails, used for priming the pump from time to time, are suspended on hooks, and lengths of leather hose, held together with rivets, wound around the axle of the rear wheels.

Three vignettes add interest to the music cover. One shows a fireman with a bugle, dashing from his home before sounding the alarm; a second portrays a uniformed member of the company with axe in hand. The handsome gentleman at the top of the page is undoubtedly Captain Henry B. Packard, the company commander.

The lithographer of the title page is the well-known John H. Bufford of Boston, who illustrated a number of other covers in this book.

Dedicated to the Protector Fire Company No. 3 of North Bridgewater Mass.

FIREMAN'S SCHOTTISCH.

COMPOSED BY

A. REYNOLDS JR.

ARRANGED FOR PIANO

BY

C. H. FAXON.

He was embroiled in the affairs of government from the age of twenty-one on. A resident of Greeneville, Tennessee, where he had settled when he was eighteen, his first elected position was that of alderman. The eighteen votes he received were barely sufficient to get him a place on the seven-man town council. Two years later he was chosen mayor of Greeneville, and by the time he was twenty-seven he had attained a seat in the state legislature. His next advance was to the state senate, from which he took aim at Washington. In 1843, when he was thirty-five, he found his mark, and was elected to the House of Representatives. A life-long Democrat, his outspoken advocacy of homesteading, the offer of free government land for free labor, and his courage in standing up for every issue to which his beliefs drew him, made Andrew Johnson a special target of the Whigs in the House.

By 1853 the Whigs, having taken complete control of the Tennessee legislature, set about gerrymandering districts in the state, so that Johnson found himself representing a district in which the Whigs had an overpowering majority. The handwriting was on the wall, or so it seemed. But Johnson was not discomfited. The governor of Tennessee, an outstanding Whig named William B. Canfield, decided not to run for reelection. The new Whig nominee, Gustavus A. Henry, was an old-time politician who many Democrats felt would be vulnerable if they could induce Andrew Johnson to accept the candidacy. A great squabble ensued before the Democrats could resolve their differences (as has happened so frequently over the last hundred years), but eventually the party united behind Johnson. In the ensuing election, Henry was defeated by three thousand votes.

Johnson's life story, from his modest start as a tailor's apprentice, to his impeachment as President of the United States, is familiar to any student of American history. It is not so well known that he was the subject of a number of pieces of popular music, some depicting him as a hero, others venting their spleen at his conduct.

In 1856, when Johnson was governor of his state, a Maryland composer and organist named Henry Schwing wrote a lively march entitled "The Wreath," which he dedicated to "His Excellency, Andrew Johnson, Gov. of Tenn." On the title page is a striking likeness of the fearless governor by Winslow Homer.

Homer, who grew up in Boston, exhibited an interest in art at an early age. Higher education had no appeal for him, so his father helped him to find a job. In 1855, in the "help wanted" section of a Boston paper, Mr. Homer spotted an advertisement, inserted by the lithographing firm of J. H. Bufford of Cambridge, seeking "a boy with a taste for drawing. No other wanted." As luck would have it, Winslow's father and Mr. Bufford were members of the same volunteer fire department. Undoubtedly that association helped young Homer land the apprenticeship, though to insure that his son would be taken on, it is reported that the elder Homer gave Bufford three hundred dollars.

Homer's superior talent was soon recognized, so while other apprentices were assigned routine tasks, Winslow was put to work drawing and designing. His first job required him to design the title pages for two songs that were to be published by the Oliver Ditson Company in Boston. The lithographs made a favorable impression on both Bufford and the publisher, and further calls for Homer's work followed.

TO HIS EXCELLENCY, ANDREW JOHNSON GOV. OF TENN.

THE WREATH

March for the Piano Forte.

Composed by

HENRY SCHWING.

BOSTON

Published by **OLIVER DITSON** 115 Washington St.

C.C.Clapp & Co. Boston S.T.Gordon New York J.E.Gould Philad. H.D.Hewitt N.Orleans D.A.Truax Cin.

J.H.Bufford's lith. Boston

Unfortunately, Homer resented working at Bufford's. He longed for more freedom in which to express the artistry he knew he possessed. During the two years of his apprenticeship he turned out not more than a dozen designs for music title pages, and when he had completed his stint in 1857 he made his way to Boston, never again to do any work for a lithographer.

Fortunately, a few copies of the Homer lithographs have been preserved. In the opinion of many critics, none is more impressive or better drawn than the fine likeness of Andrew Johnson, governor of Tennessee.

THE LEDGER POLKA 1857

Peter S. Duval, to whom references have already been made, managed, for the "Ledger Polka" title page, to invest the countenances of several well-groomed males with an air of incredulity. What in the world could cause these solid citizens to stand with mouths agape as they listen to one of their number read from the columns of the Philadelphia *Public Ledger*? The date of copyright of the "Ledger Polka" is given as 1857, a somewhat uninteresting year as far as American history is concerned.

The answer, though not immediately obvious, eventually emerges. The costumes of the gentlemen on the cover are a bit old-fashioned, even for 1857; they indicate, rather, the styles of the late 1840s. And though Beck and Lawton, Philadelphia music publishers, indicated that they had copyrighted the piece in 1857, it has been discovered that when they engaged in business they purchased the music plates of an earlier Philadelphia publishing house, Edward L. Walker, which they were free to use as they desired. Upon further investigation it was found that an earlier edition of the Ledger Polka had been issued by Walker—in 1849.

Suddenly the import of the story on the first page of the *Public Ledger* becomes apparent. Gold has been discovered in California. What a worldshaking announcement! Little wonder, then, to see the Philadelphians' expressions of amazement as they read the news in their morning paper.

Duval, the lithographer of the 1857 edition, used as his inspiration an earlier lithograph by Thomas Sinclair, who designed the title page for Walker in 1849. The Duval picture followed that of his predecessor closely and appears to be a slightly cleaner delineation than the 1849 original. (Sinclair, though, stood high in the ranks of his profession [see "The City Museum Polka"].)

James Bellak, who composed the "Ledger Polka," was born in Prague in 1814, and as a youthful immigrant to America found Philadelphia to his liking. There he settled as a dealer in musical wares. He has been classified as an "outstanding minor musician," whose services were in wide demand. Copies of his works, mainly piano solos and duets, bear the imprint of at least a dozen publishers. His arrangements were, for the most part, light and easy to handle for the run-of-the-mill female parlor pianist.

The *Public Ledger* was for many years ranked among America's most influential newspapers. Founded in 1836, it sold for a penny a copy and so relied for profits on its advertisers; but it tried to avoid eyebrow-raising advertisements such as other dailies were satisfied to accept. In its first year

THE LEDGER POLKA.

P.S. Duval & Son's Lith. Ph.

Dedicated

to the

READERS of the PUBLIC LEDGER Philad.ª

by

JAMES BELLAK.

Philadª Published by BECK & LAWTON, 166, Chesnut St Cor. 7th

Successors to J.E. GOULD

Boston, OLIVER DITSON & CO. New York, ST. GORDON. TRUAX & BALDWIN, Cincinnati.

of publication it announced: " . . . We do not hold ourselves responsible for any thing in our advertising columns . . . excepting what is forbidden by the laws of the land, or what, in the opinion of all, is offensive to decency and morals."

The owners of the paper held to their principles, including the selling price of one cent a copy. By the end of 1864 this bargain for its readers had cost the *Ledger* some $100,000, and the proprietors were forced to turn over their cherished offspring to a new owner, who immediately raised the price of the daily to two cents, thereby saving its life.

The *Ledger* made it on its own for another seventy years. It ceased publication in April, 1934, and the next day merged with the *Philadelphia Inquirer*. For ninety-eight years it had led an exemplary existence, a creditable representative of a sometimes unquakerish community: *Requiescat in pace*.

THE DRAMA MARCH 1857

When in 1857 Septimus Winner wrote a march that he dedicated to Edwin Forrest, Philadelphia's most popular composer was associating himself with America's most talented dramatic actor. Each had well-publicized successes to his credit: Winner had written the romantic "Listen to the Mocking Bird"; Forrest had played a galaxy of leading roles, in *The Gladiator, Metamora, Richelieu,* and *Jack Cade*, not to mention his portrayals of the great Shakespearean heroes Macbeth, Hamlet, Shylock, Lear, and Othello.

Edwin Forrest's first theatrical role fell to him in 1817, in his home town of Philadelphia, when, at the age of eleven, he volunteered to be cast as a female captive in a Turkish prison. It was an inauspicious start, but it provided the boy with determination to make the stage his profession. When he was sixteen he signed up with a traveling company that introduced Shakespeare and modern melodrama to the Middle West and the South. After a two-year stint that took him as far as New Orleans, Forrest returned home.

He made his New York debut at the age of twenty, playing the role of Othello in Shakespeare's tragedy. A leading critic of the day who saw the performance wrote, "He came—we saw—and he conquered!" When, a few months later, he appeared in the same part in New York's handsome new Bowery Theatre, the applause of the audience at the final curtain was so thunderous that the theater's stockholders called Forrest into their committee room and spontaneously granted him a raise in salary—from twenty-eight to forty dollars a week! So popular did he become, almost overnight, that within a year he was being paid two hundred dollars a performance.

Forrest, a devotee of physical culture, developed a Herculean body. He was five feet ten inches tall, and his muscular limbs and shoulders were spectacular. When the foremost actress of her time, Fanny Kemble, first saw him, she burst out, "What a mountain of a man!"

Forrest was also a health fanatic. Meats, fish, and fruits were not for him. He ate lightly before each performance, but when he returned to his hotel after the final curtain, he would gorge himself on cream or buttermilk and cold cornmeal mush, oatmeal, or brown bread.

THE

DRAMA MARCH

COMPOSED & RESPECTFULLY DEDICATED

TO

Edwin Forrest Esqr.

BY

SEP: WINNER

PHILADELPHIA

PUBLISHED BY LEE & WALKER 722 CHESNUT St

In 1828 Forrest offered a prize of five hundred dollars for the best American play with an Indian as the principal character. Fourteen would-be playwrights responded; he promoted similar contests for another seven years, withdrawing the restrictions respecting Indian heroes. He played the leading role in most of the prize-winning selections, which included *Metamora* by Augustus Stone, *The Gladiator* by Robert Montgomery Bird, and *Jack Cade* by Robert T. Conrad. These melodramas remained parts of Forrest's repertoire for years and years.

As long as he continued to grace the stage, he was, in the eyes of the public, head and shoulders above any other American tragedian. When Winner wrote his *Drama March*, Forrest had completed what he believed was his farewell engagement in New York.

Actually, Forrest continued to act for another fifteen years. He was enamored of his profession, and worked almost ceaselessly until his death in 1872.

"The Drama March" bears a title page with the portrait of Forrest executed in the crisp style that symbolized the lithography of Sarony, Major, and Knapp (see "The Ithaca March") of New York, and is embellished with a facsimile of Forrest's dashing signature.

KANE'S FUNERAL MARCH CA. 1857

Elisha Kent Kane died in Havana in 1857, at the age of thirty-six. A semi-invalid for the last half of his life, his amazing stamina impelled him to undertake expeditions from which most strong, healthy men would have recoiled.

Having studied medicine at the University of Pennsylvania, Kane was commissioned an officer in the U.S. Navy Medical Corps and was immediately thereafter assigned as medical officer to an embassy about to depart for China. Although any ocean breeze of more than five knots made him deathly sick, he became a confirmed sailor. He also had the impulses of a born explorer. The contingent bound for China stopped in many lands en route, and Kane was always off to the country's interior. In three years he saw an enormous part of the Orient. On his homeward trip he mountaineered in the Alps, the Himalayas, and the Andes. He was pulled from a volcano in Luzon; he ate locusts in Africa; he contracted bubonic plague in Alexandria.

For the most part, Kane was able to avoid the routine of the navy. However, he did see actual service on two voyages. On one he contracted yellow fever and was invalided home; on the other he had an attack of lockjaw.

But Kane's fame rests on his ability and intrepidity as an Arctic explorer. In 1850 he volunteered to join a United States naval force in a search for Sir John Franklin, a prominent English explorer, who, with his ships, had been missing in the Arctic for three years. The two American vessels, *Advance* and *Rescue*, with Kane as the party's surgeon, joined eight other English and French ships on the rescue mission. The concerted effort, which lasted many months, was unsuccessful, but it whetted Kane's appetite for further probes into the unknown Arctic regions.

In 1853, with private financial help, Kane undertook a second attempt to locate the Franklin party. Not until the fall of 1855 did Kane and his crew return, empty-handed once more, but having explored and mapped

KANE'S FUNERAL MARCH.

Composed and respectfully inscribed to the memory of

ELISHA KENT KANE, M.D., U.S.N.

BY

William H. Shuster.

Published by Wm H. Shuster, No 97 North 8th Street Phila

L. N. Rosenthal Lith. Phila

138

Northern Greenland and having opened the sea-lane, the so-called American route, which Commander Edwin Peary used to reach the North Pole in 1909.

Kane was now a national hero. He completed a fine book about his pioneering efforts. But his strength was waning fast, and even a desperate attempt to recover it in the dry climate of Cuba was of no avail.

"Kane's Funeral March," written and published by William H. Shuster, a musician in Kane's native Philadelphia, is unspectacular, but the title page bears a striking likeness of the young explorer. Drawn from a photograph, it is the work of John H. Sherwin, a lithographer and painter who was sufficiently talented to have his work exhibited at the Pennsylvania Academy in 1860.

The cover was lithographed by Louis N. Rosenthal, who came to Philadelphia from Poland about 1850, after having attended a rabbinical school in Berlin. Along with three brothers, he was an active lithographer, printer, and publisher, until 1875. In his later years he attained recognition as a miniaturist.

The Rosenthal family may be best remembered as pioneers in chromo-lithography—or color lithography—in America. During the Civil War Louis's brother Max sketched about one hundred and fifty views of camp life from which the Rosenthals later made prints, many of them hand-colored. The family's collective talents put them in the forefront of the innovative lithographers of their time.

WARREN GUARDS QUICK STEP AND REPUBLICAN BLUES MARCH 1860

The four smartly bedecked military men who posed for their group portrait in 1860 could hardly have been aware that in another year they would be engaged in the deadliest war their country had ever known. The identity of the sergeant, the corporal, and the two privates may forever remain a mystery, but there is much evidence that the Warren Guards, once they had been transferred into the armed forces of the Confederate States of America, on June 27, 1861, were a brave and active fighting force.

As part of Company F of the Twelfth North Carolina Infantry, they participated in a series of heavy engagements from the spring of 1862 until the end of the war. Their casualties were frightful—at Malvern Hill and Boonsboro in 1862, in the battles of Chancellorsville and Gettysburg in 1863, and in the Wilderness campaign and at Winchester in 1864.

In such a closely knit group, some of the losses were particularly heart-rending. Consider the fate of the three Allen brothers, Daniel, Hugh, and Turner. Turner was the first to die; he was killed at Malvern Hill. Hugh fell at Chancellorsville, and Daniel two months later at Gettysburg.

As the war neared its close in 1865 the guardsmen were battling in the trenches around Petersburg; and they were at Appomattox when General Lee surrendered there, ringing down the curtain on the devastating conflict.

Captain Benjamin O. Wade, to whom the quickstep is dedicated, led his outfit with daring and with skill. As a result he won one promotion after another, winding up as colonel of the Twelfth North Carolina Regiment.

Charles H. Kehr, a fellow guardsman, was not a professional musician, but he took pleasure in composing a lively tune in honor of Captain Wade and the members of his company.

The music was published by Henry McCaffrey of Baltimore, who produced hundreds of instrumental pieces before and during the period of the

WARREN GUARDS QUICK STEP.

COMPOSED AND RESPECTFULLY DEDICATED

CAPT. B. O. WADE

AND THE MEMBERS OF THE GUARDS

by

their Companion in Arms

CHARLES H. KEHR

of Warrenton N.C.

Lith by A.Hoen. & Co. Balto.

BALTIMORE,

PUBLISHED BY HENRY McCAFFREY NO. 207 BALTO. STREET.

WASHINGTON D. C. JOHN F. ELLIS.

war. The lithographer of the title page was the well-known Baltimore firm of A. Hoen and Company, who have been referred to earlier in this volume.

As for the Republican Blues, from Savannah, Georgia, their organization might seem like an anachronism in such a solidly Democratic community. Yet the name was chosen with care and deliberation; it indicated the enthusiasm of the young members of the outfit for the republican form of government. It had no political connotation at all.

The Republican Blues were organized in 1808, and the charter members chose blue as the color for their uniforms. As one of the oldest infantry units in Georgia, the Blues saw action as early as the War of 1812, and again in 1836–42 in the Seminole War in Florida. Several of its members reported for service in the Mexican War. In 1852 it combined with six other volunteer corps to form the Independent Volunteer Battalion of Savannah, which in 1856 became the First Regiment of Georgia Volunteers and as such fought in the Civil War.

In 1860 the Republican Blues visited New York City, where they were guests of the New York City Guard. Dressed in their best bibs and tuckers, the Blues made a striking appearance, as the lithographic cover of the "Republican Blues March," done by Sarony, Major, and Knapp of New York, makes clear.

The march was written by L. Louis, frequently referred to in Savannah newspapers as Professor Louis. News dispatches tell of his conducting at concerts, and refer to a farewell dancing soirée in 1866 at which his pupils presented a silver goblet to their departing leader.

The young military men who were the subject of the march continued as members of the National Guard of Georgia, which, in due course, participated in World War I as part of the Thirty-first Dixie Division. Their identity still preserved, they became, in 1921, part of the Headquarters Battery of the 118th Field Artillery. The uniforms then worn were a far cry from those of the gentlemen who sported their beautiful blue jackets and white trousers sixty years before.

These compositions followed a tradition, started twenty-five years earlier, of giving musical recognition to many state volunteer companies. Marches or quicksteps had been written in the 1830s honoring companies of militia in Pennsylvania and Massachusetts. These proliferated into a flood of military sheet music in New England and New York in the 1840s and 1850s. Volunteers in the Middle West and the far west, as well as those in the South, received musical tributes; marches were composed for military companies in Muscatine, Iowa, and Milwaukee; in St. Louis and Sacramento; in Cincinnati and Chicago.

The title pages of most of the music were illustrated with likenesses of the companies' leaders or sometimes with a large group of the men in formation. The Warren Guards were the only outfit from North Carolina and the Republican Blues the only volunteers from Georgia to earn such recognition.

REPUBLICAN BLUES MARCH

ENTERED ACCORDING TO ACT OF CONGRESS IN THE YEAR 1860 BY FIRTH, POND & CO. IN THE CLERKS OFFICE OF THE DISTRICT COURT OF THE SOUTHERN DIST. OF N.Y.

COMPOSED & RESPECTFULLY DEDICATED
TO THE
OFFICERS & MEMBERS
OF THE
REPUBLICAN BLUES
OF SAVANNAH, GEO.
BY
L. LOUIS.

LITH OF SARONY MAJOR & KNAPP 449 B'W? N.Y.

NEW YORK.
PUBLISHED BY FIRTH, POND & CO 547 BROADWAY.

LONG JOHN POLKA

The saga of the Chicago mayoralty is enlivened by a number of colorful encumbents. In this century Big Bill Thompson (who offered to punch King George of England in the nose) and Richard H. Daley, whose more-than-twenty-year ironfisted rule has set a longevity record, are names for the history books.

But it would be a pity if these books did not also pay special tribute to John Wentworth, who may well lay claim to being the biggest mayor who ever ran any city hall. Long John, as he was called, stood six feet seven inches tall in his stocking feet, and he weighed three hundred pounds. Elected mayor of Chicago in 1857, he served a term as representative of the Republican Fusion ticket. He took no salary, but declined a second term. The voters insisted on restoring him to office in 1860, at which time the "Long John Polka," dedicated to the mayor, was published.

On the stump, Long John had the reputation of being as blunt as a meat ax. Once when running for mayor he walked out of the courthouse to find an unruly, yelling crowd of men. Not bothering to remove his hat and regarding the men with scorn, he spat out the shortest stump speech that Illinoisans had ever heard: "You damn fools . . . you can either vote for me for mayor, or you can go to hell" (*DAB*, p. 658).

In his younger years, Wentworth had served as a member of Congress at the same time as Abraham Lincoln. Lincoln had then begun to aspire to the White House, and Wentworth offered to manage his campaign, telling Lincoln he "needed somebody to run him" (ibid.). Lincoln declined the offer, saying that only events could make a president.

As mayor, Long John was both fearless and innovative. When he decided to bring Chicago its first working steam fire engine, the firemen rebelled and rioted against the "damned teakettle on wheels," whereupon the mayor arrested two hundred of them for disorderly conduct.

The toughest section of Chicago was the Sands district; thieves and pickpockets abounded there, and bordellos proliferated; often one of their customers was murdered. Wentworth determined to eliminate this physical eyesore. One day there was a big dogfight at the Brighton Race Track, and most of the gamblers and hustlers assembled there for the sport. The mayor seized the opportunity to rush into the Sands with wrecking crews, who pulled down many of the shacks, after which the fire engine was brought in to tear apart other flimsy buildings with streams of water.

Wentworth Avenue in Chicago is a lasting civic tribute to the memory of Long John.

The "Long John Polka," probably the mayor's only musical tribute, was written by John B. Donniker, or "Doninker," as it was misspelled on the title page. Donniker was primarily a blackface minstrel and only incidentally a composer. He had been associated with most of the best-known minstrel troupes of the 1850s, sixties, and seventies. As a member of George Christy's famous troupe in 1860 he found time to write this polka in honor of Long John. Ten years later he was leading the orchestra at New York's London Theatre; following that stint he took in violin pupils.

John G. McRae, of New York, who executed the handsome engraving of Long John in his prime, is identified as an artist who worked on copper in line and stipple between 1850 and 1880. H. M. Higgins, the Chicago music publisher, who could find no sufficiently capable artist in the city, was fortunate in his choice of an out-of-town portraitist. Long John's rugged features are faithfully portrayed.

Was he a model mayor? He certainly looks like one.

TO THE
HON. JOHN WENTWORTH
Mayor of Chicago.

Long John
POLKA

John Wentworth

Composed by
J. B. DONINKER
Of Geo. Christy's Minstrels

Arranged by
CHAS. C. SMITH

CHICAGO
Published by H. M. HIGGINS 117 Randolph St.

PERRY'S VICTORY MARCH

There is a peculiar type of history student who has an uncanny memory for dates. If such an individual were asked, "What important event took place on September 10, 1813?" he would be able to reply instantly, "The Battle of Lake Erie."

Those students who are better with names and slogans than with dates will remember that it was Commodore Oliver Hazard Perry who whipped the British in that fight on one of the Great Lakes (where pollution, alas, has lately taken its toll) and who delivered for the benefit of future patriotic Americans, as well as for his own men, words that have been memorized by millions of schoolchildren over the past hundred and fifty years: "We have met the enemy and they are ours."

Immediately after the battle Perry was honored by the songwriters of the day, who turned out several victory songs toasting the brilliant commodore. Most of them were dead serious, but one, entitled "Perry's Victory; or, September Tenth in the Morning" and set to a well-known air of the times, was a mocking excoriation of Great Britain's ruling family, starting with the words "When old queen Charlotte, a worthless old varlet . . ."

As the years passed, and Cleveland became an important lake port, Clevelanders were keen to embellish their city. What better way to begin than to erect a statue? In 1857 the city had no monuments honoring past heroes. A committee from the City Council planned to collect funds for a statue of a great citizen of yesteryear, namely, the gallant commodore. The committee appointed a firm of marble workers, T. Jones and Sons Company, to find a well-known sculptor and give him the assignment of reproducing the great man in marble, after which the city of Cleveland would place the statue in a suitable location. Six thousand dollars was considered a sufficient sum for the job (it was later increased to eight thousand).

Several sculptors were consulted before Jones commissioned William Walcutt to produce the monument. Walcutt, a native of Columbus, Ohio, had shown an interest in art from the age of four and, at seventeen, had gone to the Antique School in New York; at thirty-three he decided that his metier was sculpture. Two years later he took the Perry contract.

The Cleveland city fathers determined to unveil the statue in the public square on September 10, 1860, the anniversary of the famous battle. Over 30,000 people came into town by railroad; thousands more arrived in other vehicles or on foot. September the tenth was bright and clear; the streets were packed with pedestrians, for the day had been declared a civic holiday. Cannon were fired constantly, and the air was filled with martial music. A huge procession preceded the unveiling.

The event was too important to be overlooked by a well-known composer, William Dressler, who wrote "Perry's Victory March" to commemorate the occasion. The title page is illustrated by a facsimile of the statue by Walcutt against a black background, so that the marble figure stands out sharply. An experienced firm of lithographers, Ehrgott, Forbriger, and Company, of Cincinnati (see "Progress March"), did their usual competent job; and the statue of the commodore, sword in hand, makes patriotic Americans recall a naval hero whose deeds are inscribed in the annals of their country's history.

William Walcutt
Sculptor.

CLEVELAND,
Published by S. BRAINARD & Co. Nº 203 Superior Street.

HONEST OLD ABE

The Republican party entered the presidential campaign for the first time in 1856. John C. Fremont was the party's standard-bearer, and an attractive man he was, good-looking, of heroic mold, with a young, pretty wife. But he was no politician, and the election, which went to the Democrats with James Buchanan, proved disappointing, though not disastrous, to the ambitious Republicans.

Four years later came their great opportunity. The Republican convention met in May, 1860, in Chicago, where an enormous "wigwam," large enough to hold ten thousand people, had been built. The party's favorite had appeared to be William H. Seward, senator from New York. And indeed, on the first ballot, Seward received almost twice as many votes as Abraham Lincoln, who took second place. But half a dozen more serious contenders were in the fight; Seward needed sixty additional votes for a majority and the nomination. He never got them. The Lincoln forces gathered momentum, the delegates falling into line behind him like Illinois wheat bending before a mighty wind. With the third ballot it was all over, and Lincoln was the Republican presidential candidate.

From then on the party burst out in more whoop-de-do and razzle-dazzle than had been displayed in any campaign since William Henry Harrison and Henry Clay had battled it out twenty years before. Biographies of Lincoln were published in the month following the convention. Coins were struck; they bore the candidate's head on one side and a soap advertisement on the other. But above all, there was music; marches and polkas were dedicated to the several presidential candidates (there were four that year), but there were more compositions in honor of Lincoln than all his competitors combined.

A song that sought to deride the other candidates while it ballyhooed Mr. Lincoln was "Honest Old Abe" (he was fifty-one at the time). The words were written by D. Wentworth; the composer of the music sought to conceal his identity by calling himself "A Wide-Awake." The music, incidentally, is suspiciously like that of "Old Rosin the Beau," a song of Scottish origin, written over twenty years earlier and used in other Lincoln campaign songs (and various presidential campaign material from the 1840s to the 1890s).

One verse, singling out two rival candidates, Breckenridge of Kentucky and Bell of Tennessee, begins:

Your Tennessee Stallion aint game, boys,
Your Colt of Kentucky aint sound,
And you'll find in the end that you're lame, boys,
For old Buck [Buchanan] will be cheating all round.

As for "A Wide-Awake," the origin of his name can be traced to Hartford, Connecticut. The previous February, while Lincoln was campaigning in that city, a few dozen active Republicans had adopted a strange costume (intended originally to withstand wet weather) consisting of a cap and long cape of oilcloth. To the unusual attire had been added a long staff, on the end of which was a torchlight. The group, marching in orderly ranks, escorted Lincoln from the hall where he spoke, to his hotel. They called themselves the Wide-Awakes.

The name and the costume were adopted by Young Republican adherents so rapidly and in such numbers that soon nearly every northern county or village had an association of Wide-Awakes, who became a powerful force in Lincoln's victorious campaign.

The appealing lithograph of the beardless Lincoln was executed by J.

HONEST OLD ABE

Yours truly
A. Lincoln

SONG & CHORUS
WORDS BY
D. WENTWORTH, ESQ.
Music by
A WIDE AWAKE.

Published by **BLODGETT & BRADFORD** 209 Main St.
BUFFALO, N.Y.

J. Sage & Sons, Buffalo, N.Y.

Sage and Sons, of Buffalo. The Sage company prospered for over fifty years, beginning in 1850, when their business consisted of the odd combination of music and hair—odd, that is, until 1970, when the combination found new successes. By 1860, when they did the cover for "Honest Old Abe," they had a thriving lithography business, which continued until 1900.

The song, published by Blodgett and Bradford in Buffalo, may have contributed in a small way to the 1860 New York State election returns. In New York, Lincoln outran Douglas by a vote of 362,000 to 312,000.

THE LIVE OAK POLKA 1860

Baseball did *not* originate in the United States, it must regretfully be admitted. Rather, it sprang from the English game of rounders, played early in the eighteenth century. Our English cousins had the unmitigated gall to describe their game as "baseball," in a small 1744 volume of rhymes by John Newberry, London, entitled *A Little Pretty Pocket-Book*.

The British brought the game to America during the Revolutionary War, and the diary of a revolutionary soldier named George Ewing gives an account of a game of "base" played at Valley Forge on April 7, 1778.

In the early 1840s, a group of New York gentlemen used to meet at frequent intervals for a bit of baseball. In 1845 Alexander Cartwright, a member of the New York Fire Department, suggested that the men constitute themselves a club and secure a playing field. Thus was born the Knickerbockers Baseball Club, the first organization of its kind. The members rented a five-acre tract, known as Elysian Fields, in Hoboken-on-the-Hudson. The Knickerbockers were a pretty snobbish crowd in those days, out for a good time with opponents of their own choosing. They composed their own song, too, such as:

> The young clubs, one and all, with a welcome we will greet,
> On their fields or festive hall, whenever we may meet
> And their praises we will sing at some future time;
> But now we'll pledge their health in a glass of rosy wine.

Membership in the Knickerbockers was limited to forty and included not only professional men but also a hatter, a "Segar Dealer," a United States marshal, and several "gentlemen." Community standing was as much a requisite as athletic prowess.

By the 1850s the popularity of the game had spread to all walks of life. One club was formed by firemen, another by barkeepers, a third by schoolteachers. In addition to the fifty amateur baseball clubs in New York and Brooklyn (the professionals were not to take over until the next decade), baseball enthusiasts had organized clubs throughout New York State, New England, Pennsylvania, and Maryland. Came the 1860s, and the gentlemanly aspects of the game were fast deteriorating. Heavy bets were being wagered on the results; there was rowdiness, and even an occasional riot, among the spectators.

One of the teams frequently accused of unsportsmanlike conduct was the Rochester Live Oaks, the subject of the illustration for this article. The Buffalo Express, upstate rivals of the Live Oaks, complained that the behavior of the Rochester team was not exactly proper and creditable. The Buffalo boys had strong evidence to sustain their accusation. When the umpire called a close play against the Live Oaks, the Rochester captain heaved the ball into the air, and the team walked off the field.

150

Three Rochester amateur teams, the Flour City, the Live Oaks, and the Lone Stars, staged weekly matches. The Live Oaks had crushed all opponents until the day the Lone Stars brought a brand-new gimmick into the ball game. Their pitcher, Richard Willis, discovered, for the first time, how to throw a curve ball, and the Live Oak batters were stopped cold. Loudly and often did the Live Oaks protest that the curve was illegal. The showdown came in the fifth inning. The game was suspended, and the umpire, a well-known local lawyer, was told to make a decision on the subject. The players gathered round him, all talking at once, and an ever-widening and threatening ring of partisans surrounded the participants. As the angry shouting grew to a dangerous decibel-count, the umpire, spotting a weak place in the ring, suddenly broke through it. He dashed for the fence, vaulted over, and was rapidly driven from the playing field in a friend's carriage.

For all their strong-arm methods and short tempers, the Live Oaks were a very dressy baseball club. Their shirts were made of "Marie Louise" blue flannel, trimmed with white silk, and over the left breast were neatly embroidered sprigs of oak, encircling the letters *L.O.* The white flannel pants had blue stripes down the side, and the white flannel jockey caps were corded and trimmed with blue.

The title page of the 1860 "Live Oak Polka" is the first, and probably the most attractive, colored lithograph for sheet music that depicts a baseball scene. The firm of Endicott and Company of New York did the cover for Joseph P. Shaw of Rochester, the publisher. The ballpark, with the players stationed much as they would be in today's games, is replete with action. High-silk-hatted spectators sit a respectful distance behind first base. In the right foreground is a model of a properly dressed young Live Oakster, hat in hand, steadfast of look. Who would not place a wager on his team?

The composer, J. H. Kalbfleisch, is a comparative unknown; but how could his lively air fail to qualify when the subject matter was so attractive? Live Oaks forever!

THE ITHACA MARCH

1860

The charming little city of Ithaca, nestled on a narrow plain below the foothills that stretch out behind it, gives no hint in this 1860 view of the fame it would later achieve as a great educational center. True, among its most respected citizens was Ezra Cornell: but it would be another five years before that highly successful entrepreneur and generous patron of philanthropic causes would steer a bill through the New York legislature to establish a college in Ithaca.

Mr. Cornell had started from scratch, one might say, arriving on foot in the small city in 1829, to acquire a position as manager of a machine shop. A dozen years later he left Ithaca to work as a plough salesman, walking 1,500 miles between Maine and Georgia to sell his wares. Strangely, the plough was the fulcrum on which Ithaca was eventually raised to its eminence in the academic world, for it was as a plough salesman that Cornell met Samuel Finley Morse, inventor of the telegraph. Morse was looking for equipment that could dig a ditch for laying telegraph wires underground and then fill it again; Cornell was ingenious enough to devise the necessary method and produce the machinery. Later, his holdings in the Western Union Telegraph Company made him a very wealthy man, and he lavished benefactions on his city and invested in its industries.

In 1860 the town that was the subject of the lovely lithograph by

THE
ITHACA MARCH

ARRANGED BY

J.H. Hintermister.

ITHACA
PUBLISHED BY
HINTERMISTER & Cº

NEW YORK.
FIRTH, POND & Cº

Sarony, Major, and Knapp of New York appeared serene in its location "far above Cayuga's waters." There was no trace of the horrible flood that had ravaged Ithaca three years before, sweeping away dams and bridges, destroying property, and snuffing out lives.

The serene little community of 5,000 people was the subject of "The Ithaca March," a lively piano number written in the key of B major, with a five sharp signature to annoy all but the most talented keyboard performers. The composer was J. H. Hintermister, a music dealer of some local standing, who after twenty years took on the distribution of organs and then became the general agent of the Ithaca Organ Company.

Through the decade from the mid-1850s to the mid-1860s, there was no more popular team of lithographers than Sarony, Major, and Knapp. Napoleon Sarony, New York's prodigious lithographer, had taken in his first partner, Henry B. Major, in 1846. Major's son Richard succeeded his father in the business in 1855. Two years later Joseph F. Knapp, a New York draftsman and lithographer, entered the firm; and the three men enjoyed a fabulous business at their plant on Broadway for another ten years, at which time Sarony stepped aside to permit the two younger men to carry on without him.

HERMANN POLKA
AND WYMAN'S POLKA

1861
1854

Fifty years before the great Harry Houdini was fascinating huge audiences with his "supernatural" powers, two exponents of the magic art were dominating the field of wizardry in America. Carl Hermann and John Wyman were, literally, names to be conjured with.

Hermann—or Herrmann, as his name was usually spelled—came from Hanover, Germany, and was the oldest of fifteen children. His early years were uneventful as far as magic was concerned; but in 1847, shortly after his thirtieth birthday, he burst forth upon the continent as a stellar conjurer. A year later he opened in London, where he captivated audiences for months, becoming known as the "Acknowledged First Professor of Magic in the World" (Clarke, p. 134).

As a sleight-of-hand artist Herrmann was amazing, and it is this aspect of his art that is depicted on the title page of the "Hermann Polka." But his proficiency in the magical arts was astounding. At a performance for children in Buenos Aires he pulled from an apparently empty basin several hundred yards of paper ribbon, rolled them up, tore them apart, and out came four live geese. He could flatten a cloth on a table and then produce from beneath it four bowls full of goldfish. After he had insisted that someone in the audience examine his person and inspect his clothing, he would "conjure up" the fifth bowl from a hollow in his back.

He was the first magician to introduce an "aerial suspension" act, which he called "Horizontal Floating by the Means of Chloroform," a trick that so disturbed the police force in Berlin that they forced him to suspend the act for several days until they could assure themselves that the person being held in a horizontal position was not in danger of permanent damage.

As for "Wyman the Wizard," Herrmann's contemporary, he was an American by birth, hailing from Albany, New York. He began his professional career as a ventriloquist, when he was just twenty years old, and soon undertook the practice of magic. One of his greatest assets was a delightful sense of humor, which quickly put him *en rapport* with his audiences, who were then ready to absorb any show of his wizardry.

"Professor" Wyman's appearances were confined to the United States

HERMANN POLKA.

COMPOSED BY

STRAUSS

BOSTON.
PUBLISHED BY OLIVER DITSON & C? 277 WASHINGTON ST

C.C. Clapp & C? Boston. J.E. Gould Philad? Firth. Pond & C? N.York. John Church Jr Cinn. John C. Haynes & C? 33 Court St Boston.

and Canada. His popularity was so enormous that he had no need to extend his performances to European cities, as did many of his contemporaries.

Although other magicians of the time expressed the opinion that Wyman never produced an original act, the record of his appearances is impressive. Early in his career he gave a special show for President Martin Van Buren. President Millard Fillmore was entertained by him in the White House; Abraham Lincoln invited him there four times!

Despite such prestigious "command performances," Wyman was called "a small-town magician" by the writers of the day, who were aware of his willingness to tour the country's byways. The lesser-known cities that he visited clamored for his return year after year. For example, one Norfolk, Virginia, newspaper advertisement read, "Seventeenth Annual Visit of Wyman the Wizard." A notice in a paper reading, "Wyman is in town. This simple announcement is sufficient. Library Hall, this evening" (Mulholland, p. 11) served to pack the house.

The big cities loved him, too. He performed for eleven successive years in New York, with runs lasting up to nine weeks, and had long stays in Philadelphia and Boston.

After Herrmann's American appearance in 1861, a bitterness developed between the two magicians. Herrmann, the old maestro from Europe, had been exploited from afar, and his tour in the United States was anticipated with much excitement by his potential audiences. Wyman was furious at the challenge to his position. He sent to the press copies of a letter he had dispatched to his German rival in which he wrote, in part, "I will bet you any sum of money you choose to name, not less than $25,000 . . . that I can beat you at your own tricks. We are to give two public exhibitions—you select your best tricks. I am to perform your experiments. I am to select a set of my tricks, you are to execute them. We are to have ten umpires each, and the best fellow to take the dimes. . . . Respectfully, Wyman the Wizard" (ibid., p. 13).

The Wizard's challenge went uncontested; Herrmann declined to reply to him.

Both artists were the subjects of dances composed in their honor. The distinguished musician Johann Strauss—the "Waltz King" of later years—composed the "Hermann Polka" in 1861. Strauss was young then, but the sprightly melody in 2/4 time gave evidence of the more exciting music that might be expected of him in his maturity.

The quaint title page illustrates Herrmann exploiting one of his principal stocks-in-trade, with a playing card, the ace of spades in one hand, and other cards being manipulated by small devils who are pulling them from a high silk hat. John H. Bufford of Boston, a workhorse in the lithographic game, did the cover. The name of the artist is not shown, but it may well have been Joseph E. Baker, who drew the cover for the "Peabody Funeral March," described later in this volume.

The Wyman cover illustrated here was executed by Alphonse Brett, a Frenchman who worked in Philadelphia during the 1850s. Here again the artist is unknown, but he may have been one of the three Thurwanger brothers, designers of some of Brett's lithographs in the 1860s. Wyman stands in a formal, but relaxed, position, eyes fixed on some distant object, almost as if he is pondering the make-up of sets for his next performance.

The polka, "Respectfully Dedicated to Professor Wyman," was composed in 1854 by J. A. Janke, a less distinguished musician than the one Carl Herrmann had been able to attract for his musical tribute.

Wizardry as a form of entertainment had its heyday in the 1850s and sixties. Now if only a spot of magic could dissolve some of the ills of the 1970s . . . Herrmann—Wyman—can you hear us?

Composed by
J. A. JANKE
and Respectfully Dedicated to
PROFESSOR WYMAN

price 25 ¢

Philad'a Pub by WINNER & SHUSTER, N⁰ 110 North 8ᵗʰ St

Soon after the establishment of the Confederacy in 1861, efforts were made to write a national hymn for the united southern states. Most such attempts died a-borning; they did not prove sufficiently inspiring to warrant adoption. Actually, the tune that thrilled Southerners the most was that of an old minstrel song that had originated in New York in 1859 —"Dixie." In fact, "Dixie" was played at the inauguration of Jefferson Davis in Montgomery, Alabama, in 1861.

But there was another song that seemed to strike just the right patriotic note for Southerners—one that combined a sense of dedication with a fervor for dauntless defense in aid of the justice of their cause. Its title was "God Save the South." The verses were written in 1861 by George Henry Miles of Emmitsburg, Maryland, which lies not far from Gettysburg, Pennsylvania, and they were adapted to music by two different composers, C. T. De Coëniél and Charles W. A. Ellerbrook.

As was true of so many songs written by southern sympathizers during the Civil War, either the name of the poet was omitted from the song sheet or a nom de plume was used to protect an author who might have been subjected to punishment were his identity known. Miles adopted for this purpose the name of Ernest Halpin or Earnest Halphin, and it was under the first of these pseudonyms that he appeared as author of "God Save the South."

The "anthem" proved extremely popular. At least twelve editions were printed—four in Augusta, Georgia, one in Charleston, South Carolina, one in New Orleans, one by a publisher with establishments in Macon and Savannah, two in Richmond, and three in Baltimore.

De Coëniél's melody was used for the edition whose title page is illustrated here. The lithographer, E. Crehen of Richmond (probably of French extraction), is recognized for the execution of a number of plates of "Uniform and Dress of the Army of the Confederate States." His handsome kneeling Confederate officer bears a striking resemblance to lithographs of General J. E. B. Stuart and may have been intended to represent him.

George Henry Miles had a sparkling career as poet and dramatist. Graduating from college at the age of eighteen, he competed, two years later, for a $1,000 prize that the great actor Edwin Forrest (see "The Drama Polka") was offering for a tragedy in which he would star. Miles won the competition with a work entitled *Mohammed*.

Shortly afterwards he wrote another drama, *The Seven Sisters*, for one of America's leading actresses, Laura Keene. Again he met with success; the play ran for two years. Miles enjoyed the friendship of numerous luminaries of the American stage, for which he continued to write throughout his all-too-brief life (he died in his forties).

Two verses of "God Save the South" indicate its strong appeal to the Confederacy:

God save the South! God save the South!
Her Altars and Firesides! God save the South!
Now that the war is nigh Now that we'er arm'd to die
Chanting our battle cry, Freedom or Death! . . .

God make the right Stronger than might!
Millions would trample us Down with their pride!
Lay thou their legions low, Roll back the ruthless foe.
Let the proud spoiler know, God's on our side. . . .

OUR
NATIONAL CONFEDERATE
ANTHEM

GOD SAVE THE SOUTH

THE TEXT BY ERNEST HALPIN
COMPOSED BY **C. T. DE CŒNIÉL** RICHMOND Vᴬ

PUBLISHED BY THE **COMPOSER** AND MAY BE HAD
AT HIS RESIDENCE GRACE Sᵀ COR 1ˢᵀ & OF ALL THE PRINCIPAL BOOK & MUSIC STORES IN THE CONFEDERACY

LITH BY E. CREHEN 146 MAIN Sᵀ
Antered according to the act of congres by C.T. De Cœniel Richmond Va

RIDING A RAID

Many songs espousing the cause of the Confederacy that were published in the South during the Civil War were the work of unknown poets and composers. Whether modesty or a fear of reprisal prevented them from proclaiming their authorship is not clear.

One such popular song, whose creators will probably remain anonymous forever, is "Riding a Raid," which was written in 1863 and which pays tribute to "Jeb" Stuart, the most daring raider of the war, and to Stonewall Jackson, under whose leadership Stuart conducted his widespread forays. Richmond editions of the song carry lithographed title pages showing the dashing Stuart in plumed hat, broad sash, and high boots. The edition shown here, which was published in Baltimore by A. Hoen and Company (see "Sun Quick Step"), bears a picture of Jackson on the cover, but not the imposing general whose full beard was more luxurious than that of any other high officer on either side of the conflict. This lithograph shows a handsome man, apparently in his early twenties, with a plentiful growth of cheek-whiskers but no sign of a mustache or beard.

Although the picture is entitled *Old Stonewall*, the probability is that it represents General Jackson as a young artilleryman at the time of the Mexican War, during which he had been brevetted major for his gallantry at Chapultepec. The embroidered insignia on the collar is not genuine; it was probably a figment of the unidentified artist's imagination.

Thomas Jonathan Jackson had graduated from West Point in 1846, in the same class as two other men whose names were later to be more than household words and whose opposition he was to encounter in the great war: George B. McClellan and Ambrose E. Burnside.

After the Mexican War, the studious Jackson accepted a position as professor of physics at the Virginia Military Institute, where he also served as instructor in artillery to the cadets. A deeply religious man and a Presbyterian deacon, he was considered by many of the students to be a dull teacher, who stuck rigorously to the text of his subject, showed no imagination, and exuded no personal charm. These early judgments were dispelled, however, when he left his school for his last career, that of fighting man.

The verses of "Riding a Raid" are quoted here, in part:

Tis old Stonewall, the Rebel, that leans on his sword,
And while we are mounting, prays low to the Lord:
"Now, each cavalier that loves Honor and Right,
Let him follow the feather of Stuart tonight."
Come tighten your girth and slacken your rein;
Come buckle your blanket and holster again;
Try the click of your trigger and balance your blade,
For he must ride sure that goes Riding a Raid!

And, to indicate the intensity of the songwriter's feeling about Abraham Lincoln:

There's a man in a white house with blood on his mouth!
If there's knaves in the North, there are braves in the South.
We are three thousand horses, and not one afraid;
We are three thousand sabres, and not a dull blade!

RIDING A RAID

"OLD STONEWALL"

Song

Gallop

A. Hoen & Co. Lith.

BALTIMORE

Published by **GEORGE WILLIG**, No. 1 N. Charles St.

Entered according to Act of Congress A.D. 1863 by G. Willig in the Clerks office of the Dist. Court of Md.

As students of Civil War history are aware, the Confederate states had a staunch ally in Great Britain. England appeared to do everything in its power short of entering the conflict to bring discomfiture to the North and to further the implementation of the secession.

The secretary of the navy of the South, C. R. Mallory, entrusted the arrangements for acquiring British material support to the shrewd and able commander James D. Bulloch, a skilled internationalist. Bulloch's ability apparently became a family trait; years later one of his nephews was called on to patch up a bad business between Russia and Japan. The boy's name was Theodore Roosevelt.

Bulloch went to England and found an excellent lawyer, who helped him interpret Queen Victoria's Neutrality Proclamation to mean that it was no offense for British subjects to equip a ship even though that vessel would cruise against a friendly state. "The mere building of a ship within Her Majesty's dominions by any person . . . is no offense, whatever may be the intent of the parties" (Boykin, p. 79).

So Bulloch arranged for Britain to equip and build. Cargoes of rifles and munitions, purchased in England, reached Southern ports despite efforts by Northern men-of-war to mount an effective blockade. Sea-raiders, built in English dockyards, roamed the Atlantic, capturing or burning dozens of vessels of Northern ownership.

The Union, while relentlessly pursuing the Southern ironclads and wily raiders, was hard put to curb the damage they were inflicting. Northern statesmen and military men were bitter at England's open espousal of the Southern cause. Condemnation was forthcoming from eminent writers, too, some severe, some more restrained.

James Russell Lowell was one of America's foremost literary figures. His two series of *Biglow Papers*, one written in the 1840s and the other in the 1860s, discussed topics of the times in homespun language. Lowell was highly critical of British attempts to scuttle the Union, as the second set of papers attested. The *Biglow Papers* made no mention of Lowell, but purported to be, in the main, the writings of Ezekiel Biglow and his son Hosea. Much of the writing is in verse, colloquial in tone, phonetic in spelling.

In 1862 Hosea wrote a set of verses mildly reproving England for her policy toward what Lowell and many Northerners called the Rebellion. He entitled this particular poem "Jonathan to John," Jonathan (or Brother Jonathan) being an early epithet for Uncle Sam, and John referring to John Bull. The verses begin:

It don't seem hardly fair, John, When both my hands was full,
To stump me to a fight, John, Your cousin, tu, John Bull!
Ole Uncle S. sez he, "I guess We know it now," sez he,
"The lion's paw is all the law, Accordin' to J. B.,
Thet's fit for you an' me!"

Hosea's poem was popular enough to be set to music. Francis Boott, its composer, was a serious student of music who had left his native Boston at an early age to study harmony in Florence. For Lowell's poem he devised a spirited melody in 6/8 time, easy to sing and at the same time soundly constructed.

The quaint title page, portraying two glaring antagonists, listed the author as Hosea Bigelow, with a gratuitous "e" for good measure. The lithograph was executed by L. Prang and Company of Boston.

Louis Prang, born in Breslau, Germany, left home in his early twenties

Jonathan to John.

Words by HOSEA BIGELOW

Music Composed by F. BOOTT.

BOSTON.
Pub.d by HENRY TOLMAN & CO. 291 Wash.n St.

Entered according to act of Congress in the year 1862 by Henry Tolman & Co. in the Clerks Office of the District Court of Mass.

and eventually made his way to America. Settling in Boston, he taught himself wood engraving; then, after a few years, he entered the lithographic business, which proved to be a most profitable venture for him. During the Civil War he produced many designs for the title pages of sheet music. "Jonathan to John" was one of his most ingratiating covers.

GENL. BURNSIDE'S GRAND MARCH 1863

Ambrose E. Burnside might well have served as the inspiration for W. S. Gilbert when he wrote the well-known patter song in *Pirates of Penzance*: "I am the very model of a modern major general." Tall, handsome, and stalwart, yet modest and considerate of the men under his command, Burnside nevertheless had the misfortune to fall short in those qualities that are requisite for a successful leader.

Although he had rapidly advanced in rank and had been given command of the Army of the Potomac when George McClellan was removed from that post late in 1862, he was inflexible in emergencies; he was unable or unwilling to change tactics to meet changing situations on the battlefield.

Burnside suffered a severe setback in December, 1862, when he attempted to cross the Rappahannock River at Fredericksburg and open an approach to Richmond. His army was much larger than that of his opponents, but miserable weather conditions, added to the general's overly cautious moves, prevented him from sweeping the enemy before him. When he finally committed his men to the attack, they were mowed down in droves by Confederate gunners. As one Northern correspondent put it, "It can hardly be in human nature for men to show more valor, or generals to manifest less judgement" (*American Heritage* [1961], p. 281).

Shortly after Fredericksburg, Burnside was relieved of his command, accepting other less prominent military duties. Amiable gentleman that he was, he did not sulk in his tent like Achilles but continued to lead and even to inspire the troops assigned to him.

Always he strove to maintain sartorial elegance and the grooming that befits a gentleman. His uniforms were beautifully made and, insofar as was possible, well pressed and carefully cleaned. As for his whiskers, they were, in a sense, unique. Rare was the face of a general that did not present a luxuriant growth of hair on lip and chin; beards were the order of the day. Burnside's was one of the very few shaven chins among his fellow generals. His preference—odd for his day, more commonplace in ours—was to allow the facial hair to grow down the length of his cheeks and to join the full mustache protruding over the generous mouth.

The side whiskers were notorious: they were Burnside's personal trademark. After the war, other men, some in important offices of state (even one president), affected the hairy cheek and smooth chin, and soon a name for the style sprang up. People called the growth sideburns in recognition of the man who had started the new tonsorial fashion; and "sideburns" they remain to this day.

A likeness of the affable general appears on the title page of "Genl. Burnside's Grand March," a spirited air written by J. Brinley and distributed in 1863 by John Church, Jr., Cincinnati's foremost music publisher. The lithograph is the work of Ehrgott, Forbriger, and Company, of Cincinnati, one of the largest and most respected firms of its kind in the Middle West. Despite his tribulations, Burnside was certainly as imposing as any "modern major general."

GEN!. BURNSIDE'S

GRAND MARCH.

CINCINNATI

Published by **J. CHURCH Jᴿ, Nº 66** West Fourth St.

THE FAIRY BRIDE POLKA

Phineas Taylor Barnum was America's greatest showman (see "Barnum's National Poultry Show Polka"). To achieve his phenomenal success, he often descended to charlatanism; but more often than not his exhibits and featured artists were genuine, as advertised.

Of all the oddities, virtuosos, horrors, and awesome beasts, no single adjunct of the great man's entourage brought him such lasting success as Charles S. Stratton. Stratton came to Barnum's attention in 1842, a few months after P. T. had acquired the American Museum in New York. When Barnum first met the Stratton family, Charles was five years old, stood twenty-five inches tall, and weighed fifteen pounds. His father, a poor carpenter in Bridgeport, Connecticut, was quite willing to allow Barnum to exhibit his son, for which privilege Charles and his parents were paid seven dollars a week, plus board.

Barnum billed the boy as General Tom Thumb and soon began extensively to publicize the midget's unusual features. For advertising purposes he increased the general's age from five to eleven years, and changed the place of his birth from Connecticut to England. Tom Thumb's image was enhanced by these statements, and accounts of his intelligence and charm began to flood the newspapers.

With Tom Thumb as a stellar attraction, Barnum's fame grew steadily. He became rich and, in the process, helped the little general grow wealthy, too. Wealth appealed mightily to Tom Thumb, who used his money to buy horses and yachts.

Twenty years after these two remarkable individuals first became associated, Barnum added a second midget to his retinue, a seventeen-year-old native of New Hampshire named George Washington Morrison Nutt. He was a bit shorter than the general, Tom Thumb having added some ten inches to his height and over thirty-five pounds to his weight since his affiliation with the showman. Barnum commissioned Nutt a commodore.

Still a third small person joined the Barnum troupe, an attractive little lady named Mercy Lavinia Warren Bumpus, a schoolteacher from Massachusetts. Barnum called her Lavinia Warren. Commodore Nutt was smitten with Lavinia—as was General Tom Thumb. The general was a man of the world, the commodore still a teen-ager; the youngster had no chance. Barnum employed his astute showmanship to promote the rivalry and the eventual indication of Lavinia's preference for the general. After their engagement had been announced huge crowds attended every exhibition in which the pair participated.

In February 1863 General Tom Thumb and Lavinia Warren were joined in matrimony at fashionable Grace Church, New York City. Commodore Nutt was the general's best man, and Lavinia's sister, Minnie, who was even tinier than the bride, served as maid of honor. A carefully selected list of guests—among them Mrs. John Jacob Astor, Mrs. William H. Vanderbilt, and General Ambrose Burnside—witnessed the wedding. The honeymoon included a call on President Lincoln and dinner at the White House.

The scene of the ceremony was captured on the title page of "The Fairy Bride Polka," composed in 1864 by G. R. Cromwell, who dedicated his sprightly piece to Lavinia, the new bride.

Major and Knapp of New York were the lithographers. They had been partners of the highly successful Napoleon Sarony, who withdrew from the firm shortly before this picture was made (see "The Ithaca March"). Richard Major and Joseph Knapp continued their meticulous work into the early 1870s and then retired.

THE

FAIRY BRIDE POLKA

AS PERFORMED AT THE LEVEE'S OF

GENERAL TOM THUMB AND LADY, Comº NUTT ᴬⁿᵈ MISS MINNIE WARREN.

COMPOSED BY

C. R. CROMWELL.

New York, Published by FIRTH SON & Cº 563 Broadway.

I VANTS TO GO HOME

If there had been no war between the states, there would have been no grandiose European plot-of-the-century. If there had been no European plot, there would have been no emperor of Mexico. And if Mexico had been spared the distasteful temporary subjugation by a horde of men who knew little and cared nothing about their alien country, the youthful Emperor Maximilian might well have been spared a tragic early death, to live out his days, gracefully and happily, as Archduke Ferdinand Maximilian of Austria.

But there *was* the war; and the plot and the empire and the emperor's fate were destined to make history. The plot was conceived in London by representatives of England, France, and Spain, who agreed on an armed invasion of Mexico, the first step being the occupation of military coastal positions, with a later advance to the capital. Then, according to plan, they would assist the backward people of Mexico to establish a new form of government—an empire, with a puppet ruler whom they could manipulate.

The schemers were convinced that the United States, with its hands full of secessionists, would be in no position to intervene, even though its image stood to be seriously tarnished. Louis Napoleon, Bonaparte's nephew, now France's emperor and nicknamed "Moustachio" by the irreverent, the central arch of the arch-conspirators, saw the move as an enormous opportunity for the enrichment of his country and the aggrandizement of his own position.

For a while, everything went according to Hoyle. As the emperor-to-be, Louis Napoleon and his associates selected a young Austrian archduke, Ferdinand Maximilian, who, encouraged by his aspiring wife, Charlotte, (later to be known as Carlota), was happy to oblige. The coastal landing went smoothly, and the city of Vera Cruz was occupied by the naval forces of the three European countries.

But soon came trouble. Bitter arguments among the three allies resulted in the withdrawal from the scene of the English and Spanish troops, so that France had to go it alone. After some fierce fighting the French eventually made it to Mexico City, subduing it in June, 1863. The throne was then formally offered to Maximilian, subject to the popular vote of the people of Mexico. The French, skillfully controlling the "election," saw to it that "Maxl" was a shoo-in by a vote of 8,000,000 to 250,000.

But after the young sovereign had been installed in June, 1864, he ran into two serious problems that proved, quite literally, fatal: a revolution led by Benito Juárez, former president of Mexico and recognized as such by the United States; and the position of the United States itself. William H. Seward, the Secretary of State, was one of the most skilled diplomats in U.S. history. Despite France's urging that America recognize the new Mexican government, Seward parried the point tirelessly until, after Appamatox, he knew there was no danger that the Union would be fragmented. Then, invoking the Monroe Doctrine, he pressed home the American decision that the government would not tolerate a Franco-Mexican alliance below the border.

Not until 1867 did the tragedy end. Juárez and his army forced the surrender of the European forces in May, and Maximilian, along with his closest advisers, was arrested. A military court-martial sentenced them to death; near the city of Querétaro a burst of rifle fire cut down the attractive young monarch.

During the few years of the power play, songs—most of them humorous—had been written about the novel situation in Mexico. One such song,

published in 1865 in St. Louis, was "I Vants to Go Home," with words by Bob Barkis and music by T. M. Brown. Brown, a one-time piano teacher at Bonham's Seminary in St. Louis, had composed numerous sentimental songs and written variations on popular melodies by Johann Strauss and others.

Barkis describes the appeal of Maximilian to Louis Napoleon, which goes, in part:

> But mine friend Jeff is vipped, he runs here if he can,
> And den Unkel Sam comes, I fear,
> Oh! let me come back to de dear vaterland,
> It is so very unhealthy here.

The illustrated title page shows a very young Maximilian sobbing at the knee of Louis Napoleon. Though unsigned, the cartoon was probably done by F. Welcker, a German-born artist working under the direction of Alexander McLean, the lithographer whose name appears on the cover sheet. McLean, born in Scotland in the 1820s, came to the United States as a young man and, after brief periods of activity in Philadelphia and Louisville, settled in St. Louis, where he worked for twenty years. His sheet music covers are rare; the subject matter is diversified and always entertaining. None is more comical—despite the tragic end of the antihero—than the title page of "I Vants To Go Home."

PETROLEUM COURT DANCE

1865

Henry C. Eno of New York illustrated only a few music sheets during his first year of operation in the 1860s. He was busy with larger lithographs of views in New York City and elsewhere. His best-known work was of a champion race horse, Hambletonian, which sired the ancestors of the greatest trotters of the present day.

Among his title pages for sheet music the most impressive is one done in 1865 of an oil well owned by the New York, Philadelphia, and Baltimore Consolidated Petroleum and Mining Company, which illustrates the cover of the "Petroleum Court Dance." The music, written by Henry C. Watson and Charles Fradel, is even more elaborate than the title of the corporation; it consists of a schottische, a polka, a galop, and a waltz. The piece is dedicated "to the ladies of the United States."

The company, incorporated in 1864, seems to have taken full advantage of the great gamble for Pennsylvania oil properties during the mid-1860s, after a practical method to refine the oil had been developed. The wildest wildcatters, the shadiest dealers in stocks, the rough-and-tumble population that pours into every new avenue for easy money, were out to make a killing in Pennsylvania oil.

This is not to say that the New York, Philadelphia, etc., Company was not legitimate. It gambled in properties, as did nearly all speculators in the area. But its prospectus for stock subscriptions could offer nothing positive but only tantalized prospective customers.

For example, the prospectus stated that the company's properties were "near" some of the great producing wells of the region. They were "near" the Phillips Well, on the Tarr Farm, from which flowed 4,000 barrels a day; they were "near" the Sherman Well, gushing 3,000 barrels daily, and the Woodford Well, spurting 2,000 barrels daily.

The company listed twenty-six properties belonging to it and did its utmost to make subscribers to their stock dream beautiful dreams. With a capital of 300,000 shares of a par value of $5.00 each, they offered the

stock to investors at $1.00 per share, with the following tempting assertions:

> It is not only a possibility, but a strong probability, that large wells will be struck on this Company's property yielding *several hundred barrels*, and perhaps *several thousand barrels of oil* per day, which would make the stock of the company *very valuable*, and yield to the shareholders very large dividends. . . . There is only a small amount of the stock remaining unsold, to be had at the subscription price of $1 per share. . . . The Trustees feel confident they will be able to declare handsome dividends monthly, after the books are closed.

Had each prospect been furnished with a copy of "The Petroleum Court Dance," displaying on its cover the handsomely groomed men and women who, with funds sagaciously invested in the right oil company, were proudly parading around the well, sales of the stock might thereby have been sharply enhanced.

Indeed, the music may have been distributed with this thought in mind, for the back cover contains the offer of the stock and lists the names of the officers and trustees, along with the addresses of the company's offices in New York, Philadelphia, and Baltimore.

As for the success of the venture, no report has been found. In a manual of extinct companies appeared this obscure notice of the at-one-time-promising operation: "Charter dissolved by proclamation, April 2, 1924."

EMILIE MELVILLE POLKA 1866

She was a buxom, wholesome lass, whose star blazed for the first time at the new Bowery Theatre in New York in April, 1865. The girl's delightful soprano voice had been used but sparingly in her early appearances—in plays like *Ireland and America*, where the songs were only incidental to the unfolding of the story—but her opportunity to prove her singing ability came early that summer when Donizetti's *The Child* [*sic*] *of the Regiment* was billed at the Park Theatre in Brooklyn. On this occasion her enactment of the title role was so successful, both vocally and histrionically, that when the season came to a close in July, a benefit performance was arranged for her; the young Emilie Melville seems to have thoroughly captivated her audiences.

From then on, her path led her to opera houses around the country and eventually around the world. Our principal interest centers in her appearance at the Greenlaw Opera House in Memphis, Tennessee, the year after her New York debut. The Greenlaw, which had been used mainly for lectures and variety shows, was "fitted up" as a theater in August, 1866, and the management determined that the opening performances should be memorable ones. They decided to introduce light opera to their growing community and arranged to put on *The Child of the Regiment*, with Emilie Melville as the attractive, well-developed "child."

Opera seats were not prohibitively expensive in those days, particularly in nonmetropolitan areas. One dollar bought a choice seat in the parquet or dress circle, and one could climb to the gallery for a quarter. Despite the conclusion of the Civil War, integration in a Tennessee theater had not yet been accomplished, for seats in "colored boxes" were advertised at fifty cents each, and those in the "colored gallery" at twenty-five cents.

Memphis operagoers were entranced by Emilie Melville. As her company's run in the city was nearing its end, newspaper advertisements, which carried her name in large capital letters, warned, "Last night but four!"

EMILIE MELVILLE

POLKA

AS PLAYED BY THE ORCHESTRA OF THE MEMPHIS OPERA HOUSE

inscribed to

Miss Emilie Melville

BY

E. O. EATON.

Published by H. BERNARD 298 & 300 Second Street Memphis Tenn.

JAS. A. McCLURE. A. E. BLACKMAR. D. P. FAULDS.
NASHVILLE TENN. NEW ORLEANS. LOUISVILLE, KY.

GERMAN BROS. LITH. LOUISVILLE

"Last night but three of the Triumphantly Successful Engagement of the young and beautiful Comedienne and Vocalist, Miss EMILIE MELVILLE!"

To add to the lady's popularity, a Memphis music publisher released the "Emilie Melville Polka," composed by E. O. Eaton. The title page is adorned with a portrait of Miss Melville, in military uniform—with obvious alterations—as worn in *The Child of the Regiment*. Otto Starck, a young Louisville artist, prepared the illustration for a Louisville lithographing firm run by Charles W. and Philip T. German.

Noting the well-filled vest and shapely regimental jacket, it must be deduced that Miss Melville's regiment arranged for their child to be well-fed and, as a result, fully proportioned.

WEARING OF THE GREEN 1865

In 1865, "Wearing of the Green," a song to quicken the heartbeat of every Irishman, was issued by several American song publishers. The first, Harvey Dodworth of New York, enlivened the title page with a stunning likeness of T. H. Glenney, star of the show in which the song was introduced, wearing his green jauntily over the maroon costume of a country squire.

This handsome lithograph is by the respected house of Bufford of Boston. John H. Bufford was as prolific as any of the lithographing fraternity. His activity spanned a period of nearly forty years, first in New York and then in Boston, and he employed some of America's leading artists to design for him. So widely recognized was the quality of his work that he had the unusual distinction of being the subject of a front-page article in an 1864 Boston newspaper, which described his prints as the rarest gems of modern art.

Dion Boucicault, author of *Arrah na Pogue*, the play in which "Wearing of the Green" was sung, was the innovator of stage techniques that are today an old and accepted part of the theater. For example, he was the first to use fresh flowers for room decorations, and the first to put a carpet on the stage floor; and it was he who introduced the idea of shifting stage scenery.

Boucicault also had some innovative notions about a man's personal life. At the age of thirty-three he had married Agnes Robertson, a beautiful young actress, who bore him six children. Thirty years after the wedding he declared that he had never been legally wed, and he took a new wife, Louise Thorndike, a member of his company; she presented him with two more offspring.

Agnes's suit for divorce seriously injured the great reputation Boucicault had acquired; his popularity waned, and he died a poor man.

Arrah na Pogue, Gaelic for *Exchange of Kisses*, opened at Niblo's Garden in New York shortly after its introduction in Manchester, England, in 1864. "The Wearing of the Green" appears to have been the show-stopper.

Boucicault claimed credit for its authorship, but in fact the lyrics and the melody predated him by many decades. The tune has been traced back to 1747 to a Scottish musician named James Oswald (Fuld, p. 514). In America it has been known since the late 1830s.

Some of the words, too, had seen print long before *Arrah na Pogue*, even as early as the beginning of the nineteenth century, when a booklet in Ireland published lyrics to a song that included the words "they hang men and women for wearing of the green"—the sober thought with which Boucicault's song ended ("They're hanging men and women there, for wearin' of the green").

WEARING OF THE GREEN

AS SUNG BY

J.H.BUFFORD'S LITH. BOSTON

T. H. GLENNEY,

AS

SHAUN THE POST IN ARRAH NA POGUE.

PUBLISHED BY DODWORTH, 6 ASTOR PLACE N.Y.

But the American playgoer was never disheartened by plagiarism. *Arrah na Pogue* had a successful run in New York, and the audiences were much taken by Glenney's acting and vocalizing, despite the fact that a few critics felt his stage presence was inferior to some of the excellent Irish comedians then on the American scene. If the lithographic portrait is any indication, he must have been a real charmer.

PROGRESS MARCH 1866

From the 1850s on, Cincinnati was recognized as the bastion of an enlightened and progressive segment of the German-Jewish religious community in the United States. Its leaders were less rigid about orthodox ceremonial observances then were the Jews residing in New York and Philadelphia. The principal advocate of the movement that relaxed the tight bonds of orthodoxy among so many of his coreligionists was a brilliant, dynamic little man named Isaac Mayer Wise.

The German-born Wise had been a rabbi in Bohemia and had emigrated to the United States in 1846. Eight years later he took over the pulpit of the Congregation K. K. (standing for *Kehillath Kodesh*, "holy congregation") Bene Jeshurun in Cincinnati.

Bene Jeshurun (meaning "Sons of Israel") had been incorporated in 1842 by a small group of Jews who faithfully practised the religious and ritual observances of their German forebears. Its worshipers had increased slowly but steadily, so that its quarters on Lodge Street were beginning to become inadequate by the time Wise was invited to assume the rabbinate. Under his direction, it became evident that larger accommodations for the congregation were a necessity.

In 1860 a committee was appointed to develop plans for a new house of worship, but the approaching Civil War loomed large, and the implementation of plans had to be postponed. Nevertheless, the Jews of Cincinnati continued their study of the future development of their synagogues. In 1861 some of the wealthier citizens conceived the idea of erecting a palatial temple and merging two smaller synagogues, with Rabbi Wise presenting his sermons in English, and a Rabbi Lilienthal delivering lectures in German. Under this plan Bene Jeshurun would have lost its individual identity.

Rabbi Wise's response was forthright. "I will not leave K. K. Bene Jeshurun," he said. "The honor of Judaism in Cincinnati and throughout the West requires K. K. Bene Jeshurun, hitherto the banner-bearer of reform and progress on this side of the Alleghenies, to come out of Lodge Street into the broad daylight of a more suitable locality. . . . If some of our wealthy members leave us I will stay with you, even if by necessity my salary must be reduced one-half" (*History*).

That firm pronouncement from the most respected religious leader of American Jewry put an end to all plans for consolidation. Instead, a general meeting of the congregation was called in May, 1863, and by a unanimous decision, it was determined to build a new temple. A lot on the corner of Eighth and Plum streets was purchased, even though building could not begin until the war was over.

The cornerstone was finally laid in May, 1865, and the edifice was completed fifteen months later. At the impressive dedication ceremony a great procession marched into the new temple, with the oldest members carrying the scrolls of the law, the young boys bearing the curtains for the holy ark,

To Mrs. Rev. Isaac M. Wise.

PROGRESS MARCH.

K. K. BENE JESHURUN.

BY

P. MARTENS.

NEW YORK,
JOHN L. PETERS.

ST. LOUIS,
J. L. PETERS & CO.

CHICAGO,
De Motte Bros.

CINCINNATI,
J. J. Dobmeyer & Co.

GALVESTON,
T. Goggan.

BOSTON,
White, Smith & Perry.

Entered according to Act of Congress in the year 1867 by J. L. Peters in the Clerks Office of the U.S. Dist. Court for the District of N. Jersey.

and the girls carrying flowers and decorations. A daily paper said that "Cincinnati never before had seen so much grandeur pressed into so small a space."

To commemorate the occasion, the "Progress March" was written by P. Martens, a Cincinnatian. The title page of the music bears a lithograph of the handsome new building, with an array of fashionably dressed parishioners streaming towards its doors. The lithographers were Ohio's well-known Ehrgott, Forbriger, and Company. Like many craftsmen of the period, Ehrgott and Forbriger were of German extraction, having come to America as young men, possibly to escape the German draft. Ehrgott's work in Cincinnati extended over some thirty years and included many reproductions of Civil War incidents and views of the city and its environs.

Isaac M. Wise continued his indomitable leadership of the reform element of American Jewry until his death in 1900.

SUSPENSION BRIDGE GRAND MARCH 1867

Hines Strobridge, proprietor of the company that produced the handsome lithograph of the great bridge over the Ohio River, sold dry goods and then prayer books before he went into lithography in 1854. Once on his own in his new business, he reproduced views of California, New Mexico, and Texas, and his company flourished. During the Civil War he did an extensive series of battle scenes, with all details minutely and painstakingly worked out, so as to furnish authentic pictorial records.

The 1867 picture of the suspension bridge between Cincinnati, Ohio, and Covington, Kentucky, indicates the care and thoroughness of Strobridge's work.

Over fifty years elapsed between the dreams of Cincinnati's pioneers for a bridge to span the Ohio and John Roebling's stunning accomplishment. Early in the century the river had become the great "highway to the West," and towns along its banks proliferated. By the 1840s two rival bridge builders had stirred the imaginations of the forward-looking citizens of Cincinnati. One was Charles Ellet, a Philadelphia engineer and master showman; the other was Roebling, German-born and educated, whose headquarters were in Trenton, New Jersey—a man of magnetic personality, with an overpowering urge to succeed.

In 1846 the Kentucky General Assembly endorsed a plan to bridge the Ohio at Covington. Ellet and Roebling were consulted, and Roebling submitted a plan, which was immediately demolished by the emotional anti-bridge argument of a prominent Ohio surveyor, who was supported by steamboat men, ferryboat owners, and others who derived their living from the river traffic.

A few years later Ellet was commissioned to build a bridge over the river at Wheeling, West Virginia. When completed in 1854, it was the largest suspension bridge in the world. But the long bridge had a short life. Ellet had failed to brace the suspension spans sufficiently, and the bridge collapsed in a violent windstorm. The disaster plunged the hopes of the Cincinnati-Covington contingent to a new low.

But they did not give up. The Covington-Cincinnati Bridge Company persuaded Roebling to present them with new plans, and in August, 1856, in a burst of enthusiasm, gave him a contract to construct the long-overdue bridge.

The finished product was dedicated eleven years later. Much more than the usual problems besetting construction helped to postpone the date of completion. Not the least of these was the Civil War. Not only was there

Suspension Bridge

CINCINNATI, O.

BOSTON
O. DITSON & CO.

PHILADELPHIA
LEE & WALKER

C. Y. FONDA 72 W. 4TH ST.

NEW YORK
W. A. POND & CO.

Strobridge & Co. Lith. Cin.

a great scarcity of materials, but in 1862 the Confederates, under General Edmund Kirby Smith, began a march through Kentucky with intent to cross the river, lay siege to Cincinnati, and commence an invasion of the North. The situation looked desperate, but ingenuity and courage saved the Queen City of the Ohio. A clever Cincinnati architect constructed a pontoon bridge across the river, and General Lew Wallace (who later wrote *Ben Hur*) sprang to the head of the defenders.

Within a week, 70,000 Northern men had crossed the river, and Smith, with just 12,000 troops, quietly withdrew. Cincinnatians could breathe again, and construction of the bridge was resumed.

The great bridge, with a span of 1,057 feet between the tower centers and rising 100 feet above the river, was formally opened on New Year's Day, 1867.

The "Suspension Bridge Grand March," written by Henry Mayer, a Cincinnatian, was published later that year. The music is unimaginative, but the title page was a spectacular decoration for any piano.

RINK WALTZ 1868

Detroit had never seen anything like it, nor had any other American city. The largest skating rink in the United States, completed in the fall of 1866, was designed to accommodate several hundred people at a time. With thirteen thousand square feet of ice, plus a dining room, a kitchen, large dressing rooms for the lady-skaters and for the gentlemen-skaters, it captured the fancy of the athletically minded.

The most modern type of lighting—gas-burners, to the number of 280 —cast a bright glow over the immense palace. (Nor was it to be vacated in the summer months. An excellent floor for "parlor skaters," or roller skaters, was provided for that purpose.) The cost of the project came to eight thousand dollars.

America, in the mid-nineteenth century, was fad conscious, particularly when the fad had to do with some form of physical prowess. Rowing and sculling races were all the rage in the 1830s; the baseball fever broke out around 1860, and football ten years later. The middle sixties witnessed the first wholesale interest in ice skating, and it was this sudden enthusiasm that inspired Mr. B. H. Davis of Detroit to plan the rink for his fellow citizens.

Season after season the rink provided a year-round sports arena for Detroiters. Davis was a showman; he studded the pleasurable evenings at the rink with occasional grand carnivals, where many skaters appeared in fancy costume and competed for prizes. So popular did the rink become that within two years an additional two hundred feet was added to its length, nearly doubling the skating area. At one end was an auditorium "with cushioned seats, arm chairs, etc. . . . and warmed by range furnaces"! Indeed, the height of luxury.

In 1868 the great showplace was the subject of a musical composition, the "Rink Waltz," by an admiring Detroiter, James E. Stewart, who dedicated his piece to "S. H. Davis & Co., Proprietors of Detroit Skating Rink." The unusual title page boasts views of both the inside and the outside of the vast building—which appears to be spacious enough to swallow a future General Motors assembly plant.

The well-established lithographic firm of Ehrgott, Forbriger, and Company of Cincinnati (see "Progress March") again came through with a striking design. The throngs of merry, graceful skaters represent one

To
S. H. Davis & Co.
Proprietors of Detroit Skating Rink.

RINK WALTZ

BY JAMES. E. STEWART.

EHRGOTT, FORBRIGER & CO. LITH, CINCINNATI

DETROIT.
Published by J. HENRY WHITTEMORE & CO. 179 Jefferson Ave.

Entered according to Act of Congress in the year 1868 by J. Henry Whittemore & Co. in the Clerks Office of the US District Court for the Eastern Dist. of Michigan

of the most cheerful scenes on any of the old sheet music covers, while the horse-drawn sleighs and transit vehicles speeding outside the commodious rink combine to make a period piece that any American history buff should delight in.

VELOCIPEDE POLKA 1869

Like every other symbol of American domestic progress that made its impact felt in the nineteenth century, the bicycle, earlier known as the velocipede, was the subject of many musical contributions. A prolific writer of the period, E. Mack (probably a pseudonym), wrote several velocipede pieces, which were distributed individually by Lee and Walker of Philadelphia, with a common cover used for the "Velocipede Set." The title page is ornamented with an illustration by Thomas Sinclair of Philadelphia and portrays the skillful handling of the tricky apparatus by a few stylishly dressed young cyclists of both sexes.

Sinclair, as noted elsewhere (see "City Museum Polka"), was one of Philadelphia's most popular and prolific lithographers. His light touch for a whimsical subject is shown at its best in this joyous portrayal of his young cyclists.

Eighteen sixty-eight and 1869, when most of the music appeared, were the years of the bicycle. The contraption that sent America two-wheeling like crazy was actually called a velocipede, a term coined in the early 1850s when cranks and pedals had been affixed, experimentally, to the "dandy-horse" the young blades used to propel through the streets of the large cities in western Europe.

The "dandy-horse," or hobbyhorse, was a kind of bicycle without pedals, sprockets, or at times, even a seat; a man straddled his two-wheeled mount and propelled himself with long strides far more speedily than could the average walker.

More than a dozen years passed before the first practical velocipedes were designed in France. Two men, Ernest Michaux and Pierre Lallement, each claimed the honor of being the inventor. Michaux remained in France; Lallement came to America and built the first American velocipede near New Haven, Connecticut. A patent was granted in November, 1866, for a rotary-action, crank-driven velocipede. And then—nothing happened. The public wasn't interested; at least, it evinced no enthusiasm until 1868.

In that year a smart fellow by the name of Pickering brought to New York a velocipede built in Paris and began to manufacture replicas of the French model. Then he became a one-man public relations company and rode one of his own vehicles around City Hall Park in New York, generating considerable excitement and landing a few customers.

Soon he had competition; "other firms began to manufacture their own version of celebrated Parisian velocipedes, and a bustling new industry was born" (Gittings, p. 243). Every company soon had a backlog of orders as the fad grew into an accepted mode of transportation.

Much like the driving schools of today, riding schools were opened in every sizeable city to cater to the many enthusiasts who sought anxiously to learn to master the "boneshakers." Comfort played no part in the satisfactions of a bicyclist of the late 1860s. The rigid wooden frames, the iron-tired wooden wheels, and the cobblestoned streets and rutted roads were unkind to backbones and buttocks.

But the bicycle was a method of locomotion not to be denied, and the volume of cyclists continued to mount, decade after decade, until the horseless carriage signaled the dawn of a new era.

"A NEW THING UNDER THE SUN"

VELOCIPEDE MARCH VELOCIPEDE SCHOTTISCH VELOCIPEDE WALTZ

VELOCIPEDE GALOP VELOCIPEDE POLKA

Philadelphia LEE & WALKER 722 Chestnut St

W. H. BONER & CO. 1102 Chestnut St. A. & S. NORDHEIMER, Toronto, Ca.

CHAWLES OF THE H-OXFORDS

It was the most exciting match of the century. Never before—nor for the next hundred years—had an international audience become so involved with a nautical sports contest. For weeks beforehand, the New York *Times* titillated its readers with accounts of the condition of the participants, the equipment, the water, the weather. It even went into detail about the daily diet of the athletes. The event was the subject of editorials and spirited letters from the public.

What could have stimulated such tremendous interest on both sides of the Atlantic? What could have aroused the tempers of red-blooded Americans and Englishmen to such a fever pitch? Just a boat race—but what a boat race! The greatest university four-man crews of the two countries—Harvard and Oxford—were to give their all on a stretch of water near London in a battle to determine the premier oarsmen of the civilized world.

There was little else in international athletics to challenge the overwhelming importance of this test of strength and skill. It was only the summer of 1869; the first modern Olympic Games were almost thirty years away, and the first World's Series would not take place until after the turn of the new century.

The preliminaries had started many months before that August day when the crews met. The oarsmen of Harvard, conquerors of Yale, their archrivals, were confident that the vaunted shells of Oxford and Cambridge were inferior to their own, and they issued a challenge to the two great English universities to meet either of them on the Thames for a championship race. Cambridge, insulated from the world about it, refused to reply; but Oxford was happy to oblige.

The Harvard crew ordered two specially built sculls, selected the one that suited them best, and loaded it and themselves onto the steamer *City of Paris*, which docked in England some weeks before the great race.

The thousands of men and women who lined the course were delighted —at least most of them were—to see the Oxford four, the bookmakers' favorites, assume the lead shortly after the start of the contest and hold it throughout, to finish with a wide stretch of clear water showing between the boats.

Many wagers had been made on the outcome, but there is no record as to how much money changed hands after the race was over.

The following day nearly the entire first page of the New York *Times* was devoted to the great event. A detailed map of the course was inserted, and the "blow-by-blow" was faithfully enumerated. The Harvard men were acclaimed; they had performed nobly, but the gentlemen from Oxford were just a bit nobler.

The musical world also took note of the event. David Braham, a popular composer, and J. F. Sheridan, a comedian of the music halls, brought out a humorous song entitled "Chawles of the H-Oxfords." John Sheridan, of the team of Sheridan and Mack, introduced it to an audience at the Theatre Comique, on lower Broadway in New York, the month following the contest. A regular on the variety stage circuit with Sheridan was Annie Hindle, an entertaining male impersonator, known to theatergoers as "The Great Hindle," and it was to the Great Hindle that "Chawles" was dedicated.

The chorus goes:

> Yes I'm Chawles of the H'Oxfords you know,
> Whom the 'Arvards went over to row
> Of seconds a few, we beat them 'tis true,
> But a tight pull they gave us you know.

Dedicated to the Great Hindle.

Chawlie of the H-Oxfords you know!

Written and Sung by J. P. SHERIDAN

Music by D. BRAHAM

Plain
4

Colored
5

NEW YORK,
Published by Wᵐ A. POND & Cᵒ 547 Broadway.

BOSTON, CINCINNATI, SAN FRANCISCO, NEW ORLEANS, MILWAUKEE,
KOPPITZ, PRÜFER & Cᵒ C. Y. FONDA. M. GRAY. L. GRÜNEWALD. H. N. HEMPSTED.

Entered according to Act of Congress A.D 1865 by Wᵐ A Pond & Cᵒ in the Clerks Office of the District Court of the South Dist at New York.

TELLER & GIRNER 147 SPRING ST. NEW YORK.

The comic figure on the title page, a caricature of an oarsman, in ludicrous regalia, with monocle firmly in place, is apparently at the same time a caricature of the long, lean Annie Hindle. The firm of Teller and Gipner did the lithography; the artist was too modest—or felt it might be unsafe—to disclose his identity.

PEABODY'S FUNERAL MARCH 1869

When George Peabody died, in 1869, at the age of seventy-four, he was memorialized as America's foremost benefactor. And so he was, at least up until that time.

Starting from "scratch," like so many of the country's wealthy men, and with but four or five years of formal education, his astute mind and resolute discipline brought him material fruits from his young manhood onward, so that he became a multimillionaire at a time when multimillions were practically unheard of.

Doomed to lifelong bachelorhood, Peabody felt no need of costly domiciles or extravagant habits. In the years when his income ran to a figure of some three hundred thousand dollars, he was spending only 1 percent of that amount on himself.

His benefactions were enormous and, occasionally, spectacular; nor were they confined to the United States. In London, where Peabody lived for many years, he gave upwards of two and a half million dollars to develop an impressive housing project for the poor, which consisted of blocks of buildings, surrounding a public garden, that were leased at nominal rents. This magnificent indication of his generosity inspired Queen Victoria to offer Peabody a baronetcy if he would become a British subject, an honor he politely declined, settling instead for a miniature of the queen.

In America one of his greatest individual gifts went to found the Peabody Institute of the City of Baltimore, the city where he had begun to amass his enormous fortune. Nearly a million and a half dollars were allocated to the development of this institution, which opened its doors to scientists, academicians, and musicians in 1866.

A still larger amount went to the Southern Education Fund, established to provide educational facilities for children, both black and white, in the impoverished states of the South.

After his death, which occurred in London, the queen, supported by the Dean of Westminster, expressed the wish that Peabody be buried in Westminster Abbey. His will, however, stipulated that his body be interred in his native Massachusetts: so after a ceremony at the Abbey, his coffin was placed on board Britain's newest and largest warship, the *Monarch*, and transported home. The final services were held at a little church in Peabody (formerly Danvers), Massachusetts. On the border of that small city, in Harmony Grove Cemetery, the great philanthropist was laid to rest.

In the nineteenth century the death of a prominent individual often inspired the composition of a funeral march in his memory. So it was with George Peabody. The composer of "Peabody's Funeral March," in 1869, was Septimus Winner, one of the most popular musicians of the period (see "Drama March"). For the funeral march Winner incorporated a touching melody, "Flee As a Bird," written a dozen years earlier. The somber piano selection, in which the tempo of a "Marcia Funebre" is indicated, is stately and effective.

The title page of the sheet music bears the portrait of Peabody in his later years. The face portrays the strong character of the financier, touched with an expression of benevolence, as befits the great philanthropist.

In memory of the world's benefactor.

PEABODY'S FUNERAL MARCH

INTRODUCING THE FAVORITE MELODY
"FLEE AS A BIRD"

NEW YORK:
Published by **C. H. DITSON & CO.** 711 Broadway.

BOSTON:
O. DITSON & CO.

PHILADA: CINN: BOSTON: CHICAGO.
C.W.A.TRUMPLER. JOHN CHURCH JR. J.C. HAYNES & CO. LYON & HEALY.

Entered according to Act of Congress AD. 1869 by O. DITSON & C? in the Clerks Office of the District Court of Massachusetts

J. H. Bufford, Boston's most important lithographer of the mid-nineteenth century, is responsible for the fine work. The artist was Joseph E. Baker, an experienced portraitist. Baker had been apprenticed to Bufford a dozen years before, along with another youth whose name was to become considerably better known as time went on—Winslow Homer. Like Homer, Baker employed his drawing talents during the Civil War, when he became known for his cartoons. After the war he returned to Bufford, with fortunate results for them—and for us.

SOLID MEN TO THE FRONT QUICK STEP 1870

As a prime example of combined efficiency, ruthlessness, and corruption in government, consider William Marcy Tweed.

Tweed was a grossly fat man. At five feet eleven inches his weight varied between 280 and 320 pounds. But his energy was boundless, and he worked incessantly—on his own behalf.

Elected in 1851 as one of New York City's forty aldermen (frequently called the Forty Thieves), Tweed, at the age of twenty-seven, started on a career of graft and chicanery that ultimately cost the taxpayers of New York City close to 200 million dollars.

After a brief term in Congress, during which wine and women diverted him from his congressional duties, Tweed returned to New York, where he was soon elected to the city Board of Education, whose members peddled appointments to teachers and sold textbooks, pocketing the funds derived from such sales.

His next step up the political ladder landed him on the county board of supervisors, which controlled the city's operating expenses and had charge of all public improvements. Soon he was the acknowledged master of the board and was levying a 15 percent tax on everyone who wanted to do business with the city.

Tweed and his toadies earned the name of the Tweed Ring. One commentator defined the Tweed Ring as a hard band in which there is gold all round and without end.

Tammany Hall, the headquarters of the Democratic politicians of New York, was a ripe plum that now fell into Tweed's ample lap. As both grand sachem of the Tammany Society and the controlling force in the executive committee of the New York County Democratic committee, Tweed was in command of the city's Democratic party and its patronage. He bribed the money-conscious capitalists who were willing to pay for favors that would accrue to their credit. He maneuvered his henchmen into the highest offices in the city and state. John T. Hoffman was advanced from mayor of New York in 1866 to governor in 1869. Tweed had a second candidate for mayor, A. Oakey Hall, ready to step into City Hall when Hoffman was "moved upstairs."

By this time Tweed was stealing over a million dollars a month from the city treasury. But his dreams were on a far vaster scale: he would make Hoffman president of the United States and Hall governor of New York State, while he himself would become a U.S. senator.

He had almost the entire city in his pocket; but fortunately there were still a few brave and honest men willing to do battle with him. The one newspaper in New York he could not control was the *Times*, and it was the *Times* which, in July, 1871, began to publish the inside story of the corrupt Tweed Ring. As the details of Tweed's chicanery and the enormity of his theft of city funds were disclosed, the Boss and his associates

panicked. George Jones, the owner of the newspaper, was offered $5,000,000 if he would discontinue his crusade; he refused.

Eventually, in the fall of 1873, Tweed was brought to trial. Found guilty, he was sentenced to twelve years in jail and fined $12,750. (The term and the fine were soon reduced to one year in prison and $250.)

But Tweed's power had been broken. In and out of prison for the remaining years of his life, he died in the Ludlow Street Jail on April 12, 1878. A faithful Negro servant was his only attendant when the end came.

In 1870, when Tweed ruled his well-stocked roost, C. S. Grafulla, who had been leader of the New York Seventh Regiment Band during the Civil War and who was still a well-known composer of popular music, wrote a spirited quickstep, "Solid Men to the Front," which he dedicated to "Hon. William M. Tweed." The title page, lithographed by Major and Knapp of New York (see "The Fairy Bride Polka"), bears a flattering likeness of the Boss, under a reproduction of Tammany Hall. Beautiful symbols of democracy embellish the cover—a peace pipe, a French liberty cap (with stars and stripes), and high-sounding slogans like "Local sovereignty," "Chartered Rights," and "Good Faith Among Men." Virtue Triumphant!

THE KNABE POLKA 1871

Any student of elementary German knows that the word *knabe* means *boy*. And in the Knabe family of Baltimore there were two extremely able boys, sons of an extremely able father whose passion was pianos.

William Knabe, who came to Baltimore from Germany in 1833, had completed a distinguished apprenticeship in the old country. In his new surroundings he set about to master the English language and the unusual commercial opportunities offered there. After six years of assiduous attention to these essentials, he felt ready to launch his own piano business; he opened his factory in 1839.

Extraordinarily successful, after twenty years Knabe controlled the piano market of the southern states; but a crushing blow was dealt him when the Civil War wiped out his trade. The tribulations were too much for the elderly gentleman, and he died, overcome by worries, in 1864, leaving a great, but stagnant, business to his two sons, William and Ernest.

William assumed responsibility for the manufacturing end, Ernest for financing and distribution. To save a desperate situation, Ernest decided on an extended trip to the North and the West, seeking new fields for potential customers. Prior to his departure, Ernest went to his bank and requested a loan of $20,000 to meet the weekly payrolls during his absence. When the banker asked Ernest what security he could furnish to protect the loan, the young man replied simply, "Nothing but the name of Knabe." The banker shook his head from side to side and asked Ernest what he now proposed to do. "I shall go down to my factory," replied Ernest, "and tell my employees that I am compelled to discharge them all because your bank refused a loan to which I am entitled" (Dolce, p. 284). Seizing his hat, he walked out the door.

The banker was startled, but impressed. Before Ernest reached the Knabe piano factory, a messenger had arrived there, with a note from the president of the bank, advising that Knabe's account had been credited with $20,000.

In true Horatio Alger style, Ernest's sales trip was so successful that the firm was not obliged to use even a dollar of the loan. Branch houses were opened in other cities; the Knabe concert grand was one of the most admired pianos at the centennial exposition in Philadelphia in 1876.

TO
ERNEST KNABE ESQ.R

THE

Knabe Polka

Composed for the

PIANO

By

B. COURLAENDER.

BALTIMORE,
GEO. WILLIG & CO. PUBLISHERS.

In 1871 the name of Knabe was linked with that of a prominent Baltimore composer and pianist, Bernard Courlaender. Courlaender was born in 1815, a descendant of a Danish merchant family. A gifted pianist, he had an Odyssean career, which projected him from court pianist and instructor of King Christian VIII of Denmark—where his good friends included Hans Christian Andersen and the sculptor Bertel Thorwaldsen—through an escapade in Venezuela, where he lost his fortune, and eventually, and apparently desperately, to Baltimore. Here, at the age of forty-three, he made his American debut at the piano and overwhelmed his audience. From then on his social and financial position was assured.

Courlaender's "Knabe Polka," a sprightly dance in 2/4 time, was dedicated to Ernest Knabe. On the back cover of the piano sheet appears an impressive picture of the giant Knabe factory, lithographed by the well-known Baltimore firm of A. Hoen and Company.

Prior to the death of William, Senior, the factory had turned out two thousand grand pianos. The great plant of the 1870s was equipped to manufacture many times that number. The *Knabes* had become *Menschen;* the boys had become men.

SNOWED IN GALOP 1872

Eighteen seventy-two was a year to remember—at least for the residents of Wyoming, for that was the year of the worst blizzard in the state's history. The heavy snows actually started in early December, 1871, and continued with hardly a letup until late in February.

An employee of the Union Pacific Railroad, assigned to Lookout Station, Wyoming, managed to transmit to company headquarters a report on February 26, 1872, in which he observed: "Whittier's . . . 'Snow Bound' is nice to read, but it is 'bad medicine' to have experienced." He described some of the troubles of the crewmen after freight trains became stuck in the heavy snowdrifts. "Men could not stay out of the cars more than half an hour at a time to shovel on account of the severity of the storm. One man could not keep standing room for himself on the track by shoveling the snow drifting faster into the cut than it could be shoveled out. . . . Here we were, after six days work at the train . . . worse off than when we first began. The banks at the side of the drifts . . . were in some places fifteen feet high. . . . One of our party had a photograph of a chicken with him and the six of us lived on that photograph of a chicken 24 hours. . . . We never enjoyed a meal better in our lives than looking at that photo." (*Annals*).

No passenger trains were sent out without a thirty-day provision of food and coal. During February the provision trains, loaded at the Union Pacific's terminals to the east, proceeded westward to the beginning of the snow belt, after which the supplies were carried forward by horses or by men on foot.

The agent at the Union Pacific Lookout Station managed to retain his sense of humor in spite of weather conditions. As his report neared its conclusion, he wrote: "At last we resolved, that we did not want to dictate to the Almighty, but would suggest with all due humility to providence that this thing . . . was getting altogether monotonous. One of our party found a poem 'The Beautiful Snow' and read it. . . . We passed a resolution that the author of 'Beautiful Snow' was a Damphool and had no respect for Pacific Railroads (Carried unanimously)" (ibid.).

DEDICATED TO THE SNOW BOUND PASSENGERS OF 1872.

U.P.R.R.

SNOWED IN

GALOP

H. HERMAN, OP. 47.

ARRANGED BY

CARL HESS.

PUBLISHED BY

M. GRAY,

SAN FRANCISCO,
623 & 625 Clay St.

PORTLAND, Ogn.
101 First Street.

Entered according to an Act of Congress in the year 1872 by M. GRAY, in the office of the Librarian of Congress in Washington, D.C.

The "Snowed In Galop," written by H. Herman and arranged by Carl Hess, was dedicated to the "Snow Bound Passengers of 1872, U.P. [Union Pacific] R.R."

The title page was lithographed by G. T. Brown and Company of San Francisco. Grafton T. Brown was an artist who, earlier in his career, had designed views of western towns for one of San Francisco's earlier lithographing firms, Euchel and Dresel. Brown, a Negro, established his own lithographing business in 1872. Although he produced a number of quite important lithographs with historical or descriptive subjects, the "Snowed In Galop" may have been the only piece of sheet music with a title page carrying the Brown imprint.

KANSAS-PACIFIC RW GRAND MARCH 1872

In the early 1870s, four great railroad systems linked the far west with the more populous, enterprising, and dynamic cities in the eastern half of the country. The four were the Union Pacific, the Denver and Rio Grande, the Santa Fe, and the Kansas-Pacific, and their bold ventures across the unsettled plain and desert areas were to change the face of the land.

Of the four companies, all but one survived those early years of fierce struggle. The Kansas-Pacific was the lone casualty, succumbing to the dominant Union Pacific in a multimillion-dollar fight for control.

The Kansas-Pacific Railway's main line, from Kansas City to Denver, was completed in 1872. During its few years of independence, as it hurtled its way across the prairies and picked up traffic at every cowtown on the route, the Kansas-Pacific made a kind of history. For it was at Abilene, Kansas, that Marshal Wyatt Earp is reported to have banished the town's houses of ill repute to a section south of the railroad's right of way, from which came the phrase *the wrong side of the tracks*.

In these tough frontier towns the young and vigorous trainmen, when they had time on their hands between runs, would frequently pay visits to the well-known bordellos of the neighborhood. A man would hang his switchman's red lantern outside the door so that when the callboy was sent out by the trainmaster to round up the members of the crew, the owner of the lantern could easily be spotted. This practice added the words *red light district* to the American lexicon.

The Kansas-Pacific Railway, prior to its completion, used cunning inducements to prospective settlers in the region. In 1871, through its land commissioner in Lawrence, Kansas, it advertised (in part): "The Great Farming and Grazing Region—Land! Land! 5,000,000 Acres. The prices ranging from $1.00 to $6.00 per acre, the average being about $3.00." And for a while, before the Union Pacific showed its muscle, all went beautifully. In the Kansas-Pacific's first year of operation, it showed a profit of $5,000 per mile of track, through buffalo and Indian country.

A visual reminder of this distinctive route is afforded on the cover of the "Kansas-Pacific RW Grand March," written in 1872 by George Schleiffarth of Wyandotte (later renamed Kansas City), Kansas. The title page is adorned with vignettes of scenes along the route, featuring one train pursuing a scampering buffalo, another being observed by an Indian brave in full regalia.

Like his home town, Schleiffarth also decided to change his name—at least for musical purposes. He preferred to use the pseudonym George Maywood. For the "Kansas Pacific RW Grand March" both names are used.

The cover was lithographed by C. Hamilton and Company of St. Louis.

To Beverly R. Reim, Esq.
Genl. Ticket Agt. Kansas Pacific R.W.

KANSAS CITY — DENVER

KANSAS PACIFIC R.W.

GRAND MARCH

Composed by

Geo. Schleiffarth
(Geo. Maywood.)
WYANDOTTE, KAS.

Author of: Susie had a Mocking Bird _ When we met on the sly_ Beyond the Blue Skies.
Summer birds Waltzes_ Starlight Schottische &c. &c.

Published by **KUNKEL BROTHERS**, St. Louis, Mo.

ENTERED ACCORDING TO THE ACT OF CONGRESS IN THE YEAR 1872 BY I. KUNKEL BROS. IN THE OFFICE OF THE LIBRARIAN OF CONGRESS, AT WASHINGTON, D.C.

C. HAMILTON & CO. LITH.
Cor. 3rd & Vine Sts
ST. LOUIS.

Hamilton had been a competent journeyman and later a foreman for a printer named Jonathan McKittrick. In 1871 he formed his own company of lithographers, printers, and engravers in downtown St. Louis, where he operated, apparently successfully, for over fifteen years.

The "Kansas Pacific RW Grand March," in addition to its eye-catching title page, used the back page to further promote its unique route. Here we find listed a number of inducements for prospective passengers, such as: "NO CHANGE of CARS from MISSOURI RIVER to DENVER." "It is the ONLY RAILWAY which passes through the GREAT BUFFALO RANGES OF THE AMERICAN CONTINENT. And immense herds of Buffalo, Antelope, etc., roam over the broad prairies." "There are no Disagreeable Omnibus or Dangerous Ferry Transfers by this route." "THROUGH PASSENGERS FROM THE EAST. . . . Cross all the Great Rivers on substantially Constructed Iron Bridges."

All aboard!

HANK MONK SCHOTTISCHE CA. 1877

In the days of the Pony Express, before the nation dreamed the impossible dream of a transcontinental railroad, the stagecoach driver was a kind of superman to whom passengers unhesitatingly entrusted their lives and their worldly goods. From the banks of the Mississippi and Missouri Rivers to the western shores of California and Oregon, this king of the open road had the power and the determination to protect his riders from Indians, wild beasts, and natural dangers of all sorts, avoiding landslides and yawning precipices and battling blizzards, fog, and sleet.

The best known and the most popular of these heroes was an unkempt, semiliterate, devil-may-care, hard-drinking ruffian named James Henry Monk. At the age of twenty-three, "Hank" Monk came West from his native New York State by way of Nicaragua, was hired the day after he reached Sacramento, and drove for nearly thirty years without an accident —so the story goes. A Nevada newspaperman said that Hank's relationship to his route could be compared to what the perfume is to the rose.

In his never scrupulously clean gray shirt and his tobacco-stained corduroy pants, he typified a special breed of man of studied nonchalance and uncommon valor, with a legendary capacity for large quantities of strong drink. A volunteer press agent reports that at times when Hank overindulged, he would forget what he was doing and give whiskey to his horses and water to himself, thereby accidentally becoming sober enough to handle a team of drunken horses.

He is best remembered in Nevada, where he drove the rich men who found and promoted the Comstock lode, the site of the greatest gold and silver mines in that state. Monk had a reputation for arriving promptly although he would often start his runs behind schedule.

On one such run his passengers included a pompous judicial personage, who continued to remonstrate with Monk while he was driving his horses at breakneck speed to meet the schedule. Finally the judge, unable to stand the assault on his nerves any longer, announced, "I will have you discharged before the week is out. Do you know who I am?" "Oh yes," Hank replied. "But I am going to take this coach into Carson City on time if it kills every one-horse judge in the state of California" (*Nevada*, p. 6).

Monk's most fully reported trip was the one he made in 1859 from Carson City to Placerville, California, with Horace Greeley as a passenger. Greeley had a speaking engagement in Placerville, and he was afraid he would be late when he observed Monk relaxing at the reins while the horses slowly climbed the eastern slope of the Sierras. Not realizing that a driver

Dedicated to Miss Lillie Swift.

FRANK MONK
Schottische

"Keep your Seat Horace, I'll get you thar on time."

Composed by

J. P. MEDER.

CARSON CITY, NEV.

PUBLISHED BY JOHN G. FOX, CARSON CITY, NEV.

does not run his horses uphill, Greeley urged him to increase the coach's speed, unprepared for its sudden increase of velocity as it mounted the crest and plunged at breakneck pace down the other side. Hanging on for dear life, Greeley begged Monk to slow down, to which Monk replied, "Keep your seat, Horace, I'll get you thar on time" (ibid.).

The tale of Greeley's harrowing ride spread throughout the West. Mark Twain recounted it at length in *Roughing It*. Greeley himself wrote, after the shattering experience, "I cannot conscientiously recommend the route to summer tourists in quest of pleasure, but it is a balm for many bruises to know that I am at last in California." The story became the best-known saga of the old Pony Express days, and it was bound to be represented, eventually, in sheet music form.

A few years before Hank "cashed in his chips"—as they put it in his part of the country—the "Hank Monk Schottische" was published in Carson City, Nevada. The lithographic title page is the work of Thomas Hunter of Philadelphia, a successor to Peter S. Duval (see "General Porter's March"). The artist was J. P. Marshall, a draftsman with a neat sense of humor, who seemed to enjoy depicting Greeley's terror as the four-horse coach dashed madly past the mountain ranges.

INDEPENDENCE HALL MARCH 1877

It had not always been Independence Hall. For almost ninety years before it was given that name, the building had stood on Chestnut Street in Philadelphia, a few blocks west of the Delaware River, serving the province—and later the state—of Pennsylvania, alternately rousing patriotic fervor and suffering demeaning indignities.

In the early days of Philadelphia the site was just a patch of uneven land, overgrown with whortleberry bushes. During the first quarter of the eighteenth century the members of the small legislative assembly that looked after the affairs of their province had no regular meeting place; instead, they used private homes, rented by the year. In 1729, having decided to obtain something more permanent, they secured the Chestnut Street site, then on the outskirts of town. The speaker of the assembly, Andrew Hamilton, drew up a design; a master carpenter named Edmund Woolley was engaged, and work commenced. It went very slowly, even though (some would say because) there was no such thing as union labor at the time. The assembly was able to meet in chambers on the first floor in 1735; the second floor was unusable until 1748.

But the original State House, as it was then called, had no steeple or belfry. The assembly authorized the construction of such a superstructure in 1750 and ordered a large bell from London. It was to weigh a ton and around it were to be inscribed these words from the book of Leviticus: "Proclaim liberty throughout all the land unto all the inhabitants thereof." The intention was to commemorate William Penn's Charter of Privileges in 1702. Unfortunately, the great bell was cracked by the first stroke of the clapper in 1752, so it was recast in a little Philadelphia foundry and reinstalled in the steeple in 1753. Destiny has altered its original significance and its inscription is now linked irrevocably to the proclamation of independence in 1776.

Until the Revolution, the State House was a center of activity. There the public gathered to mourn the passage of the Stamp Act, to cheer its repeal, and to sponsor town meetings to protest the Tea Tax. And there, ultimately, the Continental Congress gathered, in 1776, to subscribe to the immortal words of Thomas Jefferson, which began, "When in the course

INDEPENDENCE HALL.

FROM A PEN-KNIFE MODEL

BY ALEX. GARDINER.

M. M. C. Walker. 1006 Chestnut Str!

of human events . . ." There, too, George Washington accepted the command of the Continental Army.

For nine months Philadelphia was in the hands of the British, who used the State House first as a barracks, then as a hospital. Congress returned in June, 1778, to find the building in "a most filthy and sordid situation." After the Union had been established in 1787, and the Constitution of the United States adopted, the State House was little used; for, although Philadelphia was the national capital for ten years, the House and the Senate met in another building, later known as Congress Hall.

In 1802 Charles Wilson Peale, painter and scientist, rented the State House as a museum for his large collection of waxworks, paintings, and stuffed animals. The building was threatened with annihilation in 1816, but fortunately the city of Philadelphia decided to purchase it and its surrounding square for $70,000. When Lafayette, returning to America in 1824, visited the old structure, the public suddenly recognized its historic importance. At about the same time the name Independence Hall was bestowed on it; thenceforth it began to assume its rightful position as America's true cradle of liberty. The great bell did not become known as the Liberty Bell until 1839.

In 1877, E. Mack, one of Philadelphia's most prolific popular musicians of the period, wrote the "Independence Hall March," the title page of which bears an engraved replica of the hall after it had been treated to a new steeple, with a clock. The illustration is taken from a penknife model done by a little-known wood sculptor named Alex Gardiner. It is a unique sheet music cover for a march that fails to live up in quality to the historic subject.

FUNERAL MARCH TO THE MEMORY OF CORNELIUS VANDERBILT 1877

When the commodore died on January 4, 1877, he was eighty-two years old. More important, to the American public, who lapped up the account of the old gentleman's demise, he had amassed the greatest fortune in the United States—over 100 million dollars. This money had flowed in to him through shrewd investments in ferries and steamboats and—greatest bonanza of all—the New York Central Railroad, in which he held the controlling interest.

Cornelius Vanderbilt had accumulated most of his wealth in the last fifteen years of his life, and he had not allowed it to alter his life-style. His home on quiet Washington Place in New York City did not compare in any respect to the opulent mansions of other wealthy men of his day. Wealth in the 1870s was reckoned in six-figure terms; the man who had amassed half a million dollars was one of a select few. So Commodore Vanderbilt was a fabulous figure, high on a financial peak no other mortal in the Western Hemisphere could hope to scale.

Before he died, he had requested a simple funeral; and simple it was. He could not have prevented the enormous crowds that congregated outside his house on the morning of January seventh to witness the departure of the carriages to the Church of the Strangers around the corner on Mercer Street. Following a brief service at the church, the cortège wound its way from Broadway to the Battery, where a ferry waited to transport the corpse and the mourners to Staten Island. The rich man's humble ancestors reposed in the old Moravian burying ground at New Dorp, and there, among the generations of his forebears, the remains of Cornelius Vanderbilt were deposited.

Funeral March

to the Memory of

Cornelius Vanderbilt.

BY

Ad. Meyer

NEW YORK.

PUBLISHED BY THE AUTHOR,

AND FOR SALE AT ALL MUSIC STORES.

The two-year legal battle for the commodore's estate, fought by the two sons and eight daughters who survived, is unfortunately too long and complicated a story to be appended here. Let it only be mentioned that it was a terrific cat-and-dog fight, with one son, William H. Vanderbilt, emerging as the ultimate inheritor of nearly all of his father's wealth.

As so frequently happened in the nineteenth century, upon the death of a famous personage, a funeral march in his or her memory was promptly composed. The composer of Cornelius Vanderbilt's funeral march was Al Meyer, a name that sparkles once or twice like a firefly in the night, and then is lost to posterity.

The lithographer of the title page, a portrait of America's wealthiest man, was Ferdinand Mayer, a German by birth, who practiced his trade in New York for more than thirty years. He was best known for a number of handsome lithographs of New York views, done some years before the Vanderbilt sheet was executed. Incidentally, this music sheet cover may have been Mayer's last lithograph. If so, it was an impressive finish.

LILY REDOWA

CA. 1882

On Christmas eve, 1881, the steamer *Arizona* left Liverpool, England, for New York, carrying among its passengers the most talked-about esthete in the world. The gentleman with this singular distinction was Oscar Wilde, who had been wooed by D'Oyly Carte, the producer of Gilbert and Sullivan's famous collaborations, and who had consented to tour and lecture in the United States.

America may not have received from Wilde the type of entertainment it had hoped for, but it responded to the publicity that accompanied the famous—though not yet infamous—man, and thronged to the theaters and halls to hear what many suspected was unintelligible claptrap.

They came not only to hear, but to see. Well in advance of Wilde's arrival reports had spread of his outlandish style of dress, the black plush knee breeches, the silk stockings, the dress coat, white vest, and large white tie expanding from the rolling collar—quite an outfit for a strapping twenty-eight-year-old Englishman.

Missing, however, from his ensemble was the sunflower or the lily which he reportedly carried in his hand wherever he went; Gilbert and Sullivan, in their newest musical, *Patience*, had used him, with his floral appendage, as a model for the comic Reginald Bunthorne, the Fleshly Poet.

From city to city, throughout 1882, went Oscar. He was swamped with social invitations in New York, Boston, Philadelphia, Washington, and San Francisco. Occasionally he was ridiculed. At a lecture in Boston the first two rows of the hall were filled with Harvard students, dressed in Wildean fashion, with flowing locks (bewigged), wide ties, knee breeches, and black stockings. The audience gasped as the young men made a theatrical entrance, but Wilde, who had been warned of the prank in advance, glanced at the Harvard men and said, "I am impelled for the first time to breathe a fervent prayer, save me from my disciples" (Winmar); and in a trice he had retrieved the advantage and won the admiration of the audience.

In October Wilde was in New York to meet the beautiful woman with whom he was madly in love. Lily Langtry, the queen of the English stage, was arriving in America to fill a lucrative contract. Before daybreak Oscar boarded a small reception boat, along with other notables and newspaper reporters, and met Langtry's incoming vessel at Quarantine, where, at an auspicious moment, he dropped a cascade of lilies at her feet.

As Langtry's star ascended, Oscar's grew dim. Americans were tired of him; they could only caricature him. This was not at all difficult. Among those participating in the sport were the popular music writers. A scathing song, "Oscar Dear," appeared, as did a series of instrumental pieces dedicated to him—"Sunflower Waltz," "Daisy Polka," "Violet March," and "Lily Redowa"—by a well-known composer, Charles D. Blake. The title page of each of these floral tributes depicts Oscar, in the usual knee breeches, long stockings, and the other accoutrements for which he was famous, floating heavenward and firmly grasping a large sunflower, which seems to be propelling him on his way.

LANGTRY WALTZES 1883

Lily Langtry, born Emilie Charlotte Le Breton on the Isle of Jersey, was married in 1874 to a Belfast widower who was old enough to be her father and who was satisfied, once the marriage had been consummated, to allow his wife to make her own way in the world.

And quite a way it was. Emilie Charlotte had the face and figure of a goddess, as Britishers were privileged to discover. A yachtsman and explorer, Sir Allen Young, came across her while boating and took her to meet one of his good friends, the Prince of Wales. In no time at all the prince had another good friend—a very good friend indeed. The recognition paid her by the Prince of Wales made the lovely Emilie the toast of London, where she and her husband had gone to live. Crowds stared at her and followed her; whatever she wore was adopted as the mode. Her portrait was painted by John Millais; he titled it "The Jersey Lily," and from then on she was known, on both sides of the Atlantic, as Lily Langtry.

Oscar Wilde met Lily in 1878 and was infatuated. Though younger than she, he became one of the pack that sought her favors. He spent as much time as possible, during the next three or four years, in her vicinity; and while she appeared flattered, she did not respond to Wilde's ardor, which was expressed in such torrents of passionate poetry, as

> Lily of love, pure and inviolate,
> Tower of Ivory, red rose of fire.

In 1881, Lily made her stage debut in Sheridan's *She Stoops to Conquer*, at the Haymarket Theatre in London. The newspaper coverage—about her profile, her eyes, her carriage, her gowns—was extensive. It listed with gusto the distinguished members of the audience, which included, almost naturally, the Prince of Wales. But there was little or no mention of her acting ability.

Nevertheless, Lily's beauty alone was enough to make her sought after in America, where she was offered $3,500 a week, with all expenses paid. She reached New York in the fall of 1882, and the reports of her beauty were verified at once. So that the general public might be made aware of her flawless face, it was reproduced on the title page of an 1883 piece of popular music called, appropriately, the "Langtry Waltzes." The Grecian features, the luminous eyes, and the full lips attest to the fact that the Prince of Wales knew a good thing when he saw one.

In the United States, Lily collected, along with her astounding fees, a new bevy of male worshipers to add to her already sizeable collection.

The owner of the stunning Greek face might well have adopted for her motto a sentence coined by that well-known Roman, Julius Caesar: *Veni, Vidi, Vici.*

LANGTRY WALTZES.

By J. Albert Snow.

W. A. EVANS & BRO., Publishers.

50 BROMFIELD ST., BOSTON, MASS.

BRANCH HOUSES.

NEW YORK: 19 Park Place. PHILADELPHIA: 926 Chestnut Street.

CHICAGO: 113 Adams and 205 Clark Sts.

CINCINNATI: 286 Vine St. NEW ORLEANS: 201 Canal St. MEXICO: City of Mexico. ST. LOUIS, Mo.

(Catalogue mailed free on application.) Copyright 1883, by W. A. EVANS & BRO.

Chas. H. Crosby & Co. Lith, Boston.

The era of the bicycle in the United States began with a flurry of excitement and an overwhelming infestation of cyclists in 1868; and for almost fifty years, vehicular history was made. It was only when motoring increased to the extent that there was little room on the roads for other sorts of traffic that the bicycle sank, partially at least, into limbo.

At the outset people called the machines velocipedes; the term *bicycle* was used by manufacturers in the 1880s to describe the strange looking contraptions with an enormous front wheel and a tiny rear wheel, which gave the rider the general appearance of a human giraffe. By the 1890s the bicycle had assumed a shape much like that which it has today.

By the mid-1890s, the names of the leading bicycle manufacturers were as familiar to the public as are Ford and Chevrolet today. Nearly everybody knew that when a Columbia, an Imperial, a Spaulding, or a Victor was mentioned, people were talking about bicycles. Columbia advertised their brand as "Unequalled—Unapproached." The Overman Wheel Company, manufacturers of the Victor, stated simply, "Victors Always Lead."

There were small bicycle manufacturers too. One of the smallest companies was run by a pair of brothers named Wilbur and Orville Wright, who had a shop in Dayton, Ohio. They offered two models, the Wright Special and the Van Cleve. In a good year they might sell a hundred machines—hardly an auspicious start for the two pioneers in flight.

A special chassis design had to be developed for women riders so that even on a bicycle a lady could cope with the long and voluminous skirts of the period. Nevertheless, many women cyclists still found the skirts awkward and wore bloomers instead, a style attempted by some pre-Woman's Libbers in the early 1850s and abandoned after a year or two.

Since riding was now the rage, and at all hours, it was felt advisable that lamps be installed on bicycles, and many states laid down strict laws prohibiting cyclists from roaming the roads at night without the protection of a lantern. A new industry sprang up; lamps for bicycles were extensively advertised; people were cajoled to purchase a "20th-Century Lamp," a "Demon," a "Comet," a "Sunbeam."

A popular song writer, Theodore A. Metz, who three years later would set the country wild with "A Hot Time in the Old Town," in 1895 composed a comical balled called "Get Your Lamps Lit." The first verse started:

> I once knew a girl with a bicycle suit,
> She was awfully anxious to wear—
> It was one of those bloom-er-ers right up to date;
> And she crept out when Pop wasn't there.

Unfortunately, the young lady forgot the lamp-lighting ordinance and was soon apprehended by a policeman.

The song is dedicated, not to an individual, as was customary, but to the "Search-light Lantern."

The "Search-Light" was the best-selling lantern in the 1897 Sears Roebuck catalog. It used kerosene oil and would burn for ten hours without trimming. Made of brass and finished in nickel, it could be locked to the wheel with a removable key. "Price—each—$3.75."

The lithographed sheet music cover shows us two girls pedaling along, Miss Wise, her cycle protected by the Search-Light, and Miss Foolish, who seems to believe she doesn't need one. But riding up behind them is a policeman in full regalia, about to take Miss Foolish into custody.

The lithographer, J. E. Rosenthal of New York, was a man whose sheet music covers conveyed his keen sense of humor. "Get Your Lamps Lit," as Rosenthal interprets the piece, is a delightful bit of whimsy.

Bibliography

Parenthetical references in the text are to items in this Bibliography.

Abt, Henry Edward. *Ithaca*. Ithaca, N.Y.: Ross W. Kellogg, 1926.

American Heritage Pictorial History of the Presidents. Vol. 1. New York: American Heritage Publishing Co., 1968.

American Heritage Picture History of the Civil War. New York: American Heritage Publishing Co., 1961.

American Institute of Architects. *Guide to the Architecture of Washington, D.C.* New York: Frederick A. Praeger, 1965.

Annals of Wyoming 17, no. 2 (July 1945): 153–56.

Arbuckle, W. S. *Ice Cream*, 2d ed. Westport, Conn.: Avi Publishing Co., 1972.

Armor, W. C. *Lives of the Governors of Pennsylvania*. N.p., 1872.

Baltimore *Sun*. December 3, 1933; May 26, 1946; July 7, 1948; October 21, 1953.

Banning, William, and Hugh, George. *Six Horses*. New York: Century Co., 1930.

Barnett, James H. *The American Christmas: A Study in National Culture*. New York: Macmillan Co., 1954.

Barnum, Phineas T. *Barnum's Own Story. The Autobiography of P. T. Barnum, Combined and Condensed from the Various Editions Published during His Lifetime*. Edited by Waldo R. Browne. New York: Dover Publications, 1961.

——— . *Struggles and Triumphs; or, The Life of P. T. Barnum. Written by Himself*. Edited with an introduction by George S. Bryan. New York: Alfred A. Knopf, 1927.

Beam, Philip C. *Winslow Homer at Prout's Neck*. Boston: Little, Brown & Co., 1966.

Beard, Charles A., and Beard, Mary B. *The Rise of American Civilization*. 2 vols. New York: Macmillan Co., 1927.

Beauchamp, William Martin. *Past and Present of Syracuse and Onondaga County*. Vol. 1. New York, 1908.

Beaumont, Cyril W. *A Short History of Ballet*. London: C. W. Beaumont, 1933.

Beebe, Lucius, and Clegg, Charles. *The Age of Steam: A Classic Album of American Railroading*. New York: Rinehart & Co., 1957.

Benton, Joel. *Life of Hon. Phineas T. Barnum: A Unique Story of a Marvellous Career*. Philadelphia: Edgewood Publishing Co., 1891.

Bibliographical Index of Musicians in the United States of America since Colonial Times. Works Progress Administration. Washington, D.C.: Government Printing Office, 1941.

Bolton, Theodore. "Henry Inman: An Account of His Life and Work." *Art Quarterly* (Detroit Institute of Arts), Autumn, 1940.

Booth, Mary L. *History of the City of New York*. New York: E. P. Dutton & Co., 1880.

Boston Daily Evening Traveller, March 18, 1864.

Bowen, Frank C. *A Century of Atlantic Travel, 1830–1930*. Boston: Little Brown, & Co., 1930.

"Bowler's Journal" Bowling Encyclopedia, s.v. "History of Bowling." Milwaukee: American Bowling Congress, 1944.

Boykin, Edward. *Ghost Ship of the Confederacy: The Story of the "Alabama" and Her Captain, Raphael Semmes*. New York: Funk & Wagnalls Co., 1957.

Boyle, Esmeralda. *Biographical Sketches of Distinguished Marylanders*. Baltimore: Kelly Piet & Co., 1877.

Bradley, Hugh. *Such Was Saratoga*. New York: Doubleday, Doran & Co., 1940.

Brigham, Clarence S. *David Claypoole Johnston: The American Cruikshank*. Worcester, Mass.: American Antiquarian Society, 1941.

Brink, Carol. *Harps in the Wind: The Story of the Singing Hutchinsons*. New York: Macmillan Co., 1947.

Burlingame, H. J. *Magician's Handbook: Tricks and Secrets of the World's Greatest Magician, Herrmann the Great*. Chicago: Wilcox & Follett Co., 1942.

Burt, Nathaniel. *Perennial Philadelphians*. Boston: Little, Brown & Co., 1963.

Bushman, Norman F. *History of the Southwest Fort Known as Fort Clinton (Castle Clinton) (Castle Garden) on the Battery, New York City, New York, and Its Eventful Past.* New York: N.p., ca. 1850.

The Capitol: Symbol of Freedom. Washington, D.C.: Government Printing Office, 1959.
Catalogue of the First Exhibition of the Kentucky Mechanics' Institute at Louisville, Kentucky. Louisville: J. F. Brennan, 1854.
Charnwood, Godfrey R. B. *Abraham Lincoln.* 3d ed. New York: Henry Holt & Co., 1917.
Chase, Gilbert. *America's Music: From the Pilgrims to the Present.* 2d rev. ed. New York: McGraw-Hill Book Co., 1955.
Clark, Frank. "The Commodore Left Two Sons." *American Heritage,* April, 1966.
Clark, Joshua V. H. *Onondaga.* Vol. 1. Syracuse, N.Y.: Stoddard & Babcock, 1849.
Clarke, Sidney W. "Annals of Conjuring." In *The Magic Wand.* London, ca. 1929.
Cleland, Robert Glass. *From Wilderness to Empire: A History of California.* New York: Alfred A. Knopf, 1949.
Clement, Clara Erskine, and Hutton, Lawrence. *Artists of the Nineteenth Century and Their Work.* Boston: Houghton Osgood & Co., 1884.
Comfort, William Wistar. *William Penn and Our Liberties.* Philadelphia: Penn Mutual Life Insurance Co., 1947.
Compilation of Works of Art and Other Objects in the United States Capitol. Washington, D.C.: Government Printing Office, 1965.
Connecticut: American Guide Skills. Works Progress Administration. Boston: Houghton Mifflin Co., 1938.
Cowdrey, Mary Bartlett. *American Academy of Fine Arts.* New York: Art Union, 1953.
Crowe, William Carey. *Life and Select Literary Remains of Sam Houston of Texas.* Philadelphia: J. B. Lippincott Co., 1885.

Davis, Burke. *They Called Him Stonewall.* New York: Holt, Rinehart & Winston, 1954.
deCourcy, G. I. C. *Chronology of Nicolo Paganini's Life.* Wiesbaden: Rud Erdmann, 1961.
DeJullian, Philip. *Oscar Wilde.* Translated by Violet Wyndham. New York: Viking Press, 1869.
Detroit Advertiser and Tribune, September 12, 1866.
Detroit *Free Press.* December 29, 1866; March 10, 1867.
DeVoto, Bernard. *Across the Wide Missouri.* Boston: Riverside Press, 1947.
Dickson, Paul. *The Great American Ice Cream Book.* New York: Atheneum, 1972.
Dictionary of American Biography. 21 vols. New York: Charles Scribner's Sons, 1928–36.
Dolan, J. R. *The Yankee Peddlers of Early America.* New York: Clarkson N. Potter, 1964.
Dolce, Alfred. *Pianos and Their Makers.* Vol. 1, *A Comprehensive History of the Development of the Piano from the Monochord to the Concert Grand Player Piano.* Covina, Calif.: Covina Publishing Co., 1911–13.
———. *Pianos and Their Makers.* Vol. 2, *Development of the Piano Industry in America since the Centennial Exhibition at Philadelphia, 1876.* Covina, Calif.: Covina Publishing Co., 1911–13.
Downing, Major Jack. *The Life and Writings of Major Jack Downing of Downingville: Away Down East in the State of Maine.* Lilly Wait Colman & Holden, 1833.
Dreppert, Carl W. *Early American Prints.* New York: Century Co., 1930.
Dunlap, William. *History of the Rise and Progress of the Arts of Design in the United States.* 2 vols. 1834. Reprint (2 vols. in 3). Edited by Frank W. Bayley and Charles E. Goodspeed. Boston: C. E. Goodspeed & Co., 1918.
DuPuy, R. Ernest. *The National Guard: A Compact History.* New York: Hawthorn Books, 1971.
Dyer, Elisha. *Sketch and Reminiscences of the Providence Fire Department from 1815 to 1854.* Providence: E. A. Johnson & Co., 1886.

Eddy, Richard D. D. *Alcohol in History: An Account of Intemperance in All Ages, Together with a History of the Various Methods Employed for Its Removal.* New York: The National Temperance Society and Publication House, 1887.
Ellis, Edward Robb. *The Epic of New York City.* New York: Coward-McCann, 1966.
Emerson, Edwin. *Comet Lore. Halley's Comet in History and Astronomy.* New York: Schilling Press, 1910.

Farga, Franz. *Violins and Violinists.* New York: Macmillan Co., 1850.
Feder, Eugene; Fisher, Robert C.; and Laschever, Barnett D., eds. *Feder Shell Travel Guides, U.S.A.: Pacific States.* New York: David McKay Co., 1966.
Fielding, Mantle. *American Engravers upon Copper and Steel.* Philadelphia: N.p., 1917.
Foreman, Edward R., comp. *Rochester Historical Society Publication Fund Series.* Vol. 7. Rochester, N.Y.: Rochester Historical Society, 1928.

Fowles, Lloyd W. *An Honor to the State: The Bicentennial History of the First Company Governor's Foot Guard.* Hartford, Conn.: Bond Press, 1971.

Freeman, Douglas Southall. *Robert E. Lee.* Vol. 1. New York: Charles Scribner's Sons, 1934.

————. *Lee's Lieutenants: A Study in Command.* Vol. 1, *Manassas to Malvern Hill.* New York: Charles Scribner's Sons, 1942.

Fuld, James J. *The Book of World Famous Music—Classical, Popular, and Folk.* New York: Crown Publishers, 1966.

Furnas, J. C. *The Life and Times of the Late Demon Rum.* New York: G. P. Putnam's Sons, 1965.

Gardner, Albert T. E. *Yankee Stonecutters: The First American School of Sculpture, 1800–1850.* New York: For the Metropolitan Museum by Columbia University Press, 1945.

Garner, Wightman W. *The Production of Tobacco.* 1946. Reprint. Philadelphia: Blakiston Co., 1951.

Gelman, Barbara, ed. *Wood Engravings of Winslow Homer.* New York: Bounty Books, 1969.

Giddens, Paul H., ed. and comp. *Pennsylvania Petroleum, 1750–1872: A Documentary History.* Titusville: Pennsylvania Historical and Museum Commission, 1947.

Gittings, D. Sterett. *Riding Straight.* Baltimore: C. C. Giese Co., 1950.

Gottschalk, Louis. *Lafayette Joins the American Army.* Chicago: University of Chicago Press, 1937.

Gould, E. W. *Fifty Years on the Mississippi; or, Gould's History of River Navigation.* St. Louis: Nixon-Jones Printing Co., 1889.

Green, James A. *William Henry Harrison: His Life and Times.* Richmond, Va: Garrett & Massie, 1941.

Groce, George C., and Wallace, David H. *The New York Historical Society's Dictionary of Artists in America, 1564–1860.* New Haven: Yale University Press, 1957.

Gusfield, Joseph R. *Symbolic Crusade, Status Politics, and the American Temperance Movement.* Urbana: University of Illinois Press, 1963.

Hale, Edward E. "Christmas in Boston." *New England Magazine* 1, no. 4 (December, 1889): 355–67.

Hall, Lillian Arvella. *Catalogue of Engraved Dramatic Portraits in the Theatre Collection of the Harvard College Library.* 4 vols. Cambridge: Harvard University Press, 1931.

Hamilton, Sinclair. *Early American Book Illustrators and Wood Engravers, 1670–1870.* Vol. 1. Princeton: Princeton University Press, 1958. Supplement, 1968.

Harding, Bertita. *Phantom Crown: The Story of Maximilian and Carlota of Mexico.* Indianapolis: Bobbs-Merrill Co., 1934.

Harlow, Alvin F. *Old Bowery Days: The Chronicles of a Famous Street.* New York: D. Appleton and Co., 1931.

————. *Old Waybills: The Romance of the Express Companies.* New York: D. Appleton-Century Co., 1934.

Harris, Neil. *Humbug: The Art of P. T. Barnum.* Boston: Little, Brown & Co., 1973.

Harwell, Richard B. *Confederate Music.* Chapel Hill: University of North Carolina Press, 1950.

Hatch, Alden. *American Express: A Century of Service.* Garden City, N.Y.: Doubleday & Co., 1950.

Hemstreet, Charles. *The Story of Manhattan.* New York: Charles Scribner's Sons, 1901.

Henderson, G. F. R. *Stonewall Jackson and the American Civil War.* New York: Layman, Green & Co., 1936.

Hill, Jim Dan. *The Minute Man in Peace and War: A History of the National Guard.* Harrisburg, Pa.: Stackpole Co., 1964.

————. *Sea Dogs of the Sixties: Farragut and Seven Contemporaries.* Minneapolis: University of Minnesota Press, 1935.

History of the K. K. Bene Yeshurun of Cincinnati, Ohio, Published in Commemoration of the Fiftieth Anniversary of Its Incorporation, February 28, 1892. Cincinnati: Bloch Printing Co., 1892.

Hottes, Alfred Carl. *1001 Christmas Facts and Fancies.* New York: A. D. LaMare Co., 1937.

Houston, Sam[uel]. *The Autobiography of Sam Houston.* Edited by Donald Day and Harry Herbert Ullom. Norman: University of Oklahoma Press, 1954.

Howard, John Tasker. *Our American Music: Three Hundred Years of It.* 3d. ed. New York: Thomas Y. Crowell Co., 1954.

————. *Our American Music: A Comprehensive History from 1620 to the Present.* 4th ed. New York: Thomas Y. Crowell Co., 1965.

"How Our Christmas Customs Came." *Natural History,* November 11, 1928, pp. 617–25.

Hoyt, Edwin P. *The Peabody Influence.* New York: Dodd, Mead & Co., 1968.

Huber, Leonard V. "Heyday of the Floating Palace." *American Heritage*, October, 1957.

Hull, Denison B. *Thoughts on American Fox-Hunting*. New York: David McKay Co., 1958.

Hungerford, Edward. *Wells Fargo: Advancing the American Frontier*. New York: Random House, 1949.

Hutchinson, Asa. *Book of Brothers; or, The History of the Hutchinson Family*. New York: By and for the Hutchinson Family, 1853.

Hutchinson, John Wallace. *Story of the Hutchinsons (Tribe of Jesse)*. 2 vols. Boston: Lee & Shepard, 1896.

Industries of Maryland: A Descriptive Review of the Manufacturing and Mercantile Industries of the City of Baltimore. New York: Historical Publishing Co., 1882.

James, M'Gill, *Baltimore Sun*, December 3, 1933.

Jenkins, Stephen. *The Greatest Street in the World: The Story of Broadway, Old and New, from the Bowling Green to Albany*. New York: G. P. Putnam's Sons, 1911.

Johnson, Gerald W.; Kent, Frank R.; Mencken, H. L.; and Owens, Hamilton. *The Sunpapers of Baltimore, 1837–1937*. New York: Alfred A. Knopf, 1937.

Johnson, H. Earle. "The Germania Musical Society." *Musical Quarterly* 39, no. 1 (1953).

————. *Hallelujah, Amen! The Story of the Handel and Haydn Society of Boston*. Boston: Bruce Humphries, 1965.

Jones, Caroline. "Fox Hunting in America." *American Heritage*, October, 1973.

Jones, Frank N. *George Peabody and the Peabody Institute*. Baltimore: Peabody Institute Library, 1965.

Jordan, Philip D. *Singin' Yankees*. Minneapolis: University of Minnesota Press, 1946.

Kansas Historical Quarterly 25, no. 1 (Spring 1959): 1–16; 32, no. 2 (Summer 1966): 161–86; 36, no. 4 (Winter 1970): 390–401.

Keefer, Lubov. *Baltimore's Music: The Haven of the American Composer*. Baltimore: By the author, 1962.

Kelly, J. Frederick. *Architectural Guide for Connecticut*. Published for the Tercentenary Commission of the State of Connecticut. New Haven: Yale University Press, 1935.

Ketchum, Richard M. "The Decisive Day is Come" (from *The Battle for Bunker Hill*), *American Heritage*, August, 1962.

Kimball, Marie. *Thomas Jefferson's Cook Book*. Richmond, Va.: Garrett & Massie, 1938.

King, Moses. *King's Handbook of Boston*. 5th ed. Boston, 1883.

Kirstein, Lincoln. *Dance: A Short History of Classic Theatrical Dancing*. New York: G. P. Putnam's Sons, 1935.

Lamb, Mrs. Martha J. *History of the City of New York: Its Origin, Rise, and Progress*. Vol. 2, pt. 2. New York: A. S. Barnes & Co., 1880.

Lane, Roger. *Policing the City: Boston, 1822–1885*. Cambridge: Harvard University Press, 1967.

Lee, Alfred McClung. *The Daily Newspapers in America*. New York: Macmillan Co., 1937.

Lewis, Lloyd, and Smith, Henry Justin. *Oscar Wilde Discovers America*. New York: Harcourt, Brace & Co., 1936.

Longstreet, Stephen. *Chicago, 1860–1919*. New York: David McKay Co., 1973.

Lossing, Benson J. *History of New York City: An Outline Sketch of Events from 1609 to 1830, and a Full Account of the Development from 1830 to 1884*. Vol. 2. New York: Perine Engraving & Publishing Co., 1884.

Lyman, Susan Elizabeth. *The Story of New York: An Informal History of the City*. New York: Crown Publishers, 1964.

McKelvey, Blake. *Rochester, the Flower City, 1855–1890*. Cambridge: Harvard University Press, 1949.

McKitrick, Eric L. *Andrew Johnson: A Profile*. New York: Hill & Wang, 1969.

MacLeish, Archibald. *Let Freedom Ring. The Story of Independence Hall and Its Role in the Founding of the United States, with the Text of the Lumadrama Spectacle "The American Bell."* New York: American Heritage Publishing Co., 1962.

Mandelbaum, Seymour J. *Boss Tweed's New York*. New York: John Wiley & Sons, 1965.

Marcuse, Maxwell F. *This Was New York: A Nostalgic Picture of Gotham in the Gaslight Era*. New York: Lim Press, 1969.

Memphis *Daily Argus*, September 24, 1866.

Menke, Frank G. *Encyclopedia of Sports*, revised and enlarged. New York: A. S. Barnes & Co., 1944.

————. *Encyclopedia of Sports*. 4th rev. ed. New York: A. S. Barnes & Co., 1969.

Metcalf, Frank J. *American Writers and Compilers of Sacred Music*. New York: Abingdon Press, 1925.

Miers, Earl Schenck. *Where Liberty Stands Guard: The Story of Our Nation's Capitol.* New York: Grosset & Dunlap, 1966.

Miller, J. Jefferson, II. "The Designs for the Washington Monument in Baltimore." *Journal of the Society of Architectural Historians* 23, no. 1 (March 1964).

———. *The Washington Monument in Baltimore.* Baltimore: Peale Museum, 1966.

Missouri Historical Society Bulletin 24, no. 3 (April 1968): 212–13.

Moody, Richard. *Edwin Forrest: First Star of the American Stage.* New York: Alfred A. Knopf, 1960.

Morrison, John H. *History of American Steam Navigation,* 1903. Reprint. New York: Stephen Daye Press, 1958.

Morse, John T., Jr. *Abraham Lincoln.* Vol. 1. Boston: Houghton Mifflin & Co., 1893.

Mulholland, John. "Wyman the Wizard." *Sphinx* 44 (March, 1945).

Myers, Gustavus. *The History of Tammany Hall.* New York: Burt Franklin, 1968.

Nelson, Edna Deu Pree. "Santa Claus and His American Debut." *American Collector.* December, 1939, pp. 8 and 9.

Nevada State Journal, September 28, 1952; October 26, 1958.

New Mirror (New York), December 30, 1843, p. 194.

New York Historical Society Quarterly 22, no. 4 (December, 1938).

Nicolay, John G., and Hay, John. *Abraham Lincoln: A History.* Vol. 2. New York: Century Co., 1886.

Odell, George Clinton Densmore. *Annals of the New York Stage, 1732–1894.* 15 vols. New York: Columbia University Press, 1927–49.

"Old Boston Music Hall." *Musical Courier,* November 7, 1900, p. 40.

O'Neill, Rosetta. "The Dodworth Family and Ballroom Dancing." *Dance Index* 2, no. 9 (April, 1943).

Page, Thomas Nelson. *Robert E. Lee: Man and Soldier.* New York: Charles Scribner's Sons, 1911.

Parker, Franklin. *George Peabody.* Nashville: Vanderbilt University Press, 1971.

Pearson, Hesketh. *The Man Whistler.* New York: Harper & Bros., 1952.

Pennell, E. R., and Pennell, J. *The Life of James McNeill Whistler,* 6th ed. Philadelphia: J. B. Lippincott Co., 1919.

Pennsylvania Magazine of History and Biography 27 (1904): 379–81.

Peters, Harry T. *America on Stone.* Garden City, N.Y.: Doubleday, Doran & Co., 1931.

———. *California on Stone.* Garden City, N.Y.: Doubleday, Doran & Co., 1931.

———. *Currier and Ives: Printmakers to the American People.* Garden City, N.Y.: Doubleday, Doran & Co., 1942.

Powell, Henry Fletcher, comp. *Tercentenary History of Maryland.* Vol. 12. Chicago: S. J. Clarke Publishing Co., 1925.

Pulver, Jeffrey. *Paganini, the Romantic Virtuoso.* London: Herbert Joseph, 1936.

Reminiscences of Chicago during the Civil War. New York: Citadel Press, 1967.

Rice, Edward Leroy. *Monarchs of Minstrelsy: From "Daddy" Rice to Date.* New York: Kenny Publishing Co., 1911.

Riker, William H. *Soldiers of the States: The Role of the National Guard in American Democracy.* Washington, D.C.: Public Affair Press, 1957.

Rinhart, Floyd, and Rinhart, Marion. *American Daguerreian Art.* New York: Clarkson N. Potter, 1967.

Ritter, Frederic Louis. *Music in America.* New York: Johnson Reprint Corporation, 1970.

Robert, Joseph C. *The Story of Tobacco in America.* 1949. Reprint. Chapel Hill: University of North Carolina Press, 1967.

Rodgers, Cleveland, and Rankin, Rebecca. *New York: The World's Capital City.* New York: Harper & Bros., 1948.

Sandburg, Carl. *Abraham Lincoln.* Vol. 2, *The Prairie Years.* New York: Harcourt, Brace & Co., 1926.

Saussine, Renée de. *Paganini.* Westport, Conn.: Greenwood Press, 1954.

Scharf, J. Thomas. *Chronicles of Baltimore.* Baltimore: Turnbull Bros., 1874.

Scharf, J. Thomas, and Scharf, Westcott. *History of Philadelphia, 1609–1884.* 3 vols. Philadelphia: L. H. Everts & Co., 1884.

Scheer, George F., and Rankin, Hugh F. "Rebels and Redcoats." *American Heritage,* February, 1957.

Schwartz, H. W. *Bands of America.* Garden City, N.Y.: Doubleday & Co., 1957.

Sears Roebuck Catalogue. Chicago: Sears, Roebuck & Co., 1897.

Seymour, Harold. *Baseball.* Vol. 1, *The Early Years.* New York: Oxford University Press, 1960.

Sitwell, Sacheverell. *The Romantic Ballet from Contemporary Prints.* London: B. T. Batsford, 1948.

Smith, Robert. *Baseball*. 1947. Reprint. New York: Simon & Schuster, 1970.

Southern, Eileen. *The Music of Black Americans: A History*. New York: W. W. Norton & Co., 1971.

Southern Folklore Quarterly 9, no. 2 (June, 1945).

Stauffer, David McNeely. *American Engravers upon Copper and Steel*. New York, 1907.

Steinman, D. B. *The Builders of the Bridge*. New York: Harcourt, Brace & Co., 1945.

Stille, Charles J. *Major-General Anthony Wayne and the Pennsylvania Line in the Continental Army*. Port Washington, N.Y.: Kennikat Press, 1968.

Stow, Charles Messer. "America's First Lithographer, Bass Otis." *The Antiquarian*, July, 1930, pp. 55, 66, and 86.

Stratton, Stephen S. *Niccolò Paganini: His Life and Work*. New York: Charles Scribner's Sons, 1907.

Sullivan, Mark. *Our Times*. Vol. 1, *The Turn of the Century*. New York: Charles Scribner's Sons, 1928.

————. *Our Times*. Vol. 2, *America Finding Herself*. New York: Charles Scribner's Sons, 1929.

Taft, Robert. *Photography and the American Scene*. New York: Macmillan Co., 1938.

Tatham, David. *Lure of the Striped Pig*. Barre, Mass., Imprint Society, 1973.

Tucker, Glenn. *Mad Anthony Wayne and the New Nation*. Harrisburg, Pa.: Stackpole Books, 1973.

Tuckerman, Henry T. *Book of the Artists*. N.p., 1867.

Turner, H. H. D. *Halley's Comet: An Evening Discourse to the British Association at Their Meeting at Dublin on Friday, September 4, 1908*. Oxford: Clarendon Press, 1908.

Upton, William Treat. *Anthony Philip Heinrich: A Nineteenth-Century Composer in America*. New York: Columbia University Press, 1939.

Van Urk, J. Blan. *The Story of American Foxhunting*. New York: Derrydale Press, 1940.

Villarejo, Oscar M. *Dr. Kane's Voyage to the Polar Lands*. Philadelphia: University of Pennsylvania Press, 1965.

Wade, William W. "The Man Who Stopped the Rams." *American Heritage*, April, 1963.

Wallace, Irving. *The Fabulous Showman: The Life and Times of P. T. Barnum*. New York: Alfred A. Knopf, 1959.

Waller, George. *Saratoga Saga of an Impious Era*. Englewood Cliffs, N.J.: Prentice-Hall, 1966.

Wallop, Douglas. *Baseball: An Informal History*. New York: W. W. Norton & Co., 1969.

Weitenkamp, Frank. *American Graphic Art*. N.p., 1912.

Wells, Helen. *Barnum, Showman of America*. New York: David McKay Co., 1957.

Werner, M. R. *Barnum*. New York: Harcourt, Brace & Co., 1923.

West, Harold E. "History of the Sun." *Baltimore Sun*, November 14, 1922.

Whitlock, Brand. *Lafayette*. Vol. 1. New York: D. Appleton & Co., 1929.

Whitridge, Arnold. "The Peaceable Ambassadors." *American Heritage*, April, 1957.

Wildes, Harry Emerson. *Anthony Wayne, Trouble Shooter of the American Revolution*. New York: Harcourt, Brace & Co., 1941.

Wilmerding, John. *Fitz Hugh Lane*. New York: Praeger Publishers, 1971.

Wilson, James Grant, ed. *The Memorial History of the City of New York from Its First Settlement to the Year 1892*. Vol. 3. New York: New York History Co., 1893.

Winsor, Justin. *Memorial History of Boston*. Vol. 4. Boston: J. R. Osgood, 1881.

Winston, Robert W. *Andrew Johnson, Plebeian and Patriot*. New York: Henry Holt & Co., 1928.

Winwar, Frances. *Oscar Wilde and the Yellow Nineties*. New York: Harper & Bros., 1940.

Wisehart, M. K. *Sam Houston: American Giant*. Washington, D.C.: Robert B. Luce, 1962.

Withey, Henry F. *Biographical Dictionary of American Architects*. Los Angeles: Hennessey & Ingalls, 1956.

Wittke, Carl. *Tambo and Bones*. New York: Greenwood Press, 1968.

Wood, Samuel. *The Cries of New York*. New York: Harbor Press, 1931.

Wright, Edith A., and McDevitt, Josephine A. "Henry Stone, Lithographer." *Antiques Magazine*, July, 1938.

Wright, Richardson. *Hawkers and Walkers in Early America: Strolling Peddlers, Preachers, Lawyers, Doctors, Players, and Others, from the Beginning to the Civil War*. Philadelphia: J. B. Lippincott Co., 1927.

Index

The Johns Hopkins University Press

This book was composed in Linotype Benedictine Book text and York display type by Monotype Composition Company from a design by Susan Bishop. It was printed by The John D. Lucas Printing Company on 100-lb. Warren Lustro offset Enamel dull paper and bound by The Optic Bindery, Inc., in Columbia Colonial vellum cloth.

Library of Congress
Cataloging in Publication Data

Levy, Lester S
 Picture the songs.

 Bibliography: pp. 206–11.
 Includes index.
 1. Music title-pages. 2. Lithographs,
American. 3. United States—Popular
culture. I. Title.

ML112.5.L43 769'.5 76-13518
ISBN 0-8018-1814-1